Lives and Works

Talks with Women Artists
Volume 2

Beryl Smith
Joan Arbeiter
Sally Shearer Swenson

The Scarecrow Press, Inc.
Lanham, MD., & London
1996

#757658

SCARECROW PRESS, INC.

Published in the United States of America
by Scarecrow Press, Inc.
4720 Boston Way
Lanham, Maryland 20706

4 Pleydell Gardens, Folkestone
Kent CT20 2DN, England

British Cataloguing-in-Publication Information Available

Library of Congress Cataloging-in-Publication Data

Miller, Lynn F.
 Lives and works, talks with women artists.
 Contents: Louise Bourgeois — Judith Brodsky — Radka Donnell-Vogt —
[etc.]
 1. Women artists—United States—Interviews. 2. Feminism and art—
United States. 3. Art, Modern—20th century—United States.
I. Swenson, Sally S. II. Title.
N6512.M518 709'.2'2 [B] 81-9043
 AACR2

ISBN 0-8108-3153-8 (cloth : alk.paper)

♾ ™The paper used in this publication meets the minimum requirements of
American National Standard for Information Sciences—Permanence of Paper
for Printed Library Materials, ANSI Z39.48–1984.
Manufactured in the United States of America.

Contents

Illustrations

Prefaces

In 1983 I became the third curator of the Women Artists Series at Douglass College, a series that Lynn Miller had helped to implement and had guided for the first ten years. Lynn's feminist outlook and her appreciation for art coalesced in her unstinting efforts to make the series a success and give the exhibiting artists credibility. Following in Lynn's footsteps has become somewhat of a habit for me, and now I am completing her portion of this book that she began with the two other authors. Although Lynn's heart remains with this project, her energies are now channeled into the practice of law, a field in which she is also a tireless advocate for women.

Ten years ago, when I became the curator of the Women Artists Series (now endowed in the name of Mary H. Dana) at Douglass College, I asked the naive question, "Is there really a need for a series that is exclusively for women?" I was quickly educated by the realities of being a woman and being an artist—the realities of diminished opportunity, scanty documentation, and decreased value for her work. The interviews in this book have added another dimension to my education. While I knew about the realities of the marketplace, what I learned from these interviews is the personal, private realities and sacrifices of being a creative woman who pursues an art career. The women in this book, now at the midpoint of their lives and careers, show in a most illuminating way the price they have paid for their art.

Although some art teachers believe that anyone can draw and paint and can in that sense be considered an artist, what is uncovered through these interviews is the uniqueness that makes these women successful ARTISTS. Almost to a woman, they have felt a sense of separation or isolation as children—there being a unique sensibility, often undefined, that set them apart. Some accepted it; for others it was a source of frustration and sadness; and for most it was the first in a chain of wistful experiences that shaped their lives and ultimately their art.

Later, in the years when marriage, children, and keeping house were the expected norm, the art force—and for them it was an unrelenting force—again shaped their lives. For some it meant eschewing marriage or close relationships to follow their art; for others it meant trying to adapt by juggling the demands of the art with competing family needs, often with a sense of failure in at least one of these arenas. Some marriages faltered, some children felt alienated, and sometimes the women felt defeated. All of them had their lives changed because of their art.

One thing that helped many to persevere was the community they created in those early years of the women's movement. They exhibited together in spaces that they created, and they supported one another in consciousness-raising sessions, providing a lifeline that gave hope to some, permission to others, and for many, for the first time, a feeling of community that had eluded them in other corners of their lives.

If we assess the importance of the women's movement today, the evaluation must be based upon what has and has not changed since 1970. Statistics indicate gains, sometimes followed by steps backward, and some things have been left unchanged. The peak years for women entering the mainstream—however grudgingly this was allowed to occur in answer to women's demands—seemed to be the period 1978–1983. During those years more women were represented around the country by shows in commercial galleries, by solo exhibitions in selected museums, by first purchases by corporate art collections, and by fellowships and artist support grants. Figures show that since 1983 many of the percentages have dropped, although none has reached the pre-1970 nadir. Is there a need for a women's movement today? And is there still benefit to be had from women's series and women artists' spaces? As long as women are excluded from or underrepresented in major exhibits and exhibition spaces and collections, as long as women's art is undervalued, as long as the documentation of women's art is scanty and trivial, as long as a woman's age or physical appearance is a determining factor in the acceptance of her art, there will continue to be a need for all the support women can give to one another and for major educational efforts.

Can women enter the mainstream from this kind of an environment? The interviews in this book indicate that some can, others have more difficulty. This book is offered to show what some women have accomplished, but even more to give encouragement to young women artists who are beginning their careers. At the same time, an audience of readers that is interested in art, regardless of gender, may be enlightened so that the next generation of women artists may direct their energies to their art rather than to the battle.

—Beryl Smith

* * *

My undergraduate years were spent at Douglass College, a women's college with a supportive environment. But this was the 1950s, a time when the curriculum and the faculty were inordinately male dominated—yet none of us seemed quite ready to recognize this as an issue.

I had my second chance at coming-to-consciousness in the late 1970s and early 1980s, when I benefited from at least four events of momentous

significance: the opening of the New York Feminist Art Institute (NY-FAI), an alternative art school; the elevation of the Women's Caucus for Art to a status separate from but equal to the College Art Association; the establishment of regional W.C.A. chapters; and the mounting of two monumental exhibitions of the work of women artists. It was a revelation to view "Women Artists, 1550–1950," curated by Linda Nochlin and Ann Sutherland Harris, in 1977, and three years later, Judy Chicago's *Dinner Party,* both at the Brooklyn Museum. In between, NYFAI opened its doors, and, in spite of the fact that I had just enrolled in a master of fine arts program at an established patriarchal institution, I managed to obtain credit for an internship at this courageous school. It was there I saw Miriam Schapiro lead a group of her students in dance and joined Judy Chicago's "Birthing" workshop; and it was in Nancy Azara's "Visual Diaries" class that my personal aesthetic and political sensibilities were nurtured. In fact, I continued to explore feminist issues by attending classes and programs throughout NYFAI's eleven-year history.

In 1984, I helped to inaugurate CERES, a feminist cooperative art gallery, where I continue to exhibit. In my studio and in my classroom I have been formed by all these associations. This is why I agreed so readily when asked by Lynn Miller and Sally Swenson to be part of this book, for I have come to realize that while feminist history is empowering, it is also very fragile and needs to be protected, preserved, and published!

Finally, a sincere thank you to all of our artists who waited so patiently for this book to appear—your lives and works are truly our inspiration.

—Joan Arbeiter

* * *

In 1981 Lynn Miller and I co-authored *Lives and Works,* a book of talks with women artists. For the first book I did the interviews, and they were edited by Lynn Miller, a librarian and coordinator of the Women Artists Series in the Douglass College Library. All the artists included in that book, as well as this, had exhibitions of their art during the first ten years of that series (1971–1981). This is the common thread that unites the artists from both volumes.

Much has happened in the art world since the first set of interviews were done. Some of these women artists have now entered the mainstream and are receiving worldwide recognition; others continue to work in obscurity. A few of these artists are now well known and widely collected. Their creations are written about; they are exhibited in major galleries and museums. One difference, since 1981, is that the word *feminism* has now taken on negative connotations. The women's movement has been a sword with two edges. As in the past, it continues both to hurt and to help women, for while it has drawn attention to women's art, in many cases it also has separated them from the art world.

In order to document the phenomenon of the women's movement in art and the way it has affected the artists who are a part of that history, Joan Arbeiter and I, both teachers and practicing artists of many years, and Beryl Smith, an art historian and librarian, have compiled this series of interviews. This time, we each interviewed four or five artists whose work was highly interesting to us personally. The focus of these interviews is on the individual artist's life and work, as it was in the first volume.

It is interesting to compare the two books from the artists' points of view: what has changed and what remains the same. In my case I used the same approach. I was interested in the sources of the artists' inspiration: who and what influenced them, how they were encouraged, how they were discouraged. Being an artist is very difficult. It often seems as if no one really cares. In spite of everything, it is the artist herself who has to want to go on.

These interviews are a living history that give the words an immediate poignancy absent from traditional art history. These are the thoughts of each artist about her own work, in contrast to critical writing which, although highly valuable, is done by others, often after the artist's lifetime.

I greatly enjoyed talking with the artists about their ideas and their works. For me this project has been both rewarding and revealing. The art of each century is a mirror of that time, and each artist leaves her own vision of her place in that period. The beauty and power of the art of these women will remain to enrich our experience and give encouragement to future generations.

—Sally Shearer Swenson

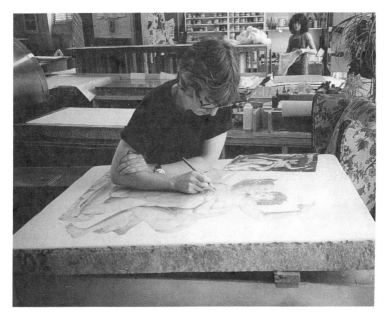

Plate 1. Dotty Attie at work on print, *Mother's Kisses*. Photo by David Attie.

Dotty Attie

Education

1959 B.F.A., Philadelphia College of Art, Philadelphia, Pennsylvania

Selected Solo Exhibitions

1993 Mary Ryan Gallery, New York, New York
1992 Montclair Art Museum, Montclair, New Jersey
1991 P.P.O.W., New York, New York
1990 Greenville County Museum of Art, Greenville, South Carolina
1989 Pittsburgh Center for the Arts, Pittsburgh, Pennsylvania (catalogue)
1980 Women Artists Series, Douglass College, New Brunswick, New Jersey

Selected Group Exhibitions

1993	Biennial, Corcoran Museum of Art, Washington, D.C.
1992	"Quotations: The Second History of Art," Aldrich Museum of Contemporary Art, Ridgefield, Connecticut (catalogue)
1991	"Crossing over Changing Places," Center for Innovative Printmaking, Rutgers University, New Brunswick, New Jersey
1989	"Gardens Real and Imagined," Bernice Steinbaum Gallery, New York, New York (catalogue)
1987	"Works from the Collection," National Museum of Women in the Arts, Washington, D.C. (catalogue)
1984	"Verbally Charged Images," Queens Museum, Flushing, New York (catalogue)

Selected Bibliography

Hough, Katherine Plake. *Transforming the Western Image in Twentieth Century American Art*. Palm Springs, Calif.: Palm Springs Desert Museum; Seattle: University of Washington Press, 1992, 104–5.

Kozloff, Max. "The Discreet Voyeur." *Art in America* 79 (July 1991): 100–106.

Robins, Corinne. "Changing Stories: Recent Work by Dotty Attie, Ida Applebroog, and Suzanne Horvits." *Arts Magazine* 63 (November 1988): 80–85.

Robins, Corinne. "Dotty Attie: Narrative as Ordered Nightmare." *Arts Magazine* 51 (November 1978): 81–83.

Kultermann, Udo. "Vermeer: Versions Modernes." *Connaissance des Arts* 302 (April 1977): 94–101.

Interview

Dotty Attie was interviewed by Lynn Miller in 1988

LM: Tell me about when you first knew you wanted to be an artist.

DA: I think I wanted to be an artist my entire life. My parents used to tell me that from the time I was two years old, as soon as I could hold a pencil, I was drawing. What I remember of my early art life is drawing on any blank sheet of paper. All my parents' books were drawn in. You know how at the beginning and the end there are a few blank pages in every book? Well, I drew all over those.

LM: Did you get in trouble because of that?

DA: They didn't like it, but I didn't stop doing it, so I guess they didn't dislike it that much. My father and mother had met at a party at an art studio, and my father had wanted to be an artist, but he married and decided he couldn't make a living as an artist, so he became a salesman instead. But they liked the idea that I showed talent when I was little. They liked that and encouraged it. They bought me lots of paper and materials. I got all of my positive reinforcement from that.

LM: Did your parents save those books?

DA: They saved nothing. They gave everything away, even things I wanted them to save for me, things I was going to collect later on, they gave away, never asking me. I don't have any of it.

LM: Did you have special art classes as a child?

DA: I'm from Pennsauken, New Jersey, which is near Philadelphia. In Philadelphia there's a place called the Fleisher Art Memorial. It was free, and I assume that it still is free. It was endowed by a wealthy person who was interested in art and felt that people should have the opportunity to go to art classes. Adults and children, all sorts of people, went there, and my parents had both gone there as young adults. They took me when I was very little, and I also took classes. So I did have a little early art education.

LM: What about your education? Where did you go to school?

DA: I went to public school. I always say I got the worst education possible for an artist, and only occasionally would there be an art teacher that was good. My high school art teacher was rather elderly and very set in her ways. She and I didn't get along well. I don't think she had a sense of anyone ever becoming a professional artist. She was the "take your stuff out on Sunday and do a nice watercolor" type of person, and she was teaching with that in mind. I hated painting watercolors, didn't do well at it, and she was convinced that I was not artist material at all. Finally she called my parents and told them that she heard that I was applying to art school (of course I didn't ask her for a recommendation), and that it would be a waste of my time and their money if they sent me there.

LM: Luckily your parents did not believe her.

DA: No. My mother said, and this is typical of my mother, "Has she been rude to you?" And I think that the teacher said that I had. And my mother

said that bothered her a great deal more than the teacher thinking I had no talent.

LM: Who did write your recommendations then?

DA: I guess other teachers.

LM: But not an art teacher?

DA: I had an art teacher. I was going to the Philadelphia College of Art, on Saturdays, and I had one teacher there who wrote a recommendation.

LM: And then you went full-time to the Philadelphia College of Art?

DA: Yes. Actually, it wasn't called that then. It was called the Philadelphia Museum School of Art. It changes its name regularly. Now it's called University of the Arts—just changed its name yet again. When my father went there it was called the Philadelphia School of Industrial Art.

LM: That explains its heritage, that they didn't have a fine arts curriculum.

DA: Until '59.

LM: By the time you graduated they had put one in?

DA: No. I graduated in June 1959, and the next September they inaugurated a Fine Arts Department.

LM: So there you were at the Philadelphia College of Art, formerly the Philadelphia Museum School of Art. What were your years there like?

DA: I loved it! I loved art school! I was so happy in art school! I had been the sort of child/person that seemed different from everybody I knew. I was different from my parents, my sister, and my friends. I was always interested in different things.

LM: How were you different?

DA: Well, I didn't like to go out and play when I was little; I liked to stay in and read. I liked to draw all the time. I wasn't particularly social. My sister was very social, very popular, and very, very gregarious. I was not at all gregarious.

LM: Who was older?

Plate 2. *Barred from the Studio,* 1987. Oil on canvas, 11″ × 34″. Photo by Adam Reich. Courtesy of P.P.O.W.

DA: My sister. I was really uncomfortable in social situations. I always felt awkward. My sister was very pretty; I was very skinny and homely. My friends also liked to play, and they were interested, when we got to be teenagers, in boys and clothes, and I still just wanted to read and go to foreign movies. It seemed as if nobody on my block had any of the same interests that I did.

LM: How much time had you been spending on drawing and making your art? Was that part of it, that you were spending a lot of time on your art?

DA: When I was in high school, no. I wouldn't say I was spending a lot of time on art in those days. I was probably reading more than anything else, going to the movies, and watching television. I watched television a lot. I've always liked to do nonparticipatory things, and I still do. I liked spending a lot of time by myself, which my parents thought was frightening. They didn't understand anybody wanting to be by herself.

LM: They understood your artistic wishes and abilities but not the wish to be alone.

DA: To a certain point. When I got to art school I met people who liked the same things I did, for the first time, and also people who valued what I did. When I was a little girl and made paper dolls people liked them, but I couldn't draw paper dolls ten hours a day. Most of the time I was doing other things in which I didn't particularly shine. But when I entered art school, what was important to me was important to everybody else for the first time in my life. I met other people who had exactly the same ideas and the same goals I did.

LM: What was the curriculum like, and what did you end up studying?

DA: The first year we had a little bit of everything that the school had to offer: painting, drawing, design courses, and industrial design. Then in the second year we had to choose our major, and I chose to major in art education, and then I had education classes as well. We continued to learn a little of everything. I guess the idea was we never knew what we were going to have to teach so we had to have a fairly catholic experience. We had painting, ceramics, jewelry making, design, graphics, and printmaking.

LM: Did they have film?

DA: No, but we had photography.

LM: What was the mix of men to women among the student body?

DA: I really don't know. I never even thought about it. Probably equal. Traditionally lots of women go to art school. Since it was a commercial art school, people were there to prepare for a career. There was interior design—that was another area available. I remember having a discussion with a woman who was majoring in interior design. I was saying that I wanted to have a career as an artist or illustrator or whatever I wanted to be at that point, and she said, "I'm just here so I can learn to decorate my bathroom." I don't know how many women went with that in mind, but I don't think too many. I think most of the people who were there really did want to have careers.

LM: Why did you choose that school over, say, a conservatory school where you could get a fine arts education?

DA: I think I went there because my father went there and because I knew about it. I don't think there was any deeper reason.

LM: But when you went you knew that the curriculum did not have the fine arts component.

DA: I don't even remember that being an issue. I think I wanted to be an illustrator.

LM: And are you?

DA: Am I an illustrator? No. I don't think so. I actually tried to work as an illustrator for about six months and really hated it at a certain point.

LM: Why was that? When I think "illustrator" I think first of all of children's books because they have some of the most wonderful drawings in the world. I wonder why you wanted to be one? Do you remember having specific ambitions?

DA: I'm not sure. I've always done figurative work. Even as a child I always made up stories in my head and illustrated them, in a sense. I was fascinated with the idea of illustration, and I like illustration, and I liked to look at it. Although I went to museums, I think I connected more with magazines.

LM: Books?

DA: And books, yes.

LM: What you saw in books was illustration.

DA: And magazines too.

LM: You told me before that when you came out of college you were a sculptor.

DA: By that time, yes. I wasn't interested anymore in being an illustrator.

LM: What made you change?

DA: I had a flirtation with illustration, which lasted from the time I was quite small until I actually worked for about six months as an illustrator and decided there were lots of reasons why I didn't like it and wasn't suited to it. I went to the Philadelphia College of Art because that was where my father had gone, and I was interested in becoming an illustrator. I felt there was no possibility of making a living as a fine artist; I grew up in a house where my father had given it up.

LM: You didn't know anyone who had made it as a "fine" artist?

DA: I knew no artists. The only person I knew who had any connection with art was my father and the teachers that I had. I certainly didn't know any practicing artists, or any illustrators either for that matter. I took illustration courses in art school and did really well in them too, as a matter of fact. When I came to New York, I applied for and got a fellowship to the Brooklyn Museum School because my cousin had received the same fellowship, and, again, it was as if I didn't know anything else. My college had never heard of that fellowship, but they agreed to apply for me.

LM: To go from the Philadelphia College of Art to the Brooklyn Museum School?

DA: Yes. I had to say to the administration at P.C.A., "I want to apply for this fellowship." They had never heard of it.

LM: Great. I hope the current placement department is better.

DA: Oh, I'm sure it must be. Now it's the University of the Arts. For me, it was just a question of going where I knew other people had gone. My cousin was studying painting, and I decided I wanted to study sculpture, which they also offered.

LM: Let me just go back to the Philadelphia College for one minute. Had you studied with any women teachers, and were they an influence on you?

DA: The only two that I remember are a teacher who told me that great artists always painted each eye in a portrait differently. The two were never alike; I also remember the head of the Education Department. She wore little hats and had frizzy hair and was very, very genteel. Just like a Hokinson person. Do you know those cartoons in the *New Yorker*? The man who was directly under her, the teacher I really liked the most, was very dynamic and exciting, interesting; he made teaching seem fun. It was really because of him that I even stayed there for three years, because I hated it from the first semester. But he was wonderful.

LM: You hated the curriculum.

DA: I hated the thought of teaching.

LM: You hated the idea of learning art education?

DA: Yes. I always thought about switching to illustration, but I never did because of him. He was exactly the opposite of Mrs. Ballinger. So, un-

fortunately, all I can remember is Mrs. Ballinger, and the other woman whose name I can't even recall.

LM: Then you made the transition to the Brooklyn Museum School.

DA: Then I went to the Brooklyn Museum Art School for a year. I moved to New York and got a room in a boardinghouse on Fourteenth Street, which I shared with a dancer from Philadelphia who was the friend of a friend. I love New York. I was really happy to be here.

LM: What time period was this?

DA: I moved to New York in September of '59. And then I got married in '62, so from 1959 to 1962.

LM: Your husband was a photographer. How did you find each other?

DA: I was living in a loft with my roommate and another woman I had met at the Brooklyn Museum Art School. In the loft above us was a man who had something to do with filmmaking—I can't really remember exactly what his job was. He gave a party and David came, and that was how I met him.

LM: After you were married, you told me you moved into his apartment and you were both working, but you kept your studio.

DA: Right. I kept my studio elsewhere.

LM: And then you had kids and bought this house.

DA: We got married, and I got pregnant. We had to move because his apartment/studio couldn't accommodate more than one person in the daytime. So we found this house, which was a great stroke of luck even though it cost a lot more than we wanted to pay. We had thought we could buy something for $25,000 at the time, but that wasn't possible. We renovated it very slowly over a number of years.

LM: And you had a studio in the house?

DA: Then I had a studio on the top floor, which was a small room but big enough; my work is small. Actually, in those days my work wasn't so small. I was doing big paintings. It was very uncomfortable, but I somehow didn't mind the discomfort. I don't know why. I never thought about it, I guess. Eventually, we had rather a big blowup over the issue of work

space. I decided that I deserved a better place to work. When David had become a photographer he had borrowed money from his brothers in order to live for a year and establish himself, and then he paid it back. I said, "Your brothers made an investment in your career. They lent you money, and you were eventually able to pay it back because you were successful *because* you had that year. Now we have to make an investment in my career." Actually, when I had said that, we had a tenant in this space, and the tenant was moving. I said I didn't think we should get another tenant. I think, at that point, our tenant was paying $175 a month. I said, "We're not going to get another tenant. I'm going to move into that space. For one thing, there's something very unprofessional about having people trek all the way up to my studio, past the bedrooms. I want to be in *my* studio, I want to have a studio that's a real studio, and eventually I'll be making enough money to cover whatever we'd have been getting in rent." And actually, I made enough money quickly, probably within a year and a half.

LM: This was around the time that you began showing in galleries? In the early seventies?

DA: I'm trying to think now when I moved. My son, Eli, was about four, and now he's twenty-one. He was born in '67, so that was '71. I joined A.I.R. in '72, had my first show in '72, and actually I sold a lot of work, if not during the show then right after it.

LM: How did your husband react when you told him that there had to be some changes?

DA: He was stunned and upset. Upset, because I think it came out of the blue for him. I had been talking to people about consciousness-raising, talking to my cousin in particular, and listening to a program on WBAI [a Pacifica Network radio station in New York City], and my feelings just started accumulating, the feelings about what am I doing? I'm not able to work. I'm not going to be able to achieve any of my goals if life continues going like this.

LM: Was that because you had primary child-care responsibility and you had to run the household?

DA: Yes. I was cleaning, I was cooking, I was really taking care of the children totally. David would do what he could when he was there, but there was no sense of his *having* to be there. As a matter of fact, during the six-month period that I was working as an illustrator, I had an interview with somebody from *Evergreen Review*. I was going to show him my portfolio. He had called me; he was interested because he had seen

some of my work. For me it was a big thing. David was supposed to come back at a certain time so I could be ready for this appointment, and he was half an hour late. Significantly late. I was very, very late for the appointment, and I just didn't know what to do. I had a terrible feeling that I couldn't keep a professional appointment on time because *he* hadn't taken it seriously enough to make sure he was back. If *he* had had an appointment with a client back here, he'd have been here. Do you know?

LM: Of course.

DA: It just made me crazy. We had a long discussion. I said to him, "How could you do this? We're changing." On that day we sat down, one of the things I said to him was, "I'm not going to ask permission from you to live my life anymore. I'm just going to live it." I said, "If I have an appointment I'm going to go, and you're going to know if you're not back here in time the kids aren't going to be with anybody. You'll have to be here, because I'm not waiting for you." And that was really what I did. I never left them alone; he was home. But he knew I was serious about that. It was a million little things. A million things that all added up to the fact that he felt what I was doing wasn't important but what he was doing was. And I didn't feel that way. I felt what I was doing was important. It was as important as what he was doing. And I think if I hadn't felt that way it would have been harder for me to take the stance that I took. I also felt that what we did was close enough to draw a parallel and say to him, "What I'm doing is just as good and important as what you're doing. And besides that, you're doing what you like, and I'm doing what I like." If he'd been out selling shoes all day I might not have been able to take the position I was taking because he would then have been doing something he hated just to support us, and maybe I would have felt that in that case I have to also make compromises.

LM: But he also had his studio right here. He was also in the building?

DA: Right. He was in the building, but he felt that somehow his work was sacrosanct. One time he even said to me, "Sometimes I hear the kids crying when I'm down in my studio." As if it were my fault and I had to change that—that he shouldn't even hear them cry. I couldn't believe it. I was furious. I said, "So, you hear them crying? I'm up here dealing with it. I can't work at all. You can at least work." I couldn't get over the fact that he was complaining—as if I'm not only supposed to take care of them and everything else, but also to keep them quiet so that he wasn't disturbed by the sound of his two children.

LM: But you said that things did change.

DA: Definitely. Things absolutely changed. The disturbing thing was that it didn't occur to him that he didn't have these rights, because he was raised in a family in which this was the norm. Women did everything. Men worked and brought in money, and that was enough. That's all a man should do. It was very hard for him to deal with the fact that I didn't feel that this arrangement was enough, that I wanted a different kind of marriage, and I wasn't prepared to behave as his mother had.

LM: He went along with it, the change? It was hard, but he did it?

DA: He definitely did.

LM: At that point in many marriages, either the woman would have said, "I don't like this anymore; I'm leaving," or the man would have said, "Oh, if that's the way you feel, then you want to be married to somebody else." A lot of couples would have split.

DA: I was ready to leave, but it never got to a point where I said I was leaving.

LM: But you would have?

DA: I saw that my life was untenable the way it was.

LM: Because you're an artist?

DA: Because I would never have been able to be a serious artist the way I had hoped I would my entire life. For me, the kind of life I was living just wasn't interesting enough. For some people it is. For me it just wasn't interesting enough to be cleaning and cooking and taking care of children all day. I wanted to do something else.

LM: After the discussion, how did it change?

DA: I moved down to my present studio, for one thing, and that was a big change because it really helped both of us to think of me more professionally. I joined A.I.R., and I started showing; the two things happened very quickly.

LM: You were one of the first members of A.I.R., in the founding group?

DA: I was one of the first six. I joined A.I.R., I had a show, and as soon as I had my first show I got reviews and people were interested. People came

to my studio and I started selling work, and I felt that I had another life that was *my* life. Even though I never made the kind of money David did, there were years when I made a significant amount of money, and I began to have a visible career and a visible life aside from my life as David's wife.

LM: And as the mommy.

DA: And mommy. I even changed my name.

LM: You did? What was your name before?

DA: Dorothy. Not Dotty. No one ever called me Dotty. My family, when I was little, called me Dotsy, and most people called me Dorothy. But I had a friend who said to me, during a discussion about success and names, that Andy Warhol would never have been as successful as he was if he continued to call himself Andrew. And he said to me, "You have a fantastic name but you never use it." And I said, "What's that?" And he said, "Dotty Attie." So when I joined A.I.R. I thought, I'm going to give it a try. I told them to put me down as Dotty Attie, and that became my professional name. All the other mothers at the kids' school, and all my friends, still called me Dorothy, so when I would pick up the phone I would know immediately what life this call was from. Then, eventually, my art persona started to take over, and now everybody, even my mother, calls me Dotty.

LM: It is a new persona. That's very interesting.

DA: To me, Dotty Attie was just a name people would remember better than Dorothy Attie. It was catchy.

LM: Tell me about A.I.R., the early years, and what it was like to put that feminist cooperative art gallery together.

DA: A.I.R. was so exciting in the beginning. It was just wonderful. First of all, we went, the four of us—

LM: Who were the four?

DA: Barbara Zucker, Susan Williams, Mary Grigoriadis, and myself. We spent one day a week for three or four months looking at work in artists' studios. First of all, we got the slide registry from Lucy Lippard.

LM: That's that Ad Hoc Women Artists Slide Registry?

DA: Yes. First of all we called everybody we knew, and asked if they knew any artists, and then we started visiting studios. But then we found that so much of the work we couldn't relate to at all.

LM: Well, what were you looking for that interested you?

DA: Nothing special, except that it had to be special.

LM: I know what you mean because I used similar methods looking for people to show in the Women Artists Series. You want strong, unusual work.

DA: We wanted work that we thought was fantastically good.

LM: It was all women.

DA: All women. Three of us had to vote yes for anyone to get in. We went to studios for about two weeks and found that a lot of the work we saw we didn't like. It was work we never would have looked at if we had known what it was before coming in. It was an uncomfortable experience because it was work of friends of friends, or friends of ours, so it was hard for us to figure out how to reject people.

LM: Yes. I'm familiar with that process.

DA: I remember we had a long discussion, and a couple of us felt that a telephone call was very important. It's something that commercial galleries would never do, and we should honor people and respect them enough to reject them with a telephone call. But after about two or three weeks of rejecting people with telephone calls (we would take turns doing it each week) we began to see that we ourselves could never find fourteen additional people if we had to reject everybody that way. It was just too difficult, and it was difficult for the people we were calling too, because they had to hear the news that somebody rejected them, which is always bad news no matter how little you may care about it, and then they had to be social.

LM: Because it's a friend.

DA: Even if it wasn't a friend. You're on the telephone. You still have to say, "Oh, okay." You still have to say something even if it's just good-bye. Whereas if you read it you can be depressed by yourself. So, I said that for us, and for them, it's better in a letter. I really lobbied for letters, and we agreed, all of us, finally. We ended up sending letters to people

that were rejected. We also decided that we should see slides first of people's work, so we got the women's slide registry, and we looked at that as a screening device.

LM: By the way, whatever happened to that slide registry? Is it gone? Or does Lucy Lippard still have it?

DA: I think it's still in existence, but I don't know where it is.[1] We looked at the registry, and again, we voted. Three of the four had to vote positively for the person to get a studio visit. We'd have a list of people whose studios we wanted to visit, and we would take turns calling them up. Interestingly enough, this whole process lasted three or four months. In the beginning, a lot of people said they weren't interested at all.

LM: Did they say why?

DA: They just didn't want to be in a co-op, or it didn't sound very interesting to them. Towards the end those same people were calling us up and telling us that they wanted us to come and look at their work, which we thought was a triumph.

LM: I wonder why they changed their minds?

DA: We thought it had to do with all the people we were rejecting. When someone finds out a lot of people are getting rejected from something, they think it's probably better than they initially thought. I could be wrong, but that was my intuition. Actually, it took a long time for us to find fourteen people. When we did, we had a big meeting of everyone, all twenty, and we showed our slides. After that meeting a couple of people dropped out, maybe three or four. Ree Morton was one of those, and Cynthia Carlson. I think Louise Bourgeois also.

LM: She wasn't really showing much back in those days.

DA: No, she wasn't. And she had approached us.

LM: Was Joyce Kozloff with you?

DA: No, never. Then we formed a new committee of all the members, and they chose the remaining three people, and from that point on we did

[1]In 1990, NYFAI donated the slides to Rutgers University where they are housed in the Special Collections and Archives.

everything pretty much by the committee of the whole. Everybody just voted. I think Barbara and Susan had a little problem with it, because A.I.R. had been their idea, and I think they would have liked to retain a little more control than they got in the end. They left very soon. Within three years they were both gone.

LM: Who else do you remember from that early, early A.I.R. time?

DA: There was Ann Healy, Maud Boltz, Daria Dorosh who's still a member, Nancy Spero, Louise Kramer, Nancy Kitchell, Rosemary Mayer, Howardena Pindell.

LM: A.I.R. had had a smaller space, but it was on the first floor when it started?

DA: We still have space on the ground floor. Now it's on Crosby Street— 63 Crosby Street, in Soho.

LM: You are no longer a member?

DA: No. I left November 1, 1988.

LM: Tell me about what function you think A.I.R. Gallery served for you and for some of the other women.

DA: It gave me a career. Until I showed at A.I.R. nobody had ever heard of me. I can remember telling someone that my ambition was to go to a party or walk into a room and introduce myself as Dotty Attie and have somebody say, "Oh! Dotty Attie! I know your work." Just to *feel* that more than my immediate family knew who I was, that was my sole ambition in those days, and A.I.R. really did that for me. I started showing and getting reviews, and selling work, and showing in more and more far-flung places. More and more people knew who I was.

LM: Do you think it made a difference that it was a group of women running things collectively rather than the traditional gallery structure?

DA: I think in the beginning it was very interesting to people that that's what we were doing. We were a forceful group, but any novelty wears off very fast, and then you have to assess whether the art is interesting or not. I think that the work in A.I.R. was very interesting.

LM: What about for you? I should think that if you are part of an artists' co-op you have more control over the way things turn out.

DA: Individually, we had no control. That was part of what A.I.R. was about. We had total control, but we *all* had control.

LM: That's what I mean. As a group you had more control. In the hands of the artists rather than some manager or something.

DA: Yes. That had good and bad things about it. It was good because we were in control. We could show whatever we wanted to show. We didn't have to worry about whether anything sold or not. If we didn't sell anything from a show, we would still get a show in two years. We could just do whatever we wanted.

LM: So being in a feminist co-op decommercialized and depressurized it to a certain degree.

DA: We were much freer. That was good. What was not so positive was that not only did we not have to worry about selling work, it was difficult to sell. It wasn't difficult for me because my work is object art, the kind that always, I think, will sell well. But for people whose work was more difficult, there wasn't one person—like a gallery manager or owner—that a collector could learn to trust and believe in and ask, "Do you think I should take a chance with this work?" Those artists really never found a base, and it's important to develop that. Collectors buy your work and then they have a private investment in it, and if they're in a position of influence they can really help you. It's important for an artist to have an influential base of collectors, and that didn't happen for A.I.R.

LM: I never thought of your work as "easy."

DA: Not easy so much, but my drawings were very beautiful—perfect, little, collectibly small—but some of them were very long even though individually they were small.

LM: In series.

DA: Yes. They might be very long, but they were attractive. They had a lot of traditional qualities. Each drawing was beautiful and, from that point of view, people didn't have a problem buying them. But if somebody makes two strands of wire hanging from the ceiling with tea dripping from it, it's more difficult to sell. It's not that it's unsellable, because there are plenty of artists who do odder things that sell. But you have to have somebody who will say, "This is really great! I think you should buy this." There has to be an atmosphere of trust in any situation where a collector feels risk is involved.

LM: So now you're with a different gallery.

DA: Yes. P.P.O.W.

LM: Let's go back a bit. You had told me that when you were looking for ways to start changing your work, you saw a show by Joseph Cornell and were inspired by it.

DA: Yes. And it wasn't boxes, it was a show of collages by Cornell. What inspired me was the feeling that his work was very, very personal and very much out of mainstream art. It was completely unique and itself. I had a strong feeling that if one could do work that was intensely personal and didn't really relate to mainstream movements it might never get as popular as mainstream art does, but it also won't fall out of fashion either. That was what I wanted to do, something very unique and very personal that didn't fit into any category. It didn't turn out that way, but that was my goal.

LM: What did happen?

DA: What happened to me? I thought I was making that kind of work. For one thing, after that I made a decision to draw.

LM: And you drew for a long time.

DA: I drew for fifteen years, and at the time I made that decision it was pretty daring because there weren't many people—maybe one or two—who were just making drawings.

LM: When did Susan Schwalb start drawing? Because she's been drawing since the seventies too. Do you know her work?

DA: I know her, but I didn't meet her until much later. I'm sure there must have been other people, but I was only aware of a very few. I felt that drawing was something I did very well. I don't paint very well, but I draw very well, and it's better for me to do what I do best even if people don't take it as seriously as they would paintings. I'd rather do something incredibly well, that people considered minor, and be the best at that than to be just one more mediocre painter. I started drawing, and then I started making narrative pieces. When I had the first show in which I exhibited narrative pieces with text, I was very nervous and worried that people would say, "She's an illustrator; she's making stories and illustrating them."

LM: Which is what you had always wanted to do anyway.

DA: It just has to do with my personality. I'm attracted to stories and pictures going together. What I was afraid of was its being used in a pejorative way.

LM: I understand.

DA: I had a show in November. In October there had been two shows, one of Duane Michaels, who did sequential photographs — another big influence on me, incidentally. Seeing his sequential photographs was the first time I had really seen sequential art, and it had a huge impact on me. He showed them with text for the first time, and there was somebody else who showed at John Gibson who was also exhibiting photographs with text. The three of us got lumped together as story artists, which then became narrative artists. It actually became a movement which I got included in, obviously, so my fantasy of doing something completely unique didn't come to fruition.

LM: But I do remember the excitement in the feminist art community over your first work. They were very small, teeny. That was different. Other people's work was not that small.

DA: And they didn't do drawings, and they didn't copy. I did a lot that was different. But what was the same was the use of text to create some kind of narrative.

LM: The work I'm seeing here in your studio is similar to, yet different from, the work we showed at Douglass about fifteen years go.

DA: Each one of my early works, framed, was about five and a half inches square. That's all I did for fifteen years.

LM: Your work is getting bigger now.

DA: Well, now I'm painting. I've been painting for about two and a half years.

LM: I think I can figure out that you're deconstructing the "masterpieces."

DA: Well, when I drew, my tendency was to take images from different eighteenth- and nineteenth-century European paintings, take fragments

of them, put them all together and write a story. And I put everything to-
gether—an Ingres and a Caravaggio, for example.

LM: Are you still doing that: mixing and matching?

DA: No. Since I've been painting I haven't been doing that. I haven't made
many painted pieces—only seven actually. I had a show in September
1988 in which I showed those seven paintings. The name of the show was
"Episodes in the Lives of the Masters." There were five artists: Ingres, Car-
avaggio, Stubbs, Eakins, and Vermeer, and I wrote little narratives.

LM: You were mentioning influences, and you had once told me about
Gorey. You had seen some work by Gorey?

DA: Yes. I received a book as a Christmas present.

LM: I wanted to ask you about Edward Gorey, because I always thought
your work had a humorous side to it, and even though the individual
drawings or paintings might be serious, when they're joined with the text
there's a disjuncture that makes the drawings a countertext, and it's
funny. Was it only Gorey's narrative style, or is it only Gorey's draw-
ings, or what is it about his humor?

DA: Well, there's a lot of things about Gorey that I connected to. There
was the horror of it. A lot of his stories are about murders and terrible
things happening that he approaches with humor.

LM: Black humor.

DA: I do the same thing. I would definitely say that I was influenced by
his work, although I can't exactly say I would have done something to-
tally different if I hadn't seen Gorey. I felt that something in me con-
nected very much with what he was doing, and it was as if a light bulb
went on in my head.

LM: A fragment?

DA: Well, he doesn't use fragments. What he had done in a couple of his
stories was use sentences that seemed random after a while; it didn't seem
like that at first. At first it seemed as if it was really a story; it just didn't
make that much sense. But then, after a while, I began to see that the sen-
tences hadn't anything to do with each other. We were connecting it.

LM: The viewer connected.

DA: Yes. The viewer connects those gaps.

LM: Which is what people do in the movies, and that's how film works.

DA: Right. Exactly.

LM: There are discrete images that your mind links together into a flowing movement, and that's how your work works too.

DA: And that was an influence. That was an influence in the sense that I don't think I would have thought of that if I hadn't seen Gorey.

LM: So where is your work going to go? Are you going to stay with the paintings? What size are they—six by six, almost tiles?

DA: Yes. When I decided I was going to start to paint it was not because I was dying to paint but because I got tired of drawing after fifteen years. I just got tired of sitting at my drawing board and doing the same thing. It wasn't exciting anymore, because I knew just what I could do, and I began to feel very resistant to doing it; so I knew I had to do something else. I decided I would try to paint. I went to Pearl Paint, and for some reason I had it in my head that I wanted to do six-by-six canvases. I found out that stretchers started at eight inches, not six. A friend said, "Did you see the little stretchers at Pearl Paint?" We went, and they had stretchers that were four by six, and six by eight, so I went to the salesman and asked if they had any that were six by six. He said no, and I asked if the company that made these could make some that were six by six. He said absolutely not. I asked why not. He said, "They just don't come like that." I said, "Look, this is four by six, this is six by eight, why can't they just take a few of these and put them together?" He said, "I doubt it very much, but how many do you want?" I said four hundred. He said, "I'll call them." So, he called them, and they said they'd do it for four hundred; that's the smallest number they'd make. I'm sure if I said two hundred that would have been the smallest number. So, they just made up these four hundred canvases for me, six by six, and there they are. I will be working on six by six for a while yet. I've used not quite half of them, I think.

LM: Where do you put your text?

DA: I put my text also on the canvases.

LM: Do you always pick a fragment from the same painting to make your sequence?

DA: No, almost never.

LM: You take from several different paintings?

DA: Yes. Everything that I just showed had nothing from the same painting. I did a long piece on Ingres and it was from many, many, many different paintings; and the same with Caravaggio. I did a small piece on Stubbs and a small piece on Eakins. There were just three images from the Eakins, from two different paintings.

LM: It's as if you're quoting.

DA: It is. And a lot of people who copy call it quoting.

LM: Copy is a whole to me; copy is a whole copy.

DA: The entire work.

LM: A fragment is to painting as a quote would be to literature.

DA: That's a good analogy.

LM: But your sequencing and then your text relates the painting to the art history world, but it makes it—what? Tell me what it is. What does the text do?

DA: What does it do for us now? Well, I always thought of my work's content as about our psychological lives. It has to do with our impulse and our attraction to all kinds of taboo subjects, forbidden acts like incest, and violence, and lust. The way my work is made, the way that it is shown, is the veneer of civilization that's placed on top of these impulses that still exist, but it masks them. We try not to act on them even though we have this attraction. We read about them in newspapers like the *Post* to find out about all these horrible things, but most of us never do these things at all, and we don't do them because there's a series of restrictions—religious, governmental, and parental influences—that don't allow us to, or help us to keep these things under control. So my work is physically very controlled and very disciplined, and also the sources are from the very greatest artists in the past who I think symbolize the greatest, most culturally acceptable and lauded achievements of all time.

LM: When you're picking a section of a painting to use, are you looking for something that reminds us of what's deeper, more hidden?

DA: Well, I can't say that I go through every section with this in mind. Generally I just go and find things that attract me, and they could attract me for all kinds of reasons. They could be of interest formally or could just be shapes I like and would like to paint. Or colors. Or it could be a situation that when taken out of the context of the actual painting, just a little fragment, looks very strange and eerie and interesting. There could be all kinds of reasons, but the way I put it together in the end really has something to do with these kinds of impulses.

LM: Like Gorey?

DA: Right. Usually what happens in my work is something weird. But then, it's seen in this particular new situation. But also, I never say in my work exactly what happens.

LM: It's suggested.

DA: It's just suggested, because once you explicate it, it becomes really repulsive. You don't really want to hear about a crime; that's not attractive. It's just the suggestion of it which is fascinating and attractive.

LM: You raise the question.

DA: I raise the question; something awful happened and, of course, everybody has their own idea of what's awful too, so the viewer really becomes a participant. Because viewers become participants, and complicit in whatever has happened, they have to accept some responsibility. It's not just mine.

LM: I was thinking about the notion of transgression—your genteel, calm transgression. It reminds me a bit of what you did in your marriage. You said, "I'm not going to live like this anymore. I'm not going to be a typical wife; I'm going to burst these bonds." I don't think you did anything horrible, but you did something that was considered transgressive, given the cultural background of your husband, yet you didn't throw everything out and have a revolution. It was a veiled kind of transgressive act that valued continuity too. That's how, perhaps, most of us would choose to live.

DA: It's not messy. When it's messy, that's when it gets unattractive.

LM: You're preserving what's on the surface.

DA: That's a good point that you're making. I guess that's part of it, that you never see the mess, the real mess.

LM: This is why I think the feminist revolution, if you'll allow me to go on one step further, does work where some other revolutions don't work. Because we haven't drawn guns or taken to the streets. We're doing the small, quiet transgressions at everyday levels, and everything changes. It really does radicalize families, and lives, and the power centers. It's a huge shift, but it might not look to someone standing on the other side of the street like anything had really changed that much. I don't know, I may be reaching for an analogy, but I'm trying to argue with you when you say there's nothing feminist in your work. I'm trying to make an observation about a methodology rather than subject matter.

DA: Well, let me say that I perceive my work as not feminist, but not unfeminist either. I perceive it as the human condition, having to do with women and men too. That's how I see it. But certainly, it could be argued that it's pertinent to the feminist condition as well.

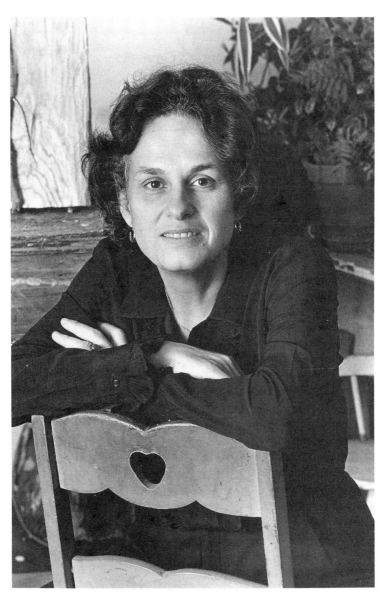

Plate 3. Nancy Azara. Photo by Merry Alpern.

Nancy Azara

Education

1974 B.S., Empire State College, Saratoga Springs, New York
1964–67 Art Students League of New York, New York
1960–62 Lester Polakov Studio of Stage Design, New York, New
 York
1959 A.A.S., Finch College, New York, New York

Selected Solo Exhibitions

1992 A.I.R. Gallery, New York, New York
1990 Lannon Cole Gallery, Chicago, Illinois
1987 Soho 20 Gallery, New York, New York
1986 WARM Gallery, Minneapolis, Minnesota
1985 Artemesia Gallery, Chicago, Illinois
1972 Douglass College, New Brunswick, New Jersey

Selected Group Exhibitions

1991 "Significant Surface," Philadelphia Art Alliance, Philadel-
 phia, Pennsylvania
 "Art as a Healing Force," Bolinas Museum, Bolinas, Cali-
 fornia
1989 "Layerists—Level to Level," Johnson-Hummrickhouse Mu-
 seum, Coshocton, Ohio
 "Visions of the Goddess," John Hartell Gallery, Cornell
 University, Ithaca, New York

Selected Bibliography

Cohen, R. "Nancy Azara." *Artforum* 30 (May 1992): 120–21.
Van Proyen, Mark. "To Touch Both Soul and Body." *Artweek* (April 11,
 1991): 11–12.
Dunford, Penny. *A Biographical Dictionary of Women Artists in Eu-
 rope and America Since 1850.* New York: Harvester Wheatsheaf,
 1990, 14.
Newfield, M. "Shaman Art." *Women Artists News* 14 (Winter 1989–90):
 7.
Rosser, P. "Nancy Azara." *Women Artists News* 12 (Summer 1987):
 29–30.
LaRose, E. "Nancy Azara." *Arts Magazine* 58 (September 1983): 19.

Interview

Nancy Azara was interviewed by Joan Arbeiter in 1988 and 1991

JA: Nancy, you have extraordinary talents which seem to be quite diverse. In addition to your active and widely recognized career as a sculptor, you are known as a psychic guide in creativity and self-healing, and you are also known for having been the cofounder and director of the New York Feminist Art Institute/Women's Center for Learning.

Could you help us understand how you arrived at all this? Is it the feminist sensibility that is the common thread?

NA: Well, we're each a person first. We're born into the world, and we get fashioned into a particular mold. My exploration has been to understand that in my art. To reflect both that and the feminist aspect is to allow myself possibilities for who I am. My feeling is that feminism is about giving ourselves permission to be whatever we need to be and whoever we are, without the limits.

JA: How does this translate, specifically, to your work as an artist?

NA: I am a sculptor who also makes artist's books. My art and my sculpture are about wisdom. It's about finding wisdom within myself, and that's why it's so focused around feminism: women, motherhood, friends, the goddesses, my daughter, my life. I'm not interested in making art if it doesn't deal with my life, doesn't deal with that exploration. I think of this as an ancient tradition. I think it goes back to prehistory and goes way back to the origins of why people made art: it was really to explore wisdom for themselves and for the people around them, to evoke magical powers within them—magical meanings that they didn't understand, things that were not explained away by so-called reality, things that were unspoken, unseen. This is what fascinates me about life and about art. I try to balance it with the seen, because I think that the things that are seen need to be juxtaposed, connected to those things.

I'm interested in the fact that we live in a world that is horrifyingly painful, that every day we pick up the newspaper, where the violence is horrifying, that people say that this is the way it is. The world seems worse now, and it is easier to be more violent now because there are more weapons, but I'm not sure that the world is any different now than fifty or five hundred or even a thousand years ago. There were massacres, and brutality, and injustices that seem to me relatively similar. What I think is different is that communication has changed so that we are much more aware, we have more knowledge about what happens, and we have more opportunity to change because of that, and more facility. So I'm interested

in that, and at the same time there is the most exquisite beauty in the world. I'm interested in putting those two together, to really try to describe and understand, for myself, how that exists and what that means. So those are the things I'm most interested in.

JA: Can you recall how these sensibilities developed?

NA: I joined a women's group in 1969, which lasted until 1975. So, my sculpture recorded a lot of the feelings that I had about myself, about the group, about my struggle for my own identity, my own individuation. It was like a mirror reflecting my background, my early childhood.

JA: When I first saw your sculpture, at the Douglass College Library, I was struck by the way most of the pieces were resting on the ground, or close to the ground—definitely below eye level—and I remember a distinct impression of bridging, like a footbridge. But I was also in awe of the fact that the whole piece took up so much room, had such presence and a kind of fragile strength. It seemed so big and important without being monolithic or monumental, which I guess had been my only experience with the notion of something important up until then. The sense of collective strength, with its hint of vulnerability, made an enormous impression on me.

NA: That piece was a self-portrait. It wasn't on the floor, but it was somewhat off the floor—maybe about one-quarter off the floor—pieces leaning against pieces, holding pieces. I realized that I wasn't standing on my own two feet. I had done a study of women's self-portraits. A lot of the women had shown themselves seated in different kinds of chairs, or reclining, and it occurred to me that it was about standing on my own two feet, so I've been trying to make pieces about that for a while now. But putting them horizontally was a conscious thing at that time.

JA: So you see these carved logs as metaphors for your torso, your body?

NA: Yes. I think each of the pieces represents some part of my spirit or body. I think what I do is I try to create. A tree is like a body, you know, a being. The tree has a "spirit-being" quality to it, which is why working with a tree is so wonderful, because it has a history of its own life, it has life. So you can connect to the tree as it is now, and you connect with the history of the tree, which you can feel when you carve it, because sometimes you find things in the tree. You know, you find nails, or you find the way the knots are growing, the way the rings are. It has its history so it's more alive than canvas, for example.

JA: A collaboration with nature.

NA: It's a collaboration. Right. So it's my history and the tree's history, and it's really interconnected in that way. And there are figurative parts to all the pieces. I mean, consciously figurative parts. There are hands, and mouths, and feet, and arms, and breasts, and stomachs, and legs, and tor-sos, just not in the way we usually see them. I mean, pieces that don't make sense in a representational way, but they all have some figurative aspect to me. They really live inside me. I see them as a real manifestation.

JA: Earlier you mentioned your childhood. What influences are you aware of?

NA: I grew up in a very hierarchical background, very hierarchical man-ner, so as a feminist I think that I've spent a lot of time trying to equal-ize that. I couldn't talk back to my parents, whereas my kids can and do talk back to me. They tell me clearly what they think, which then forces me to reevaluate what I think. My parents never had to do this—to reevaluate. Well, I guess they did some, because I was a feisty kid. I've learned a lot being a mother, and I've made pieces about my daughter, for my daughter. When she was born I made a piece about it, which my sister has.

JA: What about the ethnic influence?

NA: I grew up in an Italian Catholic tradition. There's a mystery in metaphor and a fervor and a passion that was connected to Italian Catholi-cism that I feel is in my work. The church I went to when I was little was an Italian Catholic church, as opposed to the Irish Catholic church which we moved to when I was older. The Italian Catholic church was very dark and it was like a grotto, lots of flowers, and the lights just flickered all the time. The old women went in and prayed for hours and were all dressed in black, and this whole way of living and looking at the world shaped a lot of what I am. What you see of the San Gennaro Festival is an example of what the fiestas are, but hardly what it used to be. The church elders take the saint into the streets, out on their shoulders, for instance, and parade through the parish. I was in Malta several years ago, and I saw almost a replica of what it was like when I was little, and more so, because in Malta, which is a very traditional Catholic culture, they took the saint out and were carrying the saint down the street on their shoulders in a procession. They had music, and they were praying, and the teenagers were begging the saint to give them favors—ways that in the United States were done, say, a hundred years ago, maybe in Sicily thirty to forty years ago. We used

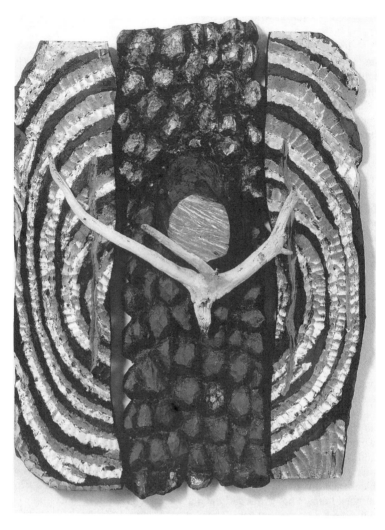

Plate 4. *Witchspell,* 1989. Carved and painted wood with gold leaf, 22″ × 31″ × 14″. Photo by Erik Landsberg. Courtesy of Everson Museum, Syracuse, New York.

to pray to the saint for favors, too, when I was small, but we were a little more modern. In Malta, during this process, they would pray to the saint, or try to, the way people approached movie stars like Elvis Presley. You know, hero worship. That's what they were doing. The old women were just fervently sitting in church and praying their hearts out. My mother al-

ways talked about how she prayed to this saint or that saint when I was lit-
tle. So that's how it's part of my background.

JA: So you had a lot of tradition to overcome. You said leaving your
house was a big step in your life and leaving the Church was a big step
too. Isn't that what *The Queen Lost Her Head* was about?

NA: Since the day I moved out of my parents' house, and before that
even, I struggled with self-knowledge, self-awareness, and attempted to
separate myself from traditional ways of being. As the years have gone
by, what I have done is try to find the tradition, part of the tradition, that's
been really valuable for me and embrace that. Like the benedictions,
some of the Catholic benedictions, some of the rituals and ceremonies
are in my work.

JA: Is that what you were thinking about in *Seven Mansions*?

NA: *Seven Mansions* is about Saint Teresa of Avila. Her book, called
Seven Mansions, is about finding the different levels of the soul in pur-
suit of God.

JA: Your work has been about self-knowledge. You also have taken on
the theme of ancient goddess practice and—

NA: Well, this whole goddess theme, for me, is an exploration about
strength. It's trying to make figures that have strength—to find my own
strength and to get a real feeling of what it would be to feel that strength.

JA: If someone were to ask of you, "Are you a religious person?" what
would you say?

NA: Well, I believe in the force of the universe. I think that would be my
religion. Religion doesn't have to be organized. I feel closer to Buddhism
than I feel to any other belief. Buddhism is a very beautiful way of look-
ing at the universe. It's simple. It's peaceful. Buddhism is the only reli-
gion in the world that practices pacifism, except for the Quakers.

JA: Would you continue to elaborate on how your work deals with your
life?

NA: Well, my work tries to deal with the issues and obstacles in my life.
Giving birth is an obstacle in the sense that when you're expecting a
child, it stops you. It's like an obstacle in terms of where you were with
your life. It's a—

JA: A crossroad?

NA: Maybe. There's an obstacle that's a crossroad, that makes you really look at your life in a new way.

JA: A milestone?

NA: Right. But "milestone" doesn't necessarily mean that. You're drawn to reflect, to be reflective. So you have an obstacle in your life, which then makes you reflective. It's that kind of progression that I've seen in my life. I've seen other people also come to that place: to obstacle, crossroad, milestone. It's a really interesting way to look at it. The work was about that, earlier. It was about my women's group. It was about the experience of self-knowledge and self-awareness through therapy. There was a piece, called *Maypole,* about initiating myself into a new awakening. There was a piece called *The Group,* which was about connecting to the dynamics of my women's group, my role in it, the pivotal aspects of being in a group. Each individual was a pivotal person for the whole group, the dynamics. The piece *Any Woman* was about experiencing myself as a person in the world and finding an awareness of myself as a woman. That was one of the first big pieces of sculpture that I made. And then in 1973 there was the piece *Many Different Levels,* which was about my experience of going to the dissection class at a medical school and watching and really being a participant as well as an observer in that dissection. So there was that. Those things were all interconnected.

Then there was the psychic. I began to open myself, surrender myself, in a way that I hadn't let myself before, exploring the unknown and the unseen forces in a conscious way rather than just letting that come up.

JA: Do you remember when this was?

NA: About 1979.

JA: Please continue about your psychic work. It's fascinating. How did this interest shift from your personal discovery to your sharing it with others as a psychic guide?

NA: As I said, I've always been fascinated by the unseen or the unknown, the unspoken—what we couldn't see or hear in practical reality. About twelve years ago I began to visit with psychics just because psychics are people who are interesting. I was interested. I wasn't profoundly interested, I was just interested. I began to see, however, that psychics were working with a phenomenon that I was trying to work with, and that they were accurate about what they described, their visions. There was an ac-

curacy that was astounding to me, that came from reading auras or just connecting to someone else's energy. I can meet strangers that come to me for readings, I can go to a stranger, put my hand on the energy of their aura—which is called a *chakra*—the energy points of their aura, and tell them immensely accurate things about themselves.

JA: And they are amazed because they haven't shared this with you verbally. Do you call it intuition?

NA: Intuition is like a road to the psychic; a highly developed intuition brings you to psychic phenomena. That's what intuition is about. Women are more psychic because they develop their intuitive powers. Men are taught that the intuitive is of no practical value. So I began to develop my intuitive self, my psychic self. I began to be able to read, to feel that energy on the aura, describe to people what that energy is and how that energy relates. And as I began to do that, I tried to translate that into visual information. And as I translated that into visual information, my sculpture would speak to me, which gave me more richness, more ideas, more feelings about what I was doing with the psychic energy. That's how it began to open up even more and work together. And then I was teaching in a job situation as an adjunct, where every semester I had to find out if I was to be hired again. I decided that I didn't want to do that anymore because it was just a debilitating way to live, not knowing about my income, no personal power, you know. It's a struggle to live that way. So, I made a brochure, and I began to teach classes based on psychic phenomena and art making—participants going into their unconscious on journeys, explorations, guided meditations and making art out of that experience. And I also began to see people privately and put my hands on their auras and do readings—tell them intimate details about their lives. These were people I'd never met before, and I would tell them about these things and tell them how they were holding these things in their unconscious and explain to them that perhaps they needed to learn what these images, colors, or shapes were, because they were there all around them. I think it's scientific. I think someday we'll discover that in our being pictorial images exist that we hold on our aura and that—

JA: Pictorial?

NA: Pictorial. Pictures or images, comments, statements, words, things that exist and live with our human energy, our aura, and they exist outside of our being, around us, emanate from our being, around it. I believe that science will be able to photograph this at some point in the future. Now, some people are skeptical, saying, "Oh, that's ridiculous." Well, I

don't think there's anything wrong with being skeptical, but the problem in thinking that this is an impossible occurrence denies the fact that, for instance, one hundred years ago we never thought it would be possible to fly.

My father remembers the first Wright brothers' trips and the excitement and how unusual they were. So if you are able to see this, there will be an infinite number of possibilities, and within these is the possibility that we project these images and pictures of ourselves. These ideas, these things that we hold—something that traumatized us, for example—we probably freeze in different parts of ourselves, because when I put my hand on someone's heart—someone who, say, has a heart condition—I can sometimes see how it's been shut down. I can see people with doors and barriers, chains, and things like that, locked on their hearts.

JA: How do you see?

NA: You literally close your eyes, you put your hands around these faces, and these things come to your mind, they just present themselves to you in your mind.

JA: Pictorially, as doors and chains?

NA: Pictorially, as doors and chains. Audibly, as, "I don't want you to come closer to me." Sometimes you hear a person say, "I want to stay locked up," and you hear another voice, and you say, "Who's voice is that?" and the person says, "It's my mother's voice." After that, I reveal that I heard this voice, and it seemed to me like her mother's voice, which said, "I don't want to lock you up." Here is an interesting example. There was a woman who came to me as a photographer, and there was a tulip in her third eye; something from her childhood. I said to her, "This sounds weird, but I see a tulip, almost like you were photographing a tulip, like a lens of a camera, photographing a tulip at your third eye." She said, "That's bizarre. I have no connections with tulips whatsoever." I said, "Well, it's from your childhood." She said, "Well, it means nothing to me." Okay. You know, sometimes that happens. When you do psychic work, you're only eighty percent right. She called me up the next day. She had spoken to her mother, and her mother told her that when she was three years old, or even a little younger, she'd been crawling around in her garden, and the neighbors next door had this beautiful row of tulips. She went and picked the tulips, and the neighbors got so upset. She was pulling tulips apart and picking them and throwing them.

JA: Playing with them.

NA: Playing because she was so fascinated by them. They were a wondrous thing to her. The neighbors called the police. The police came and lectured her about pulling out the tulips. And this woman held this image for her whole life. What it was like—her first experience of wonder—that she remembered. And her mother didn't side with her. She sided with the neighbors and was very angry with her. For this woman's whole life, until the age of forty, she had held this picture at her psychic sight and her third eye, and she was a photographer! So we talked about it, and for her, she recovered an experience. Do you know why you would want to recover an experience?

JA: To get beyond it?

NA: Yes. Once you recover the experience you own it. Before recovery it runs you. It lives inside of you and owns you, as many of us who work with therapy understand. She was able to reclaim then that experience as hers and to decide how she wanted to live with that experience within her. So this is what this process has given her: this opportunity.

JA: Amazing.

NA: See, I always suspected those underground rivers inside of ourselves were very valuable and powerful, but I had never seen it as clearly as I have since I began seeking it more. I didn't know about the value of it before.

JA: How does all of this find its way into your art?

NA: I use that information. If you notice, there are hands in the pieces, the psychic hands that give me an energy. An enormous amount of heat comes from my hands when I do this psychic work. The people who are the recipients of the energy can feel it. I use it for laying on of hands to channel energy and heal people.

JA: That's extraordinary. Let's get specific about the sculptures that really explored psychic phenomena.

NA: *The Goddess Kali* was the first major piece about that. Earlier the *Maypole* piece had been the first ritual piece, and all others in that series were from that. The next big piece, which was *Guardians of the Heart Circle,* was about the heart chakra, or energy held at the heart. This very large piece of ancient oak, from an enormous old tree, was carved and then bleached—carved like a very soft heart shape. You know, it felt like

opening your heart, almost like a coral shape, opening and receiving, the heart guarded by these three poles. So those were the first pieces about psychic awareness. There were other small pieces. Then, the next piece was *The Sun Goddess,* done in 1983, which was the goddess as the reflection of the sun.

JA: *The Sun Goddess* is eight feet high. Is that the tallest? Were you thinking about being monumental?

NA: Eight feet, three inches. That's the tallest so far. It's larger than life-size. I wanted my sense of self to be connected to my sense of awe. Then I did *The Queen Lost Her Head.* Those pieces were really exploring psychic phenomena. Really working with these things we talked about — pictures or images around people's auras.

The artist's books that I make lend themselves very well to expressing these experiences, as well.

JA: Oh! You mean the *Visual Diaries*? Let's stop to talk about them for a moment. They are one-of-a-kind, handmade artist's books? Tell me what the relationship is to your sculpture. Do they come before your sculpture? Do they relate to the pieces or are they separate?

NA: Both. They stand on their own, but they interconnect to the idea, form, and color of my sculpture. I think they're sculpture in their own form. They're very painterly, very richly painted. I think I study colors by doing them. They're studies of the sculpture, in a way, but they are themselves, in another way. Because I study the different aspects of the forms as they relate to each other, they become forms in themselves. I cut through them. I cut through the books and I put things onto them, or I add pieces.

JA: What kind of pieces?

NA: I collage them. They're not dissimilar to the process I use in sculpture. I paint them with tempera made from pure pigment and egg yolk. I use pastels. I use different kinds of paper too — they're different colors, sometimes different textures of paper. Whatever just feels right in terms of the expression. I make a lot of drawings on collages.

JA: Oh, drawings that are not in the books?

NA: Not in the books; these are studies. In 1985 I showed them along with my sculpture. I had twelve or thirteen drawings that I thought were really good and interesting. In 1987 I showed a rubbing from a wood relief titled *House Maze.*

JA: Are the hair pieces different from those other works on paper?

NA: The hair pieces are earlier—a series of handmade papers with fiber that I exhibited at Soho 20, in 1984. You know, they were twine and hemp, other fibers like that, which were unraveled and looked like hair. So there were a series of twelve to fifteen pieces dealing with the issues around woman and hair.

JA: Did you make the paper?

NA: I made the paper in unusual shapes. The paper had paint on it, and then I began to pull the hair through the paper—laced, impregnated—I developed it like that. I think that was the start of the wrappings, because I found that after I did that I started to wrap the sculpture.

JA: It's wonderful the way things evolve. Now, let's have a closer look at some of these sculptures.

NA: Okay. Now, *The Initiation,* and *The River Goddess,* and *The Horns* piece, and *The Sacrifice* piece, those are from the 1987 exhibit at Soho 20. *Orange Votive* has a little heart on the foot. Then there's *Red Path,* which has two red feet on it and a branch. Then there's a piece called *Blue Ritual,* which has a silvery blue patina. I just love that piece, that blue piece. My daughter loves it too.

JA: The metallic patina is relatively new to your work, isn't it? It's absolutely gorgeous.

NA: I use gold leaf, silver leaf, aluminum leaf, tarnished brass leaf, as well as oil and handmade egg tempera.

JA: How would you describe the sculptural processes you use?

NA: Well, I've always made carved wood pieces, either freestanding or wall pieces. They're carved, assembled, layered, and painted. If I think of it more in metaphorical terms, it's the different layers of the unconscious. The forms twist, turn, interlock. They're pinned to each other—

JA: Pinned? Do you look for a precarious quality?

NA: You can see the pegs, and they are frequently painted so you get a real sense that they're put on and a part of the piece, but they didn't necessarily grow with the piece. They are precarious. They're interlocked,

interconnected. They have been sort of randomly put together, somehow. They have that quality.

JA: Your marks are important? The tool marks?

NA: The tool marks are important. I use the chisel marks the way a painter would use a palette knife or a brush. So when you look at the work I want you to get the "hand" in it.

JA: Your marks are very expressive. I've seen words like "hacked," "charred," "bruised," "battered" used in connection with your work. Are you trying to convey anger?

NA: No. I think some pieces may have more anger in them than others, but if it's not anger, there *is* struggle there in all the work. You know, some pieces seem to express more pain, anger, and struggle than others. Like that piece with the blue hand seems to have a lot more pain in it than the one called *Fishing,* which is much gentler.

JA: They each have their own inner direction, it seems. Now what about the type of wood, the grain of the wood, or the natural color? Is that no longer important since it's being painted over?

NA: The type of wood is really important in terms of the process. When I carve the wood I work a lot with the wood for its particular quality, but in terms of the actual grain of the wood showing through, I really don't work with it that much anymore. If you carve a piece of wood and you finish it, it looks one way, but in six months it looks another way, and then in a year or two it changes again. The color changes because it ages. It looks another way, but that is too limiting for what I do now.

JA: And so, the bleaching and the rubbing and all of that is not what you're currently doing?

NA: I do some bleaching on occasion, although I haven't done any recently. I still think bleaching is something I will continue to do because it makes a color, a distinct, definite color which relatively remains. The bleaching changes some, but in time the actual grain changes.

JA: In your past, you worked with a number of different woods; oak, cherry, pine, fir, birch, willow, elm, ash, maple, and black locust. Are there any materials that you haven't worked with yet that you have an interest in?

NA: Now it's more a question of what the material can *do,* and the connection, the dialogue, I have when I work with the material rather than choosing a particular grain. I do want to cast some of these pieces and transform them into bronze for outdoors. I want to work with bronze. I also might be interested in doing some fabrication of plaster, plastic, or some of the new materials such as the new imitation stone, maybe. It might be interesting, for instance, to try to work with bronze and then do some imitation stone. I might be able to get more strength and color with that than I would by painting on a bronze.

JA: Great idea. I hope it will happen. You just mentioned plastic. Are you talking about pouring it?

NA: Yes. Making the plastic and the molds.

JA: Are artists going into that now, even though they know about the health hazards?

NA: Well, there are hazards. I wouldn't make huge pieces in plastics, but I would be interested in doing parts. I think plastic is strong, would lend itself better to color than bronze. The back part could be all bronze.

JA: Yes. That would really be unusual. Do you see as a side effect of casting that you'd be able to make multiples? Is that something you're interested in doing?

NA: Multiples would be interesting to do. I would like to do a series, cast a series of faces or masks and just have the whole wall of the gallery taken up with that. That was an idea at one point, but basically, it's not the multiple as much as it is the outdoor aspect, because now you cannot put this work outdoors.

Also, I am interested in printmaking, and I have actually started some woodcuts. I have one that I've had printed that I'm recarving, so I'm interested in doing some more experimenting with woodcuts. I explored it years ago a bit, and after that I did one out of Solo Press. The problem is that whenever I drift away from my sculpture and artist's books I end up feeling sort of sad.

JA: Nancy, we haven't talked about your role of founding member and executive director of the New York Feminist Art Institute, later renamed NYFAI/Women's Center for Learning. I know it took an enormous commitment on your part and eventually on Darla Bjork's part, as well. It lasted for eleven years and served thousands of women as a

place for discovering and nurturing their feminist sensibilities in their quest for a relevant art education.

I was one of those women who experienced a profound transformation in order to become whole — to connect being a woman with being an artist. It began in your "Visual Diaries" class in 1979 and continued throughout many classes, lectures, and workshops that I attended there. I was privileged to have had that opportunity. For me, it made *all* the difference!

NA: It's very sad that it became necessary to close NYFAI in 1990. It took a lot out of me, but it also was a fabulously rewarding experience to have worked with so many creative women, both students and professionals. We accomplished a lot, of which I am very proud!

Now, I've just built a new studio and am planning to devote more time to my work. The history of the New York Feminist Art Institute/ Women's Center for Learning remains to be written and, in fact, we are donating our archives to Rutgers University.

JA: Do you plan to give up teaching?

NA: I plan to continue. I'm traveling throughout the country conducting workshops on psychic healing and art making. Teaching is something that inspires me. I'm really fascinated by the fact that each student makes work that is different. On a recent trip, for instance, I conducted the same guided meditation every day for a week. There were eighteen people, between the ages of fifteen and eighty-six, and each one came up with different things that were inside them from these same meditations. Beautiful, different drawings, beautiful, different ways of looking at the world. There may be some similarities, but each is unique. That's what I love about teaching art — helping people to make things you never in the world would have thought of. So, teaching excites me, and then I put it back into my work. But if I do too much of it, I get exhausted. I really need the balance.

Plate 5. Cathey Billian with Chancy Sparks, at Yellowstone Studio, Madison River Valley. Photo by Jim Peaco.

Cathey Billian

Education

> M.F.A., Pratt Institute, Brooklyn, New York
> B.F.A., University of Arizona, Tucson, Arizona

Selected Solo Exhibitions

1993 "framingSpace," Cooper Union, New York, New York
1990 "Cross-cut/Piedra Lumbre." Pratt Institute, Brooklyn, New York
1988 "Frozen Moments," New York Experimental Glassworks, New York, New York
1984 "Future Antiquities," Whitney Museum Sculpture Court, New York, New York
1982 "Two Views of Nature," Elise Meyer Gallery, New York, New York

1976 Women Artists Series, Douglass College, New Brunswick,
 New Jersey (catalogue)

Selected Group Exhibitions

1993 "Concepts with Neon," SUNY/Stony Brook, Stony Brook,
 New York (catalogue)
1989 "New York Experimental Glass," Society for Art in Craft,
 Pittsburgh, Pennsylvania (catalogue)
1985 "Stopped Time," Sculpture Center, New York, New York
 (catalogue)
1985 "Five Sculptors/The Arch," Prospect Park Commission,
 Brooklyn, New York
1984 "Cathey Billian, Michael Graves, Charles Simonds at Lib-
 erty State Park," Jersey City Museum, Jersey City, New Jer-
 sey (catalogue)
1982 "Nature as Image and Metaphor," Greene Space, New York,
 New York (catalogue)

Selected Bibliography

Danneskiold, Jim. "Sculptor Captures Canyon's Evolution." *Journal
 North* (Santa Fe) 1 January 1991.
Wagner, Cheryl. "Rio Chama (N.M.) Visitor Center to Challenge Visi-
 tors." *Public Art Review* 2, no. 1 (Spring/Summer 1990).
"Places as Art." *Amenities* 1, no. 6 (1989).
Edelman, Judith. "Frozen Moments." *Craft International* 6, no. 4 (1988):
 41.
"Cathey Billian at Elise Meyer Gallery." *Arts Magazine* 55 (September
 1980): 29.

Interview

Cathey Billian was interviewed by Lynn Miller in 1988 and by Beryl Smith in 1992

BS/LM: What I'd like to do, if you don't mind, is start somewhat chrono-
logically. Do you remember when you knew you wanted to be an artist?

CB: I've always been making art. Before I could write. It was never an
issue of wanting to be—it already was. My mother (and also my ex-
husband) used to say, "Cathey has ten priorities in life. The first nine are
her art, and everything else comes tenth, including marriage, family, all
those other things." I think there was truth to that then, but people have
entered both my art and my life in greater proportion lately.

I have early memories of knowing, that kind of deep knowing inside yourself. Maybe the earliest recollections were of feeling different from people around me. When I was playing with other children, it was clear that the way I was experiencing the world was not the way the rest of them were. My interests were totally different.

BS/LM: How?

CB: Fingerpaint, for example. I could not figure out why the entire world was not transfixed with fingerpaint. What a subtle, tactile adventure! Other kids loved bouncing balls, jacks, volleyball; I was not the same. I could see it, and I could see other children my age being in situations that they could just walk away from but that would destroy or delight me emotionally.

BS/LM: You're talking about emotional sensitivity?

CB: No, raw nerves, right out on the surface, as if the insulation was missing—exposed receptors.

BS/LM: Do you remember a visual sensitivity as well? That you actually think you saw things differently?

CB: My high school buddy, and still friend, Diane Ehrensaft, used to call my attention to the abstraction of my visual world, to the myopic blur that delighted my eye. And earlier on, as a child, I had intense reactions to the mountains in the East where my mother's family lived. When I was very young they would take me on a drive and make well-intentioned fun of me. Amused, they would say, "Well, we'll take Cathey to a mountain and watch her carry on."

BS/LM: That's interesting that you had that early love of nature.

CB: I remember the Chicago shoreline along Lake Michigan, where I grew up. Other children would go to the beach to be with each other, and I would go to the beach to walk along the pilings of rocks. I had a completely different reason for being at the beach; and all winter I liked to do that as well.

BS/LM: How did your parents respond to this?

CB: They gave me the appropriate lessons! Dance, piano, and art.

BS/LM: Tell me about your art lessons. How old were you when you started?

CB: I took classes at the Evanston Art Center when I was young, and then when I was in high school I went to the Art Institute of Chicago on Saturdays. My mother raised me to be a cultured young woman. She would take me there, and each week she would buy me a different book on an artist to study. You know, I still have those books.

BS/LM: Obviously she encouraged you.

CB: At the Art Institute I'd sit on a bench in front of Seurat and get lost in drawing, for hours.

BS/LM: Let me ask you about the quality of your instruction. Any people that you remember who were particularly good or bad?

CB: Martin Hurtig, in Chicago, taught me about inquiry, integrity, humanity, and commitment. And I remember a high school art teacher, an ex-priest, who treated the art room as a retreat center.

BS/LM: You went to a public high school?

CB: Public high school in a suburb of Chicago. I was very shy, yet the arts were my passion. I used to forge "hall passes" to extend my time in the art room and excuse myself from history and Spanish. And I loved music always—never had an aptitude for recall, or for being able to memorize the score. I also loved dancing, but again, struggled to retain the sequence of steps. Visual art suited my personality. I could go into solitude and do my work, put it out there, go away and leave it to a life of its own. It would perform. Music became a source of power and soul for creating visual art.

BS/LM: Did you ever have a woman art teacher?

CB: Never. No, one in grammar school, and there was one in college who taught ceramics, which I wasn't doing. Certainly my family imprint was one of very traditional roles. I think in family, and in professional life to an extent, my father influenced my assuming a seriousness to my path. So, both parents encouraged my art in very different ways.

BS/LM: Are any of your other family members involved with the arts? Did they want you to be an artist?

CB: My mother wanted me to be cultured, but instead, I became culture. She is creative in every area of her home life, where the decor was constantly changing; she was always working on something new. She's an

inventive chef, never makes the same thing twice, sets an incredible table, and prides herself on making things new and different every time. My father enjoyed writing poetry, just for himself. He always had a creative flair, and verses would just come to him. My mother remarried many years ago, and my stepfather, too, enjoys writing verse. He's been an important mentor and spiritual support to me for twenty years, which is both unusual and fortunate.

BS/LM: So there you are in high school, already an artist, knowing that you're an artist, and then what?

CB: Actually, I think well before high school I remember teaching art. We had play groups on the block, and I held art classes for younger kids at the local park.

BS/LM: Did you decide to go to art school?

CB: I didn't want to go to an art school per se. I wanted a broader university experience. I've always preferred a context in the real world, and my work over the years has become increasingly involved with the environment as a conceptual and inspirational base. I received my undergraduate B.F.A. from the University of Arizona. I began my work at the University of Illinois but left school and went to New York, where I painted in classes five nights a week and worked a full-time job doing window displays, things like that. My roommate was from Arizona. I had this amazing apartment on the upper west side, secured by going to the Department of Cultural Affairs and showing them my portfolio to get a "professional" A.I.R. studio—very inexpensive. Six months later, my roommate and I decided it was time to go west, and overnight we got a "drive-away car," filled it with our worldly gear, and headed out of town. We stopped to see both my folks. Mom was in Allentown, Pennsylvania, then. I told her I was going west, I had to try something other than city life and see what it would do to my art. Of course she was terrified for me, didn't know how I'd survive. *Neither did I.* Next I stopped to see my dad in Chicago, and it was three o'clock in the morning. I called him from outside the city and said, "Dad, we're coming through Chicago. Do you think you could meet us somewhere a little west of town?" He said, "Of course I'll meet you." And we met at some all-night diner. Now, there was my father, like it was high noon and the most natural thing in the world. That was his style, his prime time, the middle of the night. So we were sitting there, and I said, "Well, I'm heading west. I really need to do this for my life, for my work. I've got to try another life near the land." I'll never forget that moment; he just looked at me and he said, "I wish I could go too, honey. Have a good trip, and just call me once a week. Let me know you're okay."

Plate 6. *Stopped Time,* 1986–1993. Installation: argon tube, projected and internal light, graphite-patinaed wood and metal, 18′ × 15′ × 24′. Photo by Cathey Billian.

BS/LM: He let you go.

CB: He let me go. He encouraged it. No guilt trips, no fears, no nothing. I'll never forget that. It was one of the great gifts in my life that he gave me. I guess this particular incident is really close to the top of my mind because I lost my father to cancer, and when I wrote his eulogy that was one of the first things I wrote about, that experience of going west—his understanding of how much I needed to do that and being willing to spiritually let me go. I think that was something my father fed into my life that I recognize had a great deal to do with my profile as an adult, as a creator—the sense that one can do anything. He never managed that journey himself, but I felt like I was his emissary, and he encouraged me to play out that role. I wasn't always emotionally equipped for the risks I took, but I just kept taking them; I still do.

So, I drove west, and my plan was to return to college at the University of California at Berkeley. We got to the border at the four corners of Arizona, Utah, New Mexico, and Colorado, and it was daybreak in Monument Valley. The sun was just barely breaking through and starting to delineate incredible formations on the red horizon. We stopped the car, climbed out, I put a tripod on the roof and shot a 360-degree series of photographs.

I never made it to the West Coast. I stayed two years in Arizona. Now, there were no subways in Arizona. I bought a used motorcycle, which I rode in thigh-high boots and a World War II flyer's cap. Eventually I was able to return to college at the University of Arizona, in Tucson, as a state resident, which was very economical. I was living on my own and finished my bachelor of fine arts degree there. Not being very good at compromise, I had all these art history requirements to fulfill, but I hungered for knowledge in two areas—architecture and anthropology—which I managed to cross-register for instead of art history. I became totally involved in Native American anthropology and religion of the Southwest.

BS/LM: And combined that in some of your art.

CB: I was drawn to these native cultures. I don't think I have ever experienced any culture that I felt closer to as a set of what you might call religious beliefs. I felt like, "Yes, this is really who I am. What these people are living, this feels like clothes that fit. I feel at home here." And I feel like the dual life that I've lived for years—between New York and the West—reflects fairly accurately where I'm living inside as well. I don't know how that balance will continue to shift, or how it will be revealed in my art.

BS/LM: In Arizona you went to school, but you were painting before you went. Did you continue to paint?

CB: I was "into" a canvas when I left New York, so I got out West and picked up that half-finished painting, but my palette overnight had changed. I couldn't finish the canvas because the colors I was trying to finish it with had no bearing on the colors I initially applied in New York. That's how fast the palette change took place.

BS/LM: Because of what you were seeing?

CB: Yes. Both the sense of color and the influence of the lifestyle out there. I became more involved in the issue of process, of what happens in between the mark-making and a finished canvas. I loved what happened to paint in between, and I started borrowing movie cameras to record that process—what was going on *before* the end of the painting. This led me to get more and more involved in film, and I completed an undergraduate minor in film production. Over the years, this ongoing filmic interest in sequences of events in time, altered time and inverted reality, has been a key issue in my works—in all media.

BS/LM: You were in the Southwest in the early seventies? And the women's movement in art and the feminist movement had started. Were you involved with feminism?

CB: I moved to New York in the seventies, just about the time that the feminist art movement really started to take hold. I was younger than many of the women artist-activists. Soho had no street lights, came fully equipped with rats, was totally unromantic and unsavory in many ways. I lived there because I needed lots of inexpensive space for my work. I was fortunate to have the women's movement occurring, because it was a built-in sense of peer support that I came to New York for, and along with it this notion that I could think in terms of making a strong statement with my life as a "professional (woman) artist." I don't think I ever had a game plan—a sense of what my life would be like. I simply made art. I came back from the West, having completed my undergraduate work, and ended up in a big Soho warehouse because I sensed the power and potential of a developing creative community here. I wanted that energy and dialogue. Always. So, I gravitated to it. I think I was somewhat disappointed when I got to New York and found out that many of the conversations reminded me a great deal of the values of high school popularity polls, and who knew whom, and all these superficialities of "getting ahead" as opposed to "getting ideas."

BS/LM: Do you have any ties now to the women's movement—is there anything to tie to anymore?

CB: I've spent the better part of the last few years in the Southwest or working on projects for the Southwest, so I haven't been involved in movements or energies that are rooted in the political issues of the New York art world. My issue has been the environment, which has informed the work for a long time. Yes, there are those who do draw upon issues that are involved in feminism and the earth, which is fascinating to me but is not my own thrust. I was lucky to have had the women's movement in the seventies, and I probably wouldn't quite be who I am today without it. My sense is that it was a pivotal moment, that the women's movement added support and fuel to an identity that I already had. It added grounding for my right to live out my life as a committed professional female creating in the vitality of the Soho community at that time.

BS/LM: And did you keep going west?

CB: I make pilgrimages west because there is an imprint inside me that is the Western landscape. That's the home of my soul. It stopped me dead from that first journey, and I've always returned to it as my source.

BS/LM: When you came back to New York, how the hell did you earn a living? They never teach you that in art school, do they?

CB: An excellent question. No, they don't. I had a minor in film, and I freelanced in the film industry. I directed photography on art films, documentaries, did editing, did anything filmic to support my studio habit! I had the same loft that I have now, for a fraction of the rent. Most of the floor was my studio, in one corner was the rest of my living space.

While I was working in the film industry, I received a fellowship to take my master's (M.F.A.) at Pratt, in 1975, and then, subsequently, was asked to teach in the graduate program. I was on the Pratt faculty on and off until 1989, and then did a field project in New Mexico with Pratt students until 1991. I went to Pratt colleagues and said, "I've got to leave; I can't even explain this—not that there's a paycheck; it's just a blind commitment. There's a project I need to build that means more to me than anything I've ever done. I've got to go work on it out West, and I can't say I'll be back; I don't know." They said, "Don't just leave; take us with you. This is a marvelous concept. We want to be affiliated."

I went to New Mexico with student apprentices from Pratt. Since then, there have been a dozen or so articles written nationally on this project, and the apprenticeships it has offered, multi-institutionally. It's the way I like to work. I think there's a vitality and a level of inquiry that you gain from working with college students that you don't get from any contracting crew. Contractors have an expertise that college students don't have, but

there's a moment, certain moments in every piece, when the dialogue and the gesture and the kinds of installation issues that you're working on really need to be handled by people working in art, so you can talk about interval and gesture and the spaces between the notes.[1] The students bring vitality and challenges. For me personally, working on projects in an apprenticeship situation on site is what I find *most* rewarding, most exciting. I'm fortunate that my life has worked out well professionally in the sense that it's not followed a kind of traditional track. It's evolved in a personally meaningful way, being an artist in New York but staying true to a vision that steers clear of aspects of the art world that I find distasteful, demeaning, and not true to who I am. I knew early on that if I was going to remain in New York and partake of the nurturing cultural and intellectual opportunities and the challenging people here, I'd have to pick and choose carefully or get sucked up in a frenzy of fashion and taste, pressure and fame, and all kinds of issues that are not at all what motivate me.

BS/LM: Are you supporting yourself by making art and teaching?

CB: Yes. I like to teach on a part-time basis and do my work. I was represented by Elise Meyer all the time that she had a gallery, and I felt good about that representation because I respected her vision, and she respected mine. The gallery was about certain issues between nature and structure, including the work of Agnes Denes, David Nash, Peter Berg, and other people who were interested in those issues. I started building site-specific pieces that have been, fortunately, well supported by the New York and New Jersey State Councils on the Arts, the National Endowment, and residencies with the National Park Service and the Forest Service. Through this support I've been able to build the images that my mind's eye fantasizes, and I draw as a visual diary of ideas. Projects have kept evolving over the years and some are now turning into permanent projects.

BS/LM: What have you been doing recently?

CB: Last season I finished a piece for an airport terminal in Phoenix, *bi-Planar Arrival*. It was a challenging piece to build, and I documented it on video.

BS/LM: How long did you work on that piece?

CB: A year and a half. One year in production on site; in March and April we built it.

[1] A phrase a musician friend, Roger Kellaway, is fond of using.

BS/LM: Did they come to you or did you go to them?

CB: A little of both. They knew of my work and they were interested in an artist to do an overhead piece that was luminous—and an artist who was involved in landscape and in the Southwest, so they strongly urged me to submit material for review. (I think 1,200 artists competed for the piece.) I was pleased to have the opportunity. There were a number of aspects of building this piece, *biPlanar Arrival*, that advanced the piece I'm working on for New Mexico. So, while I was not working directly on the New Mexico piece, we piggybacked elements for it, including working out the engineering suspension system.

BS/LM: Who did you work with to do that?

CB: I hired consulting engineers and a planning design phase engineer. It is supported by steel cables under 1,500 pounds of tension and is tied into the support beams of the building. It required structural, electrical, and aircraft engineering, as well as historic aviation parts suppliers: strange bedfellows find their way into my work!

BS/LM: That's the exact phrase that Agnes Denes used.

CB: But, you know, we all do work differently. My "methodology" is to get images full-blown and then work backwards to learn necessary skills to fulfill the vision. If a project requires blown neon, I learn the technique.[2] In the case of the project for Phoenix it required reinventing aircraft taxiway lights. I wanted to rip out all the functional lighting in the terminal and create illumination by means of an inverted runway in the ceiling. Runway lights mark a journey, but don't cast light on a path, so I gutted and rebuilt them to reinvent the whole light. I had to learn much to do it, but I couldn't imagine the piece any other way. Originally I budgeted for a simple industrial fixture, at one-fourth the price, that I thought would give the illusion of an aviation light, but then I went to see them and I wasn't happy with what I saw. In the process I fell in love with the particular sculptural form of an authentic aviation light, and once I saw those I was not happy with the facsimile. I just had to go about reinventing the real ones as a downlight for the terminal. That required diamond cutting the glass, annealing it for days in ovens, sandblasting it, experimenting with the fade of color from cobalt at the bottom to a rich prismatic ultramarine above—really expanding on the whole notion of what a light is as an aesthetic object.

[2]Done in 1986 for a Prospect Park (Brooklyn, New York) project.

More and more in recent years, I go out and find consultants that have the expertise necessary to help realize a vision, particularly once the work went airborne. Airborne and public is a combination that brings with it a whole kettle of liability fish. Responsibility for safety of the public. You really cannot move without engineers, to make something fly magically and gracefully through space. Part of the success of a design depends on working collaboratively with the engineers from Day One. To understand the structural characteristics allows one to design and envision something that is not fighting the site but that is informed by it.

I was awarded this commission based on my previous work, but to do the specific design required a commitment at my own risk-expense, beyond what I was paid, entailing visits to the site, talks with airport personnel, and interviews with the people that use the facility, to get a real feel for what this terminal was all about. I found out that it really was a *pilot's* world, and then the whole piece became an issue of bringing together the worlds of aviation and geology in a translation of place. The exquisite technology of airplane construction and the magic of runways at night—the taxiways, which I've always been transfixed with—combined with the spectacular landscape of Arizona, were the elements that informed the piece. Engineers, aircraft riggers, and contractors worked alongside sculpture students, with a sense of process shared during the construction, and everyone contributed to the level of inquiry and vitality on the site. What this piece then became was a symbolic taxiway of life's departures and arrivals, a conversation of materials overhead that captured the landscape in an inverted reality, transposed to a sense of place inviting travelers who pass through to journey into it.

I was delighted to produce a video to capture the process of the project; I don't think I want to do another major project without that kind of documentation. For me, even in college, I was transfixed with process, the energy of how things got created. There's the final moment, the final piece, but then there's all that invention in between: I think we got that in this tape.

BS/LM: What about the other piece, the one in New Mexico?

CB: *Piedra Lumbre?* It's a little over half done. This project about the Chama River is somewhat unprecedented and a unique project, a multiyear evolution requiring completion funding in order to get installed. I'm working with the Southwest Region of the Forest Service now, and we will collaborate on the final site for this piece as a Forest Service facility. It may be an environmental education facility as well.

I'm interested in seeing it viewed as a pilot project, the first of many, I hope, that will suggest the possibilities for creating public art projects

as stepping stones to the wilderness. It's intended to be a place of transition where people prepare to enter into another place—wilderness. It's about the transition of priorities. We come off a workweek and a set of activities that do not prepare us—no matter how much we love and revere nature—to slow down, to stop our body clocks, to be ready. I found one of the first times I floated the Chama River, as its artist in residence, that as much as I loved the Big Canyon lands, I was running at the wrong speed. There were things I was missing, so changing one's speed is in part the intention of this piece—to help people reach an appropriate interior climate before they go out into the region. The training that we have as artists can present a singular vision of the power of nature, allowing us the opportunity, in our own way, to help preserve it. This fuses my interests in ecology, theater, and architecture. The project will be a permanent installation and intends to have a sound environment as part of it. Many ideas I've been working with have come round again in this piece: the wilderness installation pieces with film in the mid-seventies had nonsynchronous soundtracks that are now going to be more fully realized with the collaboration of a composer and acoustics engineers.

I've done a good deal of documentation in New Mexico; I want that same moment captured as with *biPlanar Arrival*—even more so because there have been so many people that have been collaboratively involved.

As an artist in residence for the Forest Service I was asked to create a ceremony for the national dedication of the Chama River as a wilderness preserve. Bureau chiefs from Washington, the head of the Forest Service, and leaders of environmental organizations, such as the Sierra Club, were the keynote speakers.

With tribal leaders from the San Juan Pueblo, I codesigned a ritual in honor of the dedication of this Wild and Scenic River. It was an incredible experience for me personally—to utilize ceremony to emphasize the power of our environment. I created a large glass vessel, which was sandblasted and carved with the path of the Chama River. We had samples of water taken from the first eight originally designated Wild and Scenic Rivers in the country flown in from each of those preserves. The water samplings were added, one by one, into this glass chalice as part of a Tewa smoke-pipe ceremony, and then the mixed waters were tossed into the Chama. There is a video of it thanks to local news broadcasts. What an incredibly wonderful, powerful day it was.

I feel lucky to have experienced many things as an artist that go far beyond the art world, that have a much wider imprint.

BS/LM: It's interesting that your processes are human-made, and you feel a very close affiliation with the natural environment. There's a tension there because you're creating something that is not natural.

CB: I think that some of us who choose to work with technologic materials do so because of the kind of image they present; for me it seems to characterize best the images I see in my mind. There is a direct link between the use of technologic materials and a metaphysical, almost spiritual, kind of image I'm reaching for. The issue for me is not what I make my work out of. I get images many times, full-blown, just the whole, complete image—Hello, here it is. Some otherworld sense of place. Next, I learn of the materials I need to use in order to build the image. I've worked a lot with glass and light for fifteen years. As a guest artist, I did residencies at the New York Experimental Glass Workshop and learned how to make my own lines of light that have all the subtle characteristics of a pencil line on paper. They swell, they have density and sparseness. They are an encased, luminous vapor in a blown-glass tube pumped with argon, primarily, and neon. I wanted to draw luminous lines in space that I've been seeing for years, and just couldn't buy them, so I had to learn how to blow them or carve them into glass.

BS/LM: These images are like visions?

CB: Yes, like the piece called *Dreams Are Just Long-Range Planning*. In that, it is clearly the eruptive forces of nature—volcanic forces—consuming technology. It's an apocalyptic vision, in a sense, and was one of the most seminal projects I've ever built. It summed up many of my previous visions and metaphysics, and formal and material interests, all in one piece. I broke my neck to build that piece, but it said it all, exactly. *Future Antiquities*, which preceded it, was at the Whitney Museum's Sculpture Court, and out of that piece developed *Dreams*. Both were about technology contrasted with eroded edges (nature reclaiming). Those were built in 1984–1985, and I feel like *Piedra Lumbre*, that I'm working on now, is its sequel.

BS/LM: You really do a lot of research for your pieces then?

CB: I think when you work with light as an addiction you continually find yourself also into glass. The two are married to each other, and if you're habitually not happy with what you find on the shelf then you're also married to a sense of process and experimentation in handmade elements. I've been fortunate to be able to do that at the New York Experimental Glass Workshop. There's something very powerful and magic about certain processes, and I think glassblowing is a profoundly demanding meld of the human spirit with material: it brings with it a humility. You really are in collaboration with the elements, with the molten glass, with the fire, and it is the moment of process. It's not unlike a similar kind of energy—that of musical improvisation, bringing together tal-

ent and vision to "jam"—to make a magical moment. It's just a miracle of the human experience. We break all the traditional boundaries between human being and instrument, between human being and human being, and in the case of glassblowing it's between the elements and the person, and the timing. I'm fascinated with that.

BS/LM: You go back to nature too. If you stayed in New York all the time do you think you'd lose that connection with your vision?

CB: Yes. New York has fueled a methodology of reordering my vocabulary of elements in a neutral space, a black box, as the theater world calls it. I create another sense of energy infused with light and with characteristics of nature in the midst of an urban warehouse of visual deprivation.

I am fascinated with the way children come out of one family with the same set of parents, the same sets of information, and yet use it so differently. For some of us, we are totally informed by our urban environment and respond and reflect back, as artists, to structures and imagery that are at one with it; others of us feed on it out of deprivation and are motivated intensely to create something that counters it, or that is one part it and one part some other energy. That's been my profile. I sometimes wonder if I had stayed in the Southwest all those years what I'd be doing. I can't imagine that the work would have had the same strength or clarity, in the sense of humanity, in relation to the elements of the natural world. I think it's the two together that I crave and that I work with still. I could keep going back and re-collecting, bringing energies together, creating something that is a powerful hybrid between the worlds. There is a point when I'm in the Southwest when I'm ready to come back and charge up, and when I'm here I spend as much time as possible hiking and out in the country: that's the other charge.

BS/LM: So, you're like mediating between the two worlds.

CB: Yes. I reference structure as a product of our rational mind. Nature is the unpredictable and the forces that we cannot control. And we need to be ever mindful of their power. I think the balance in my life is changing in terms of my physical location. I think New York is a great place to work as an artist, to take in conversations, ideas, cultural stimulation, and to look at others' work, but I find it increasingly untenable as a place to create from. It has been my home since I got out of undergraduate school. It's where my property is, it's my community, it supports me in technical and brain-trust resources for the needs of my work. It certainly is not responsible for supporting my vision and my inspiration.

BS/LM: Are you working on anything else at the moment?

CB: I'm preparing an exhibition, "framingSPACE," a show of collaborative drawings at the Cooper Union in New York. It's of sculpture elements I designed with engineers—they are modular forms built from the inside out, like crystal structures. The forces at play—the tension and compression—allow geological materials to hover in a frozen moment of suspension. This was the aesthetic challenge of our collaborative process and the subject of the drawings for the exhibition. This show will open the gallery's fall season, though I'll be in Yellowstone National Park at that time, as artist in residence.

The work for Yellowstone is a project called *Beyond Margins*. It has to do with creating an expanded perceptual experience (visual-aural) for park visitors, and might take place along nodes of a "thermal" trail and/or a visitor center and a museum. While there, I will also work with the program director to capture the essence of the work done by artists in the park. Our intent, via video or a printed piece, would be to create a commentary addressing art as an interpretive tool of environmental preservation.

I need to install a private commission for the Vaughans, collectors here in New York who have been enthusiastic supporters of my work throughout the years. It's an excerpt from *Piedra Lumbre*, as if a core sample of the piece was lifted up, a suspension of native coppers and gypsum. The path of the Chama River is carved on the edge of the copper, a scale cartographic profile of the river as it will repeat itself over and over again throughout the environment of *Piedra Lumbre*.

BS/LM: When you are teaching, do you teach anything to your students about life and values as an artist, or is it primarily skills?

CB: What an important question that is. My focus is in trying to help students find their center, locate what motivates them as creative people. The earlier they locate that information, the greater the chance they're going to have of sustaining committed, creative lives. You have to go for it; you have to give it everything you've got and be totally committed, and everything else really does fall into line.

BS/LM: Cathey, your art is not traditional in the "gallery art sense." As a librarian, this leads me to ask, "Where does it get written about?" Where would I look if I were doing research on you? I could imagine you popping up in indexes like *Environmental Abstracts* as often as in the traditional art indexes, because of who might be writing about you, and where.

CB: You are right, I do show up in surprising places. There was a front-page, New Year's Day article in the major state newspaper of New Mexico. *Amenities,* a national design and planning newsletter covered a proj-

ect. I have a file cabinet drawer full of articles. But my work is also included in Lucy Lippard's *Overlay: Contemporary Art and the Art of Prehistory* and a respectable pile of exhibition catalogue essays. In recent years, it is true, the work that I've done has not been primarily in the galleries, by my choice. It's not what I've been spending my time addressing.

BS/LM: It raises a whole issue of where art is noted and how the public learns about art that may not be included in the so-called canon. This happens with a lot of different types of art, for many reasons, and it is always unfortunate when documentation is lost—or not able to be found. I am probably more aware of this because I deal with art historians in an academic library—members of the scholarly community that is in large part responsible for what is written about art that then becomes art that is known about and is taught in classes.

CB: They study what's documented so there's a whole other level that's missing. How do we fulfill that?

BS/LM: I don't know. With this book, maybe. In a way, I think it's neat that art has kind of blown its boundaries by being written about in other places. It's nice to see art going into the world beyond the traditional, expected places . . .

CB: Well, it has its drawbacks and it has its challenges, and I think the way we deal with educating the public eye to be able to look deeper is a real fascinating challenge that I'm motivated to address. Currently, I'm dealing with this in parklands projects. When you're working in a highly contemporary and unique way and presenting it in the public sector, education is a problem that needs to be dealt with. I made the tape of the project for Phoenix because I felt there has to be a bridge, there has to be a way of inviting the viewer and the public into the thought process, the creation of the piece, what it's about, who it's being done for and why, and what the intent of the artist is. We owe it to the public to invite them in because we're doing public work. I think it's important for the agencies to work hand in hand with the artist to create community comprehension and appreciation of these projects.

BS/LM: So, what are you looking forward to now?

CB: I want to continue work on a series of drawings that capture elements of the built projects I'm working on now, utilizing the personality that is the drawn line and other marks on paper. There's an immediacy in that, after working on the demands of large-scale, materials-oriented works. I want to pull into a quieter, more personal part of myself and

translate aspects of what these large pieces are about. Drawings become like parentheses, an element here, an element or detail there, a nice personal indulgence.

I find that typically in my life each piece informs the next. There are certain things that become the springboard and the emphasis of the next piece that were perhaps a minor phrase, a minor theme of the last. For inspiration I look to the structure of music and the vitality of improvisation, theatrical staging, and also sound samplings. I think those are all going to play a greater part in the work ahead, in the actual presence of sound through collaborations with sound artists, live or constructed tape, or a combination. I think I am moving more and more toward a translation of musical structure, the intervals that I spoke about, that come out of musical notation rather than a traditional sculptural process. I've used computers to work on the design phases for projects, and that's given me a whole new way of looking at structure, because you can move things around on the computer in ways that get you in all kinds of trouble! It's how I ended up involved in suspension systems; one day we obliterated all the vertical supports (on the computer). I said, "I've got to see this. What will happen if there's no verticals holding up these coppers and bronzes." The minute I saw the image I knew it was what I was after. We spent the next four days animating these pieces flying through space. That work was done at Pratt Institute as a guest artist in the computer graphics lab, designing the project for New Mexico. The second phase of the computer graphics design phase, in New Mexico, produced a set of drawings. We generated simple graphic elements moving through the piece, and then amplified them as a plan for the piece without having yet built a scale model. We were able to enter into the room and move around in it. The drawings were reflections of experimenting with the notion of moving through flying particles of minerals in space without yet having engineered how to achieve that in a world encumbered by gravity. One five-minute improvisation on the computer launched the project for Phoenix.

Certain themes seem to stay around—the eroded edge (nature reclaiming) in combination with the technology of light, a sense of theater, use of reflecting and light-transmitting minerals, and an inverted sense of place: those are issues that have been in the work for ten or twelve years, consistently. The form that they translate into is an evolving and changing process, and people who have written about the work have called my attention to these themes, much to my appreciation. (Sometimes we artists don't even notice.)

I think at different times in life we have different balances and arrive at different needs. We are willing to do certain things to fulfill a wholeness that is who we are at any given point. My life seems to have its own momentum, velocity, and direction. I take on challenges and make

choices quite apart from what may or may not be good for my physical well-being. I've stayed true to this journey simply because I can't live any other way. I think it's hard for one's family to comprehend this, to understand how different this agenda is from their life. My family has been by my side through the highest joys and the deepest pains. Open journeys always encompass risk, of all kinds. I remember getting a sizable N.E.A. grant one year, completely unrestricted funds to further my career as I saw fit, and the only thing that was required was to write them a thank-you note—what did I do with the money and what did it mean to have this grant. I said my N.E.A. grant brought me a level of professional credibility, along with the things that I needed financially, to sustain myself as an artist. Credibility, I numbered 1, 2, 3. Number 1 was, "Credibility means that you can arrive at the family Thanksgiving dinner for the third year in a row in the same old outfit and announce that you just spent $150 on a strange, esoteric light bulb."

With credibility you can get the support that lets you keep making your art, and that's the only thing that's going to make you happy on this earth if you're really obsessed with that activity. As a kid I remember being told the difference between an artist and someone who enjoys making art is that the artist has to do it. I didn't understand what they meant at the time. It sounded like the most absurd comment. I totally understand now. There is no choice. It chooses you, it takes over your life, and you know that if you stop doing it you will die. It's that simple. It's both blessing and curse.

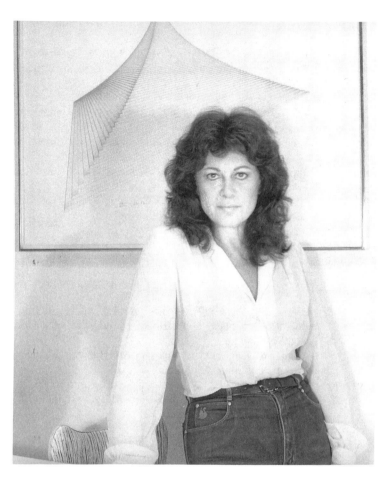

Plate 7. Agnes Denes.

Agnes Denes

Education

Studied in Sweden and the United States

Selected Solo Exhibitions

1992 "Agnes Denes—A Retrospective," Herbert F. Johnson Museum of Art, Cornell University, Ithaca, New York (monograph)

1990	"Agnes Denes—El Concepto Hecho Forma, Obras 1970–1990," Anselmo Alvarez Galería de Arte, Madrid, Spain (catalogue)
1980	"Agnes Denes, 1968–1980," Hayden Gallery, Massachusetts Institute of Technology, Cambridge, Massachusetts (catalogue)
1979	"Agnes Denes Work, 1968–1978," Institute of Contemporary Art, London, England
1975–76	Women Artists Series, Douglass College, New Brunswick, New Jersey
1974	"Agnes Denes: Perspectives," Corcoran Gallery of Art, Washington, D. C. (catalogue)

Selected Group Exhibitions

1993	"Creative Solutions to Ecological Issues," Council for Creative Projects, New York; Hofstra Museum, Hempstead, New York (traveling exhibit)
1992	"Completing the Circle: Artists' Books on the Environment," Minnesota Center for Book Arts, Minneapolis, Minnesota (catalogue)
1992	"Strata," Museum of Contemporary Art, Helsinki; Museum of Tampere, Finland (catalogue)
1989	"Making Their Mark: Women Artists Move into the Mainstream, 1970–1985," Cincinnati Art Museum, Cincinnati, Ohio (traveling exhibit; catalogue)
1978	Venice Biennale, Italy
1977	"Documenta VI," Kassel, West Germany (catalogue)

Selected Bibliography

Kivirinta, Marja-Terttu. "Strata Artist Agnes Denes Underlines Our Responsibility to the Earth—The Sensitive Artist Is Also a Sensitizer." *Helsinkin Sanomat* (Helsinki, Finland) 28 January 1992.

Hall, Stephen. "Uncommon Landscapes—Maps in a New Age of Scientific Discovery." *The Sciences* (September/October 1991): 16–21.

Oliver, Cordelia. "Maps and the Artist." In *Togail Tir—Marking Time: The Map of the Western Isles*. Isle of Lewis, Scot.: Acair, 1989, 145–48.

Selz, Peter. "Agnes Denes: The Visual Presentation of Meaning." In *Art in a Turbulent Era*. Ann Arbor, Mich.: UMI Research Press, 1985.

Meister der Zeichnung, Zeichnung Heute 2. Nürnberg, Germany: Internationale Jugendtriennale, Kunsthalle, 1982, 11–44.

Sculptures of the Mind: Philosophical Drawings—Agnes Denes. Berlin: Berliner Kunstlerprogramm des DAAD, 1978.

A Manifesto

working with a paradox
defining the elusive
visualizing the invisible
communicating the incommunicable
not accepting the limitations society has accepted
seeing in new ways

living for a fraction of a second and penetrating light years; measuring time so far before and after living existence

using intellect and instinct to achieve intuition

striving to surpass human limitations by searching the mysteries and probing the silent universe, alive with hidden creativity

achieving total self-consciousness and self-awareness

probing to locate the center of things, the true inner core of inherent but not yet understood or exposed meaning and split it open for exposure and analyses

being creatively obsessive

questioning, reasoning, analyzing, dissecting and re-examining

understanding that everything has further meaning, that order has been created out of chaos, but order, when it reaches a certain totality must be shattered by new disorder or by new inquiries and developments

finding new concepts, recognizing new patterns

understanding the finitude of human existence and still striving to create beauty and provocative reasoning

recognizing and interpreting the relationship of creative elements to each other; people to people, people to god, people to nature, nature to nature, art to art

seeing reality and still being able to dream

desiring to know the importance or insignificance of existence

persisting in the eternal search[1]

[1]Agnes Denes, *A Manifesto,* 1969.

The following is based on an interview by Beryl Smith with Agnes Denes in 1992

A great deal has been written by and about Agnes Denes. Some have compared her to Leonardo,[2] others have called her a scientist or a mystic. All agree that she is an artist with enormous vision—a pioneer who has explored and opened the frontiers of art. A beautiful monograph, *Agnes Denes,*[3] that accompanied her retrospective exhibit at the Herbert F. Johnson Museum of Art at Cornell University in 1992, brings it all together. Much of what appears in that book and elsewhere was also a part of our conversation—how her art came to be, what she did to develop various pieces, where her interests are turning. What does not emerge easily from this artist is the personal—the trivia of her person—that helps to explain her deep commitment, her drive, and the obstacles that have helped to shape who she is and what she does now, at the midpoint, or perhaps even the height, of her career.

The person of the artist is never far removed from the work, and so, because the work is important and the artist is a woman, it is important to understand something of the person behind it. Yet Agnes Denes is a very private person who shares a great and important—indeed the most important—part of herself with the public through her art. In an interview it becomes readily apparent, by the way the interview progresses, that as a result of her total involvement with her art and research there is only a very small corner of her life that remains private, and for her survival she needs to guard that privacy. Yet, to serve as a role model for young women artists, and to let the world know the gift that the artist gives and the price that the artist pays, it is important to look beyond vital statistics and exhibition and education history.

The broad details of Denes's life are found in much that is written about her, often repeated, always the same, with little to augment what is already known—always a synopsis without the emotion of what has

[2] In the *Yearbook of Science and the Future* (Chicago: Encyclopaedia Britannica, 1989), 29, Jeannette Murray quotes art historian Donald Kuspit: "Denes seems to straddle science and art in a way reminiscent of Leonardo—the effort to totalize nature in a single system and to take the visible as a sign of the invisible to be comprehended." Murray adds, "Like the great artists before her, she continues to grasp for a still greater purchase on the total knowledge of humanity. It is this bold purpose that sets the true artist apart—to express something of the unique vision of humankind."

[3] *Agnes Denes,* edited by Jill Hartz, with an introduction by Thomas W. Leavitt, and essays by Robert Hobbs, Donald Kuspit, Peter Selz, and Lowery Stokes Sims (Ithaca, N.Y.: Cornell University, Herbert F. Johnson Museum of Art, 1992).

surely been a complex and full life. Born in Budapest of parents who were supportive of their daughter's strong creative bent, the young Agnes first chose poetry as her expressive medium. When her family emigrated to Sweden and then to the United States, the teenager, bombarded by the imprecise meanings of too many languages, temporarily lost her poetic voice. Even at that young age she was unwilling and unable to compromise or use half measures to satisfy the artistic-creative urge. Perhaps only those who have also metaphorically lost their voices can fully understand the psychic trauma of this event. In the visual arts she found an artistic outlet that restored her voice.

Agnes Denes entered the art world during the period when abstract expressionism dominated the art movement in the United States, and although her earliest success was in this style, by her own account she experimented with every "ism" that she found. Denes's art education was self-directed. Although she attended art classes off and on for several years, her greatest education came from observation and experimentation. And although she sees value for some in formal art classes, and taught art very seriously for five years, for her own learning she found that classes moved at a pace, and often in a direction, that was not her own. While traditional methods taught line, form, and color, she sought concepts, unformed ideas, the processes beneath the surface. Her curiosity and energy often resulted in the need to work on several pieces at one time and experiment with different concepts, methods, and media. She recalls one art teacher who isolated her by putting her in a room by herself so that she could spread out and work on several paintings at one time. One can empathize with the teacher, having to figure out how to cope with the exuberant inquiry and probably unbridled energy that drove this student. How exciting and how frustrating it must have been. It was this teacher who said, "You have too much talent," and who years later said, "It was a clear case of the student surpassing the master." This was the teacher who chastised her in class for once copying the style of another artist—something done consciously by Denes to understand the process. For him she had a uniqueness that he did not want to see tainted, not even for an experiment.

Early in her career it must have seemed to anyone following the art world that Agnes Denes was incredibly successful. She was represented by a Fifty-seventh Street gallery in New York City, where her work was selling. In the 1960s, when women artists were finding all too often that the doors of galleries and museums remained closed to them, this was a unique accomplishment. But in 1969 she cast it aside—the gallery and the successful art—and subsequently, when she was invited to join a women's cooperative gallery in the then-unfashionable Soho area, she accepted. Not having reached the present-day level of chic, Soho rents were low, and as a charter member of the first all-women cooperative

Plate 8. *From the Stations of the Pyramids: Snail Pyramid—Study for Environmental Sculpture, A Future Habitat,* 1988. Metallic and india ink on film grid, 40″ × 57″. Copyright © 1988 Agnes Denes.

gallery in the country, Denes helped paint walls, lay floors, and renovate the space that became the original A.I.R. Gallery.

This marked a time of change that went beyond leaving one gallery and joining another; it coincided with a redirection of her art to pursue and develop new concepts and a new art that consisted of "analytical propositions set into visual form—both needing to be invented." As she recounts, she had no idea where this new direction would lead, except that she was compelled to take it. Her dissatisfaction with the status quo propelled her unquestioningly to make this bold step. Once again she was searching for a new voice, a language uniquely her own. This new language then helped her frame the questions and seek the answers those questions demanded. It was only natural that, given the opportunity, she should combine this bold new departure with the equally bold decision to join A.I.R. This step into the unknown became the foundation upon which all of her later work has been predicated: identify the issue, frame the question, research the concept, and translate the answer into art so that it can be understood without the need of further interpretation.

This new art form was so different that early on it met with misunderstanding. When Denes gave up painting, the gallery owner, Ruth White, chided her for abandoning success for the unknown: "You have

no right to give up a God-given talent." The public interest in her art evaporated, and difficult years followed. She showed her new art form for the first time at the cooperative gallery. And, after two years, she made another move that was equally unfashionable, and just as poorly understood, when she gave up her place in A.I.R. The same motivation that led her to support the founding of the gallery led her to leave it—not abandoning the gallery or the movement but instead moving on and creating a place for another woman artist. Although she had no gallery to go to, her sense of fairness and solidarity with women artists made this a logical and necessary move.

Never one to set small goals, she describes her early success as "without much meaning," but in the end it was her overwhelming curiosity and her ongoing need for intellectual challenge that led her to look beyond the easy commercial success to new goals and take on the risky ventures that moved her beyond the traditional to uncover more universal and pure expressions. The issues that the world was facing led her to eschew the purely decorative, and she turned to an exploration of the human condition and human values through a concern for the quality of life and the future of humanity, becoming a pioneer and innovator of the environmental-ecological art movement. Her first work in this vein, *Rice/ Tree/Burial,* was created in 1967–1968.

Her search for a language in painting led her in turn to search for a true bearer of meaning that could be used without distortion and with greater flexibility. She came to mathematics as the structure that could withstand the stresses of experimentation and so would be used to contain her art. Using a well-known theorem, Pascal's triangle, she added the visual element that carried it a step beyond the mathematical realm; for the first time the mathematical concept could be seen in visual form. "Once she initiated her philosophically oriented art, Denes launched investigations across the range of human knowledge that included the sciences, technology, philosophy, linguistics, theology, art history, music, ecology, and global issues of survival. Artists of world repute have carved entire careers from a single area of her art, but probably no contemporary artist has delved more deeply than she into the mysteries of the human experience."[4]

In using mathematics and other forms of science, she has never allowed herself to borrow or invent by using a grid here, a triangle there, without first completing the study leading to an understanding that determines the use to be appropriate. She has always used these elements knowingly and applied them intelligently, adapting whatever was necessary for each visualization. This ability to bring disparate elements together, to compare concepts in a way previously unexplored, is a strength

[4]As Thomas Leavitt wrote in the monograph, *Agnes Denes,* xi.

that runs through Denes's work and makes it so very unique. Her work becomes an original hybrid of art and science, with a philosophy all her own, forming an inseparable amalgam of both that is interwoven on a higher plane, uncovering answers and finding unknown patterns. With each new concept Denes steps out into the unknown; each new project means a new threshold must be crossed. An interesting sidelight is that this integration of nontraditional ideas into art draws a much more diverse and appreciative audience — one that often marvels that art can be used to express the more scientific or specialized theorems and concepts that they hold dear.

As a humanist, Denes needs to communicate, and she is concerned about the undigested-information overload of the modern world, fearing that the lack of time and the fast pace that is constantly escalating will allow no time to think and will, in fact, result in compression and an ultimate loss of much important information. She wonders, in a work created twenty-three years ago, if *War and Peace* will be condensed into one paragraph, or maybe even one sentence, because there will be no time in the future to read the whole book. She is concerned that our civilization is becoming ever more specialized and advanced, and as that happens, new languages are being developed that advance technology and propel us ever more quickly into greater and greater specialization, creating eventually a society in which individuals will be unable to communicate with one another, leading to a breakdown of understanding. In public commissions and environmental works Denes is particularly sensitive to the way her work will communicate with the public — the people who look at the art and live with it daily. Each piece must deal with human concerns, and must be neither an ego trip nor something imposed on the environment.

Where others would see freedom and choice, Denes sees boundaries that make her rebel. Even the canvas, which frees most artists to give form to inspiration, was at one time the restriction that imposed borders she had to eliminate. Just as she invented a canvas roller to eliminate borders in her painting — dispensing an unlimited expanse of canvas to be unrolled at will and rolled up when finished — so Denes tries also to reach beyond the natural borders of all things and test the reach of mind and technology via art.

As a woman and as an artist, Denes does not name discrimination as a difficulty, but rather she refers to a societal conditioning that somehow collectively makes it difficult to believe that a woman can do important and influential work. The world, she says, seems to have "trouble with truly unique concepts," especially when they are advanced by a woman. "A woman thinker is . . . problematic. . . . There is little precedence for women philosophers. It may take another generation or so for people to feel comfortable with the idea." Tom Leavitt summarizes it thus: "Al-

though Denes's creative vision and originality go beyond issues of gender, in the final analysis we must conclude that our culture is yet unaccustomed to dealing with women as progenitors of philosophical systems that seek no less than to transform our world and our perception of our place in the universe."[5] To understand, on a more personal level, one need only look to the pyramid project she proposed for the Paris Expo, which was shelved when the Expo was cancelled. A very similar pyramid now stands over the new Louvre addition, done by a male architect who had access to her work rather than by the woman artist who conceived the project. To reverse this, it is essential for a woman artist to be a promoter, to be better than a man at promoting her work—a thought that is almost oxymoronic. Promotion for most artists, and certainly for Denes, is directly opposed to the thinking, conceptualizing, abstract symbolization, and pattern finding that are facets of her and of her art.

In her career, she has known the frustration that comes from a lack of belief in the validity and significance of what she is doing, but considers it, in some respects, having been helpful for her continued growth as an artist, because she was left alone, allowed to grow and to remain unlabeled. In recent years, art historians, such as Tom Leavitt and Peter Selz, among others, have pointed out this disparity and acknowledged Denes's art historical place and her role as innovator.

In the pursuit of her art, Denes has made choices and sacrifices, as both an artist and a person. Never far from poetry and the word, she continues to write books, essays, poetry, and the analytical concepts that are part of her visual art. The only copy of a body of her haiku—the culmination of her early struggle with language—lies buried in a time capsule, placed there in discipline and self-denial, as part of her first environmental work, *Rice/Tree/Burial* (1968), and announcing her commitment to this new art form. Color was abandoned, although she speaks with animation of the sheer pleasure of using color; but color competed with content, and the content—the message—was more important. Only since 1980, and much more recently, has a new type of color been allowed back into her art. Spontaneity that was so much a part of abstract expressionism, the first "ism" of her development, was abandoned for the long, often agonizing years of study that are behind so much of her work: sixteen years to finish *Book of Dust;* seven years to read the *Webster's Unabridged Dictionary* and complete *Strength Analysis: A Dictionary of Strength;* six years to learn the code, study religions, and complete *Morse Code Message;* and so the list could go on and on. She has studied mathematics, physics, astronomy, religion, psychology, philosophy, and logic to satisfy her overwhelming drive to create this new form

[5]*Agnes Denes,* xi.

of art. Yet, despite all the years that each work took, the spontaneity and immediacy remain, masking the amount of research, thought, and labor put into it.

This study, this whole devotion to the art, has taken a personal toll. The calling that had to be followed—to create this art alone without the help of being carried by movements—placed strains on her personal life as well. Her commitment was too much for her husband; her son, seeing the sacrifices she had to make, distanced himself from art as a vocation. In some of the aloneness of the individuals of *People Paradox* one senses this artist—alone in a group with others, all having the same external characteristics, trapped into an existence from which there is no walking away, interdependent but not actively interacting or understanding the role of the people around them.

What is seldom remarked in any analysis of Agnes Denes's art is her wit and subtle humor. It may be that it is overlooked because of the strength of the intellectual aspect. Yet, who can avoid a chuckle or fail to see the humor in her map projections as they develop in the shape of a hot dog or a doughnut? Would any but the unsighted miss the biting, sardonic wit in *Investigation of World Rulers I* and *II,* in which a highly appropriate "body part" is used to depict the megalomaniacal Napoleon? How could anyone miss the irony and not smile at the balsa wood anchor, lead oars, blinking lights, and drawing of an engine that was *Noah's Ark—A Spaceship*? Can the hope and confusion of twentieth-century technology not be pondered with a bit of fun as well as serious reflection? In speaking of *Tree Mountain,* soon to be built in Finland—made of 10,000 trees planted by 10,000 people on a man-made mountain, to last 400 years—she makes a jab at the art market and the pretentions of investors, while at the same time making an environmental contribution. She states that though the trees may be auctioned at Sotheby's like any work of art, they cannot be removed from the mountain, and with the inflated sums of money that pass from hand to hand, it is sponsorship, not ownership, that the purchaser buys, learning that ultimately no art can be owned. The purchaser becomes a custodian and assumes the moral obligation it implies. And then there are the space stations that developed from her pyramids. For this work she writes:

> All the *Restless Pyramids* are related and they are born *When the Pyramids Awaken.* Realizing they are organic forms, the pyramids lose their rigidity and stillness, begin to stretch and sway, as they break loose from the tyranny of being built, knitted into form. They proceed to unglue their units, the program and method that bind their cell structure. Once their elements are free, the *Restless Pyramids* become flexible to take on dynamic forms of their own choosing. At this point they decide to fend for themselves and create their own destiny. They also begin to look out for the inhabitants, for whom they create environments.

This is the birth of giant *Fish Pyramids, Flying Bird Pyramids,* and pyramids in the shape of an *Egg* or a *Teardrop.* They are created for a different world in which the inhabitants will live in space, hovering above Earth, or else live on Earth in self-contained environments. These structures have little of "science fiction" about them; rather, they are pure technology with yet another kind of "perfection," that of the flexibility of natural systems. They have a look of freshness and vulnerability. They are the future and the future is always vulnerable and unused.[6]

As Denes describes them, the pyramids became restless, woke up, stretched, realized that they had to save the world, and so became the containers for the world's civilization: a bird pyramid, a fish pyramid, an egg.

Her art is considered spiritual, and she herself a mystic, by many. Denes is mystified by being called a mystic and sees only spirituality. The spiritual in her art is the appeal to higher emotions and an aesthetic sensibility.

As in art, Denes's involvement in the women's movement was also unique and individual. She was there at the beginning of A.I.R. She was the person who was asked to get Louise Bourgeois involved in the women's movement by bringing her to her first women's meeting. She was at the first women's conference in Washington, D.C. Always her way was different—to be a woman, to accept who you are, not better or worse, just different from men. In the long run she sees little difference between men and women, the only difference being the way society treats one or the other. She has never sought to be a man and has relished her brain as her unique and special part. She is basically an unpolitical being except for the strength of her concepts and innovations which make her art political in a sense, and she admits that she has never been very good at marching or at shouting slogans. "The best thing I can do for women," she said at a women's conference, "is to go back to my studio and make the art women can be proud of, so that young generations will have the role models we never had." She seriously lives up to being a role model.

Agnes Denes is articulate, gentle, modest, shy, most comfortable with her studies and her studio, driven by concepts and complex ideas that come from deep within her and won't let go until rendered visually, concerned with the earth and humanity today and for the future, balancing dualities of pessimistic truth/optimistic hope, reality/illusion, chaos/order, interdependence/individuality—the paradoxes of life. Her work is often ahead of the comprehension of the time, and it is only understood and discussed several years later. *WheatField—A Confrontation,* conceived

[6]*Agnes Denes,* 35.

in her concern for the universe and for humanity, was planted in 1982 but written about more frequently when the environmental art movement began to take place, after 1988. "As with all truly original artists, Denes is ahead of her time. Her art reminds us that we live in an age of readily supplied information and quick fixes and that few of us are able and willing to devote the time and effort needed to understand and enjoy complex and profound artistic work."[7] In response to the trendiness of the art world she is proud of never having "sold out" or played to the "tastemakers," although this same independence has probably, by virtue of being outside of the movements, eliminated her from much of the critical and comparative art writing today. As she phrases it, "There is a tendency in the art world to quote one another like birds imitate each other's chirp; in that chirp I'm not there." Always moving in uncharted waters, she planted a *Wheatfield* in the center of Manhattan and harvested a thousand pounds of healthy golden wheat; she is about to create a *Tree Mountain* in Finland as a permanent monument to our civilization—teamwork, land reclamation, and fostering wildlife; twenty years ago she x-rayed old-master paintings to study process and magnified the cells of a taste-bud to study structure; and she has photographed Niagara Falls from a rocky outcropping that subsequently toppled into the gorge, graphically illustrating her art on the edge. *Sun Triangle in the Arctic Circle—An Observatory,* was a proposal for the Diomede Islands in the Bering Strait, using principles that are reminiscent of Stonehenge for the capture of the equinoctial position of sunlight to create an interactive and reflective environment between East and West. Of this project she said, "No island is too desolate and no place too distant when the essence of what is human in creativity reaches its summit."[8] In this same vein, in 1982, during the wheat embargo against the Soviet Union, she proposed to the governments of the three superpowers—Moscow, Beijing, and Washington—the synchronized planting of three wheatfields.

Art is the life choice that Agnes Denes has made. The way she works, travels, lectures, the long process of study—the immersion in each new concept—is some indication of how that choice dominates her life, and of the time it takes and the demands it makes upon her. Her work has a grace and poetry—always poetry—but it never loses strength or sure-footed control, regardless of the scale and medium. She sees her art as almost stronger than she is and marks her quest and development as carried along by the strength and momentum of her work. When questioned about the art pulling her along, she explains that it is a mutually controlling and fully rewarding situation. When the suggestion is made

[7]Thomas Leavitt, from *Agnes Denes,* xi.
[8]*Agnes Denes,* 131. From a poem written by Denes in 1982.

that she is, perhaps, too humble, she smiles and acknowledges that she has a "sufficiently healthy ego" but that for her art she has humility. She has "made friends with her art," but she has always been propelled by it. Whoever or whatever does the pulling, the aims are neither small nor humble. She adheres to her principle that art transcends mere decoration, and there is a pride in having remained steadfast. Her art has a continuum that seems like a single work, a masterpiece, created throughout a lifetime. When asked about her greatest accomplishment she says: "My art. And having survived without compromising my beliefs, my thoughts, my vision. And in spite of everything, remaining sensitive, idealistic—and creative."

The following are excerpts from Denes's written work

All my philosophical concepts seem to culminate and come to life in my environmental/sculptural works. They are meant to begin their existence in the world when completed as works of art, and come to full realization as they grow and evolve with the changing needs and perspectives of humanity.

The issues touched on in my work range between individual creation and social consciousness. We have entered an age of alienation brought on by specialization, a by-product of the Information Age. This is an age of complexity, when knowledge and ideas are coming in faster than can be assimilated, while disciplines are becoming progressively alienated from each other through specialization. The hard-won knowledge accumulates undigested, blocking meaningful communication. Clearly defined direction for humanity is lacking. The turn of the century and the next millennium will usher in a troubled environment and a troubled psyche.

Making art today is synonymous with assuming responsibility for our fellow humans. I am concerned with the fact that we have taken evolution into our own hands. We are the first species that has the ability to consciously alter its evolution, modify itself at will, even put an end to its existence. We have gotten hold of our destiny, and our impact on earth is astounding. Because of our tremendous "success" we are overrunning the planet, squandering its resources. We are young as a species, even younger as a civilization and, like reckless children, initiate processes we cannot control. We tend to overproduce, overuse, and quickly tire of things. We also overreact, panic, and self-correct in hindsight. The pluralistic nature of things creates too many variables, confusing the goals to be achieved. Sustained interest and effective action are diminished with the alienation of the individual who feels little potential to interact or identify effectively with society as a whole. Overview for humanity is lacking and, as the momentum increases, human values tend to decline. [From *Book of Dust,* "The Predicament"]

Meanwhile, for the first time in human history, the whole earth is becoming one interdependent society with our interests, needs, and problems intertwined and interfering. The threads of existence have become so tightly interwoven that one pull in any direction can distort the whole fabric, affecting millions of threads. A new type of analytical attitude is called for, a clear overview or summing up.

I believe that the new role of the artist is to create an art that is more than decoration, commodity, or political tool—an art that questions the status quo and the direction life has taken, the endless contradictions we accept and approve of. It elicits and imitates thinking processes. My concern is with the creation of a language of perception that allows the flow of information among alien systems and disciplines, eliminating the boundaries of art in order to make new associations and valid analogies possible. My ideas are unorthodox compared to those usually voiced within the art arena. I incorporate science and philosophy into my work and allow the concept to dictate the mode of realization. The materials I work with are as diverse as the concepts that dictate them. By allowing this flow of information to infiltrate the art arena, art can rise above being just another self-styled, elitist system busy with its own functions. Art is a specialization that need not feed upon itself. It is capable of imbibing key elements from other systems and unifying them into a unique, coherent vision. Art need not be restricted by the limitations inherent in other systems and disciplines.

An art dealing with these issues has the power to make statements with universal validity through the assessment of a world whose issues it reflects and analyzes, and thus benefit humanity. When the creative mind is aimed at global communication and concerns, the door is open to a new form of art that goes beyond the self and the ego, without being selfless. This art must assume the difficult task of maintaining a delicate balance between thinking globally and acting independently. For the ego must remain intact in order for the self to act fearlessly, with certainty and confidence, and it must be relinquished in order to think universally.

In this sense I see the importance of this art emerging beyond a personal style, trend, or region, pointing to new ways of seeing and knowing that enhance perception and awareness, and forming new insights and new methods of reasoning. This is the essence (universal concept) I often refer to in my writings, the sum of an analytical process that has the potential to reach beyond itself and become the thermometer or gauge of its time—the summing up or perspective needed for the missing overview.

I created my first ecological site work in 1968 with these concerns in mind and have been developing these concepts ever since.

In a time when meaningful global communication and intelligent restructuring of our environment is imperative, art in the public sphere can assume an important role. It can affect intelligence, collaboration, and

the integration of disciplines, and it can offer benign solutions to prob-
lem solving. It can bring people together in meaningful and provocative
ways, while enhancing and rebuilding environments.

Artistic vision, image, and metaphor are powerful tools of communica-
tion. Artists can motivate people and influence how things are perceived.

Humanity is at a turning point, facing major decisions in order to sur-
vive on the planet while it strives to maintain its moral values and the
quality of life. A well-conceived work can have profound impact on hu-
man values.

The type of art I am discussing here can be a great moving force, not
only enhancing the present but shaping the future. The artists' vocabu-
lary is limited only by the depth and clarity of their vision and their abil-
ity to create true syntheses well expressed.[9]

My art exists in a dynamic, evolutionary world of rapidly changing
concepts and measures, where the appearances of things, facts, and
events are assumed manifestations of reality and distortions are the
norm. . . . Although I deal with difficult concepts, my work remains vi-
sual. The process of "visualization" is doubly important since aspects of
the work explore invisible systems, underlying structures, and patterns
inherent in our existence. . . . I incorporate science, philosophy, and all
those disciplines that enrich my work and are so necessary to any worth-
while human activity in the world today.

I communicate my ideas in whatever form is most true to the concept.
It is the concept that dictates the mode of presentation. My projects take
several years to complete and they are in a constant state of flux. The
work follows an evolutionary attitude and process. It questions, dissects,
reevaluates, and reconstructs through the conscious use of instinct, in-
tellect, and intuition.

By questioning our existence as well as existence itself, we create an
art universal in terms of all humanity. Personally, I am fascinated by our
human position of being somewhere in the middle of this "existence."
We live on an average galaxy; we can't see too far or too close, can't
stand too much cold or too much heat. We don't live too long, and yet,
we can look out to the edge of the universe into light years and penetrate
the atom chasing quarks and another world within. The world seems to
begin at the surface of our skin; there is a world beyond it and a world
within, and the distance is about the same. I like that.

[9]From "Notes on Eco-Logic: A Visual Philosophy and Global Perspective,"
written between 1968 and 1990. Parts of this essay appeared in *Critical Inquiry*
(1990), and it is being published in its entirety in a special issue of *Leonardo*, en-
titled "Art and Development."

Once we abandon Newtonian static physics and accept Einstein's four-dimensional principles of relativity, we question reality and know that even the laws of nature may undergo evolutionary changes. We even invented the uncertainty principle, although we use it for other reasons. We haven't begun to understand the implication of this new, relativistic existence, where everything we had known and had believed now seems to be wrong. In this new dynamic world, objects become processes and forms are pattern in motion. Matter is a form of energy and our own human substance is but spinning velocity. There is no solid matter and no empty space; time becomes an earthbound reality but remains an enigma in the fourth dimension. We must create a new language, consider a transitory state of new illusion and layers of validity and accept the possibility that there may be no language to describe ultimate reality, beyond the language of visions.

In our limited existence, evolution provides answers to where we've been and where we are going: a future prediction based on previous phenomena. The universe contains systems, systems contain patterns. The purpose of the mind is to locate these patterns and to seek the inherent potential for new systems of thought and behavior.

My work touches on the various stages of the development of my species, reevaluates and makes new comparisons in order to enhance perception and awareness, to form new insights and new methods of reasoning. . . . This analytical attitude probes the structural and philosophical significance of an invisible world where elusive processes, transformations, and interactions of phenomena go unseen, buried in the substance of time and space. I am referring to known or unknown events hidden from recognition either by their nature of spatiotemporal limitations or by our being unaware of their existence and functions.

I believe that art is the essence of life, as much as anything can be a true essence. It is extracted from existence by a process. Art is a reflection on life and an analysis of its structure. As such, art is capable of shaping the present as well as the future.[10]

[10]From "Evolution and the Creative Mind," first delivered as a lecture at the Smithsonian Institution, Washington, D.C., 1976, then incorporated into an essay, "Notes on a Visual Philosophy," included in the anthology, *Symmetry—Unifying Human Understanding,* edited by Istvan Hargittai (New York: Pergamon Press, 1986), 835–48.

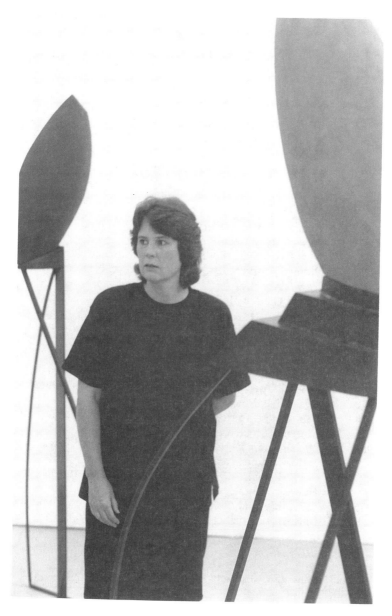

Plate 9. Patricia Lay in studio, 1989. Photo by Kaare Rafoss.

Patricia Lay

Education

1968 M.F.A., Rochester Institute of Technology, Rochester, New York
1963 B.S., Pratt Institute, Brooklyn, New York

Selected Solo Exhibitions

1992 Condeso/Lawler Gallery, New York, New York
1987 Jersey City Museum, Jersey City, New Jersey
1974 New Jersey State Museum, Trenton, New Jersey
1973–74 Women Artists Series, Douglass College, New Brunswick, New Jersey
1969 Tomac Gallery, Buffalo, New York

Selected Group Exhibitions

1992 "New Jersey Project Invitational," Robeson Gallery, Rutgers University, Newark, New Jersey
1989 "Visual Arts Fellowship Exhibition," Noyes Museum, Oceanville, New Jersey
1984 "Structures: Thirteen New Jersey Artists," Montclair Art Museum, Montclair, New Jersey
1982 "Small Sculptures in the Permanent Collection," New Jersey State Museum, Trenton, New Jersey
1977 "1977 Biennial of New Jersey Artists," Newark Museum, Newark, New Jersey
1975 "1975 Biennial of Contemporary American Art," Whitney Museum of American Art, New York, New York

Selected Bibliography

Peterson, Susan. *The Craft and Art of Clay.* Englewood Cliffs, N.J.: Prentice Hall, 1992.
Patricia Lay: Recent Works. Introduction by Stephen Westfall. Jersey City, N.J.: Jersey City Museum, 1987.
Structures: Thirteen New Jersey Artists. Montclair, N.J.: Montclair Art Museum, 1984.
Opitz, Glenn B. *Dictionary of American Sculptors.* Poughkeepsie, N.Y.: Apollo, 1984, 234.

Representative Works, 1971–1984, Women Artists Series. New
Brunswick, N.J.: Douglass College, Rutgers University, 1984.
1975 Biennial Exhibition. New York: Whitney Museum of American
Art, 1975.

Interview

Patricia Lay was interviewed by Sally Swenson in 1988

SS: I think I would like to start out by asking when you decided you
wanted to become an artist, or did you always know?

PL: Well, it's a long story, actually. I grew up in a family of artists. To
go way back, my great-grandfather on my father's side was Oliver I. Lay,
a portrait painter in New York. My grandfather, his son, Charles Down-
ing Lay, was a landscape architect and commissioner of Central Park
around 1910, and he was also a painter and was part of the artists' circle
in New York at that time. So, my father grew up surrounded by artists
and then went on to receive his B.F.A. in painting from Harvard. He went
to Yale after that and met my mother, who was studying painting at Yale
and received her B.F.A. from Yale. So, when I was born both of my par-
ents were artists. After they married they moved to New York and stud-
ied at the Art Students League. Eventually they moved to Connecticut
where I was born and grew up. When I was about three, four, or five years
old—in that time frame—my mother was painting portraits. She had her
easel set up in our living room. So, I had a sense of what painting was all
about. My mother was an early role model for me in the sense that she
set goals for herself and seemed very independent.

SS: Were you an only child?

PL: No, I have a brother who is two years older. At about ten years of
age I started taking painting lessons from a local artist but never felt very
successful at it. I felt that my parents were much more successful as
painters; I was trying to live up to what they had done in painting.

SS: It's hard when you're ten.

PL: Eventually I knew I wanted to be an artist. I decided that I wanted to
go to art school. At that point I couldn't think of anything but painting
but hoped there was something else besides painting that I could do in
the arts, because I really didn't feel that I was that great a painter. At Pratt
I studied mostly painting. I worked with Pearlstein, and Pace, and

Briggs, and Jacob Lawrence. And most of the painting that was going on then was abstract expressionist. I had very little sculpture experience at Pratt. As a matter of fact, they wouldn't let the female students learn how to weld, so I worked mostly in clay and plaster. I think it was probably in my senior year that I finally realized that I was much more successful with three-dimensional materials than with painting.

SS: Did you take any sculpture courses at all?

PL: I had one sculpture course, and I had some ceramics—maybe two ceramics courses—by the time I graduated. Ceramics was primarily pottery. They didn't think of it in terms of sculpture at all.

SS: Utilitarian type of thing?

PL: Right. But I really liked clay as a material and thought of it immediately as a material for sculpture. So, after Pratt I taught for a year—actually I taught for three years in the public schools and took graduate courses at night, with the idea that I would get a body of work together to apply to graduate school.

SS: May I just ask you, were there any studio teachers at Pratt that were women?

PL: I don't think so.

SS: Not in ceramics either?

PL: There was an assistant that was a woman, but she wasn't really the teacher.

SS: Okay. So, after you were teaching for three years and you got your body of work together, then you went to Rochester Institute of Technology?

PL: For graduate work. I went in with the idea of making clay sculpture, but they insisted that I learn how to make pottery also, because they felt that if I was going to go out with a master's, with an M.F.A. in ceramics, that I would end up teaching and I should know how to make pots. So I had to do both, which was okay. But it ended up, my thesis project was all sculpture, and I felt at that point that I had had really good training in ceramics, so that was very successful—but it was limited. If I had gone to a graduate school where the training was in sculpture rather than ceramics I would have had much more of an understanding of all the materials for sculpture. I would have learned how to weld, which is something I always wanted to do.

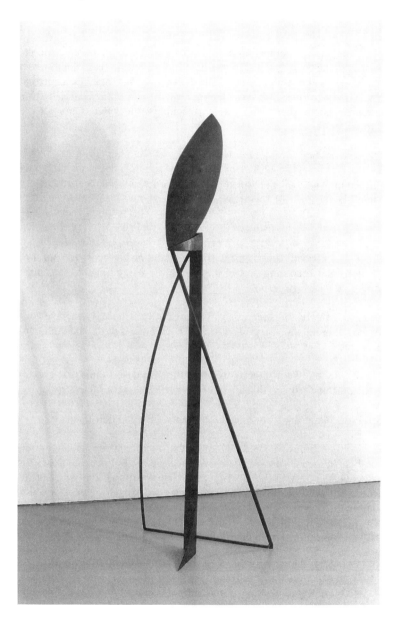

Plate 10. *Untitled #5,* 1989. Fired clay and steel, 78″ × 27 1/2″ × 19″. Photo by Patricia Lay.

SS: Hindsight is twenty-twenty.

PL: Yes. Oh, one interesting thing is that I taught in the public schools, after Pratt, because my husband (Kaare Rafoss) was a year behind me in school. He had one more year to finish at Pratt. Then he got accepted at Yale Graduate School, and so I taught for two years while he finished his graduate work. Then he got a job teaching in a college and put me through graduate school.

SS: So everybody had a turn there.

PL: Right. And we've now been married for twenty-five years this year. I feel like we grew up together.

SS: Personally and artistically?

PL: Yes, artistically and in terms of understanding our goals and our motivations and becoming part of the art world. We did it together, and I think that was very helpful.

SS: That's interesting. Seeing that you are both artists, and you have your studios at home, do you go and look at each other's work and comment back and forth?

PL: We do, but we try not to do it too often because I think you can really start interfering with each other's work.

SS: Probably at this point you are more mature; you don't need it.

PL: Well, at times we need it. I know that I really appreciate his input, and he's helped a lot technically with the pieces, putting the pieces together, recently with the steel pieces. That wasn't as true with earlier things that were all clay, but now that I am working with steel, ways of joining the clay parts to the steel and how to attach things to the wall or how to attach it to the floor if it needs to be attached—he has helped a lot with these technical problems.

SS: As you were coming along, were there any teachers in graduate school who affected you, or any artists whose work affected you a great deal?

PL: Yes. I studied with Franz Wildenhain, who was from the Bauhaus, and also Hobart Coles. I didn't have any female instructors; it was a small department. I think there were seven graduate students and two professors. I feel I fought with them more than anything else.

SS: They didn't give you what you really wanted, which was sculpture?

PL: Well, they were less interested in the sculpture. Franz was doing some sculpture in his own work. That's where the women's issue became a real thing. He said that I would never get a job teaching sculpture in college, and that I better be a good potter because I could get a job as a potter and I couldn't get a job as a sculptor. He really didn't take me seriously as a sculptor; he didn't think women should be sculptors.

SS: They told Louise Nevelson that too.

PL: Yes. That's interesting because you asked if there are any artists that were really important to me at that time, and Louise Nevelson was the one artist that I was really looking at, and I did one piece that I think was very close to her work. Her work was wood, mine was clay, but in terms of construction and forms I was really very influenced by her work.

SS: What about Noguchi? Somehow, some of your things seem warm and close in form and feeling to his work.

PL: Yes, Noguchi. Actually, it's interesting that before Noguchi's work, before I really started looking at it very carefully, I became aware of the Japanese gardens in Kyoto. I saw photographs of them at a time when I was changing my work. I was trying to think of a new direction to go in, and they hit me like a flash—a new, fresh direction to go in. The idea of landscape, the idea of a man-made landscape, the geometry and nature working together.

SS: Simplicity.

PL: Yes. It became a starting point for a whole body of new work. I then started really looking at Noguchi's work. I started thinking about geometric forms in a landscape setting.

SS: I think now's a good time to talk about this, particularly in your most recent work, although it's in your earlier work as well. There is a marriage of biomorphic forms and geometry. Would you say that that's true?

PL: Oh, definitely.

SS: In the earlier, all-clay pieces there are some very sensual forms, and then also the work is on a grid. You used a grid a great deal.

PL: Yes. The grid became very important in the landscape pieces. The grid became the structure, the geometric structure, for the organic forms to work within.

SS: Do the organic forms derive specifically from nature—from flora, or flowers, or buds?

PL: Not really. I guess in the earlier work I was thinking about cloud forms, and more specifically in the early work they were derived from actual natural forms; but in the new work it's not any particular form. I think one of the nice things about it is that it can take on a lot of different kinds of connotations. Sometimes it looks like a flower bud; sometimes it looks like a fish; sometimes, in these newest ones, it becomes almost a human body or parts of the body.

SS: Like the breast?

PL: Yes, parts, but I'm not specifically trying to make it a particular thing.

SS: It's nonobjective. There is an erotic quality and sensuousness to them too—particularly with the way the surface of the clay is juxtaposed with the steel.

PL: Yes. Part of it is the color, part of it is the texture in the earlier ones. Sometimes it becomes a kind of luscious surface. In the most recent things I have gotten away from that way of working.

SS: You have stopped using the luscious surface.

PL: Yes, because it flattened out the form and gave it too much of a surface interest so that the form itself became less important than the surface. The newer ones have a more sensuous quality in terms of their form.

SS: A lot of your works are wall pieces, which are very powerful. You are now doing large, freestanding pieces, human scale—five, six feet. The wall pieces have a way of just seeming to float off the wall.

PL: I've done a few pieces that have to go on a pedestal or on a base, and the idea of bases is just something I want to get away from.

SS: Well, that's another form.

PL: Yes, exactly. The wall is just very direct; you don't have to worry about a base. The same is true with the freestanding pieces. And also, I am interested in making small-scale pieces. I had previously made some large-scale floor pieces—the landscape pieces—and it took three, four months to complete one piece. So much of the time was just labor, and I wanted to go back to making smaller things so I could turn out a body of work, and so wall pieces seemed like a good way to go with it in the beginning.

SS: I would think for private collectors that really large-scale pieces are hard. They have to almost be for public spaces or museums.

PL: Yes, I never thought of that. I guess I'm a purist in that sense. I never thought in terms of making pieces that would sell.

SS: No, I don't mean that. I don't think most artists do, but if you talk to dealers they will say it is helpful if an artist makes at least some smaller-scale work, because people—specifically in New York—have small spaces.

PL: I've never had a gallery, and so I've never really had to deal with that issue. I've always just made the work because I need to make the work. I haven't thought about it in any practical sense.

SS: You have done a lot of architectural proposals. Would you comment on this area of your work? I have a few questions about that. Do you find on these proposals (especially being a sculptor—and this is a book on women and feminism), do you find discrimination because you are a woman?

PL: Well, yes and no. I felt that in the first couple of proposals that I did that were large scale—these were $50,000 commissions—they were not convinced that I could do it technically.

SS: I'll bet when you get one you've proven yourself.

PL: That's it, once you get one. I felt in the presentations that I'm just not very good at presenting myself when it comes to that situation. I felt that for them to be convinced that I could do it I would have to work twice as hard at convincing them as a man; they would just assume that, sure, *he* would be able to pull it off and know how to do it.

SS: Sure, if he's six foot, four inches and wears a hard hat.

PL: Because you have to deal with construction workers. The proposals that I presented were things that were cast-in-place concrete, ceramic-tile surfaces, and large landscape—environmental sorts of things. And so I would be dealing primarily with construction workers, in that situation, to get it built.

SS: Right.

PL: I think that I am the kind of personality that doesn't come off looking like I could handle that situation.

SS: Next time wear a yellow hard hat when you go to the interview.

PL: Yes, good idea. Well, the work since then is smaller scale. The work has changed totally. I am no longer doing landscape pieces. I was ready for a complete break. The first thing I did after I made the decision not to do any more proposals was to learn how to weld. I took an industrial welding course because it was something I always wanted to do, and I thought this was a way of changing my work. This was a way of getting out of this landscape thing that looked like proposals for large-scale pieces and just go in a completely new direction. So I took the welding course and started combining ceramic forms with steel, and it's just gone from there.

SS: I love the two materials together. They're very strong.

PL: I think it's really exciting—it's a wonderful combination.

SS: Because the clay is so sensual, just the material, and the steel is so hard. One of the things I wanted to ask you about is your use of color. You seem to have a pale, grayed-down palette. The newer ones are darker but still it's grayed-down valuewise.

PL: Well, some of that has to do with the fact that they are coloring oxides and slips. It's not paint, and so I am working within the colors that are available. But the other thing is the problem of using color on sculpture. It can overpower the form if it becomes too jumpy, too loud on the surface. Another thing is that it should work with the gray of the steel, or the brown of the steel if you leave the rust.

SS: The two elements don't fight with one another.

PL: Right, trying to keep it in that color range.

SS: Attaching clay to steel is a problem. Do you want to discuss it or do you want to keep that a secret?

PL: No, it's not a secret, but actually it's my husband who figured out the way of doing it, which is the way most of them are attached at this point. It's—I don't even know what to call it—it's a little fitting that you use for wood that has threads on the inside and threads on the outside so that you can screw the fitting into a piece of wood and then you can put a screw on the inside of it. I've epoxied them into the clay form and then the screws or bolts go through the steel into this fitting and it just screws on—a very simple, direct way of doing it—and it's very strong, by the way.

SS: Do you think there is a feminist sensibility or point of view?

PL: No, not really. I think it's changed a lot too. When I first became involved with the feminist movement I was in a consciousness-raising group in the seventies, and women were really very activist about it. A.I.R. started its gallery, and there were a lot of women's shows, and that was all very important and very good and needed.

SS: To get the ball rolling finally?

PL: Yes. I think at this point that women are much more accepted; I don't think they are totally accepted, but I think it's much easier now than it was in the seventies, or the sixties and the fifties. I think that women's attitudes have changed towards the alternative structure. I didn't mind being in women's shows. The series at Douglass—the Women Artists Series—was wonderful, and it was the first (well, it was really the second) one-person show I've ever had. It was very important to me, and at that point I had no chance of getting my work into a gallery. Women's shows, I think, were very important. I participated in many women's shows, but I didn't want to be part of a co-op gallery. I believe I could have been part of A.I.R. Soho 20, at one point later on, asked me if I would be part of their gallery. For many reasons, I really was not interested in doing that. One is that a cooperative gallery takes a lot of time, and I just felt like I barely had enough time to get my work done. I really didn't have enough time to sit in a gallery. There were a lot of things about it that took time. Also, there was money involved, and I was not in a position to pay out money to be able to show in a gallery at that point. I think it is important that women should not separate themselves by only showing in galleries that show only women. It seems kind of protective.

SS: It should be in the mainstream?

PL: I think if you are going to be taken seriously you have to be out there like everybody else and take your chances and be judged, and you can't be in a protective situation. Also, people see the work as—she can show in women's shows and women's galleries, but that's not the real world—that's separated from the real world. I always felt that I really wanted to become part of the establishment, the established structure of commercial galleries.

SS: When you are working, I notice that you do small, thumbnail drawings and then you also do finished drawings. Do you sometimes just work from small sketches, or do you work from a finished drawing each time.

PL: No, I usually don't work from a finished drawing. I go from the small pencil drawings right to the sculpture. I've always enjoyed seeing other sculptors' works on paper. It is a way to think about color for a piece, but it really is a very separate activity, and I am usually too anxious to get to the three-dimensional form: I bypass the larger finished drawing and go right to the sculpture.

SS: You don't make small three-dimensional models first?

PL: No. But I sometimes do finished drawings after I've done the sculpture.

SS: Do you think the studio space affects your work, because you have had different studios?

PL: Yes, in a sense it does. This space that I'm working in right now is much smaller than what I had when we lived on Broome Street, in Soho. That was a much bigger floor space, and that's when I was doing large-scale floor pieces. I think when I moved in here—it's more wall than it is floor—so I immediately thought of doing things for the walls. I think it has helped to change the work in that way. But, because this is only the beginning of studio space here, I am eventually going to have more space, and then maybe that will affect it again as I get more space.

SS: I think sometimes people have a bias against ceramic sculpture as opposed to stone or bronze or wood. Have you found anything like that?

PL: Yes, absolutely. I think part of it, for me, is that I did graduate work in ceramics and I stayed with clay exclusively for a very long time rather

than combining clay with other materials—for a good fifteen years after I got out of graduate school. I always felt people saw me obviously as a sculptor, but it was clay sculpture and they think of clay sculpture as related to the craft world. There are a lot of clay sculptors who like that world—like that craft world—but I have never felt part of it. I think of myself as a sculptor like any other sculptor working in other materials.

SS: How does your teaching affect your work, or does it? You teach ceramics in college, I believe?

PL: Yes, and I teach both pottery and sculpture. Well, I think that it's a way of talking through your ideas. I learn a lot from the students. I think that their experimentations can help me. I enjoy them. I enjoy being with that age group. I think it keeps me young. It's hard in terms of time though. It takes a lot of time between teaching and spending time with my husband and daughter. It's hard to find studio time. Next spring I'm going on sabbatical, and I'm really looking forward to that. I've been on sabbatical before, and it just makes such a difference. I think I could give up teaching and not be sorry, but since I'm not making money off the work, I need the income.

SS: What advice would you give to young artists? When you have art majors and students that are very serious about being artists, how do you advise them to make a living? Should they do something totally different like being a cabdriver? There are very few teaching positions now.

PL: Right, there are very few. I think it probably makes sense to do something related, because I think the contacts are so valuable if you are ever going to be successful in the art world and have a gallery and sell your work. A lot of it is done through contacts, so if your job keeps you in that same circle it can be very helpful.

SS: How important do you think it is for artists that want to show in New York to live in New York or near it so they can have a proximity?

PL: I think it is very important.

SS: So they get people to see their work?

PL: I think the art world is spreading out all over the country to major cities, and you can get a gallery in your home city—in Chicago or Houston or wherever—and go from there to New York. I think that works now, and I don't think it did work in the sixties and seventies at all. Then you had to come to New York.

SS: New York is still not too impressed with other cities; New York is impressed with New York.

PL: Yes. I think if you gain a reputation in your home city and then come to New York you can be fairly successful. And also, there are gallery affiliations between the cities which help a lot. But, I think, as a young artist just getting out of school, if you can come to New York it's the best place to be, or close to it. It's nice that it is spreading out a little bit so that Jersey City, and Brooklyn, and Hoboken, and Queens are considered close enough so that critics and gallerygoers are willing to come and look at work, because Manhattan itself is just too expensive for younger artists at this point. But being in the metropolitan area—I think it's very important to be there if you can be.

SS: Sometimes artists who live outside the area suggest, if you can, to share a studio or somehow store some work in the city. That way, you may be able to get a dealer to go look at it.

PL: I don't know. We've had friends who have done that.

SS: Does it help?

PL: I don't think it's very successful.

SS: And it's expensive.

PL: Yes. Because you have to be there to make the contacts. It's not just showing the work. You can't even get people to look at the work until you've gotten to know them and they start to take you seriously as an artist, and so it's really a very social thing—the more social you are in the art world the more successful you will be at getting people to see your work.

SS: So then you would advise them to go to a lot of openings and things like that?

PL: Go to openings, give dinner parties, go to parties—the more social you can be the better off you are. And it's such a different job from making art, and it's a whole job in itself that is absolutely necessary if you're interested in getting a gallery. It takes lots of time.

SS: And energy.

PL: Yes, and it's very different from working in the studio and making art. What's happening to me is that I guess as a personality I'm not that

social. Luckily, my husband is, so if it wasn't for him I would probably just stay in the studio all the time and never meet anybody, so he's been the one that's pushed the social part of it. But when I've had to make a choice between making the contacts and doing the whole social thing or working in the studio, I choose working in the studio. Between teaching and having a family, you can't do it all.

SS: That's a good point.

PL: So, I've made the work.

SS: Maybe the bottom line is to make good work?

PL: Yes, but if nobody sees it, I don't know what good it is. Actually, at this point, I think both my husband and I are going to get out there and get people interested in seeing our work, and we want to be able to support our studios by selling work. I think, at some point, you have to do that. We're supporting our work by teaching, and it just doesn't make sense; it should support itself.

SS: Yes, but it doesn't. Very often art doesn't make money.

PL: Yes, but it can. It's just hard work to get to the point where you have a gallery and people will buy the work, but it can be done if you put the time into it. I think we are both now ready to put that time into that.

SS: Well, you certainly have wonderful work to show. Would you advise artists coming out of school to show in alternative spaces like the Douglass Library?

PL: Yes, I think that in the beginning it's a good idea. You gain experience—just what you have to go through to have a show. But it can't go on and on. I think it's fine for the first five years or so, because if the work is seen it can lead to other things in commercial galleries; it doesn't hurt, but I don't think it can be used as a crutch or a protective kind of place. I think you just have to get out there and fight like everybody else.

SS: Would you like to add anything in conclusion?

PL: Yes. I'd like to talk more about my work. In 1962, before I graduated from Pratt, I guess it was after my junior year, I went on a trip to Europe for nine weeks, all over Europe. My mother and I went together. We went to Spoleto in Italy, and that was the year David Smith had his works all over Spoleto, and, interestingly enough, I didn't really even know his work. I

hadn't studied it at Pratt, and I was totally turned on by it. He had works in an amphitheater that looked like people standing on the steps of the amphitheater. And it's something that's always stayed with me. This visual impression has always been very important, which is, I think, part of the reason I started working with steel. And now in the newest things, in a funny way, I think I am trying to duplicate those pieces in the amphitheater. I know that my pieces are very different, but they are connected.

SS: The large, freestanding pieces that you are working on are going to have the same kind of personage?

PL: Right. They take on a human scale and a human sort of stance, gesture, and I think that it really does have to do with that early David Smith impression. Also, for the clay forms, I have been looking at primal forms, African forms. Brancusi has also been an important influence in my recent work.

SS: Your work seems to relate to minimalism.

PL: I hope that my work stimulates thoughts or images beyond what is given, what is seen. The pieces are very formal. They come out of minimal art in the sense that they deal with the essential. There is an economy of form; I've pared it down to the essential parts.

SS: Do you believe that less is more?

PL: Yes, I think it is a much more powerful statement.

SS: It's also harder to pull off.

PL: Yes, maybe. But I spend a lot of time in the drawing stage getting the parts of it right so that I don't have a lot of unnecessary things going on.

SS: Something that just occurred to me, if you think about the materials themselves: clay is from the earth—nature—and steel is man-made.

PL: Right. There is an emphasis on the medium and the manipulation of material, I think very definitely. I love clay as a material to work with, and at this point I love steel too. So there's an emphasis on the materials themselves. I think they are really working together well. As you said, the clay is organic form and the steel is the geometric form in most cases. The forms are arrived at through a dialogue between the artist and the materials. Part of the reason I arrive at these kinds of images is because of the materials I am using.

SS: Don't you think students have a difficult time realizing it takes a lifetime to get that kind of knowledge and dialogue with the materials themselves?

PL: I think it only comes through doing it for a very long time.

SS: That's right, that's what I'm saying—twenty years and more.

PL: I've been a sculptor for a good twenty years. In time, you really begin to understand it.

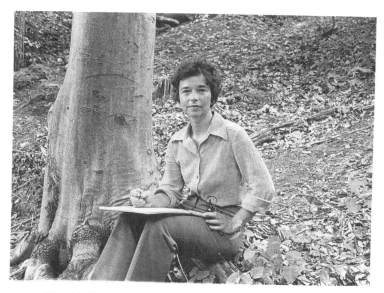

Plate 11. Charlotte Robinson, 1983. Photo by Joyce Tenneson.

Charlotte Robinson

Education

1951–52	Corcoran School of Art, Washington, D.C.
1947–48	New York University, New York, New York

Selected Solo Exhibitions

1992	De Andino Fine Arts, Washington, D.C.
1991	San Antonio Art Institute, San Antonio, Texas
1985	McNay Art Museum, San Antonio, Texas
1981	Arlington Art Center, Arlington, Virginia
1979–80	Women Artists Series, Douglass College, New Brunswick, New Jersey
1962	Casino Estoril, Lisbon, Portugal

Selected Group Exhibitions

1991	"Beauty and Eloquence: American Women Artists," Art in Embassies, Kathmandu, Nepal

1983	"The Artist and the Quilt" (traveling exhibition, 1983–86)
1976	"Gillespie, Neel, Robinson, Sleigh," Fendrick Gallery, Washington, D. C.
1962	Amadis Gallery, Madrid, Spain

Selected Bibliography

Nantz, Elena. "Watkins Exhibit Celebrates Nature," *The Washington Post,* 20 March 1992.

Callaway, Carol. "Ten Years Later: New Work by Artists from the Exhibition." *New Art Examiner* (April 1985): 59.

"The Artist and the Quilt." *Time,* 12 December 1983, 102–4.

The Artist and the Quilt. Edited by Charlotte Robinson. New York: Alfred A. Knopf, 1983.

Hands of Artists: Charlotte Robinson. Preface by Mary Swift. Arlington, Va.: Arlington Arts Center, 1981.

Women Artists Series, Year 8. Introduction by Joan Marter. New Brunswick, N.J.: Douglass College, 1978–79.

Interview

Charlotte Robinson was interviewed by Lynn Miller
in 1989 and by Beryl Smith in 1992

LM: Why don't you tell me when you first became interested in becoming an artist. When did you know you were an artist?

CR: As long as I can remember I was carrying around a sketchbook, even when I was seven or eight years old, but I didn't define myself as an artist until much later in life.

LM: Though you did draw as a child?

CR: All the time. And I took every art course that I could take in high school and in college.

LM: Let me ask you about high school. How did your educational experience in high school and college shape your identity as an artist? Did you have good teachers? Did you have any role models?

CR: Role models? Yes, my next-door neighbor. She had gone to Mexico and had studied with Diego Rivera, and she was very sympathetic to me and would take me, when I was about fourteen, to the Witte Museum for life classes.

LM: So you had a chance to draw from a model? Where was this?

CR: San Antonio. The high school teachers were not outstanding. I don't really remember any of them. And then somewhere down the line—I was about fifteen or sixteen—I decided I wanted to be a commercial artist. I didn't really know what that meant, but there was a commercial art school in San Antonio, so I started going there after class every day.

LM: What gave you the idea to be a commercial artist?

CR: The idea to become a commercial artist seemed like a way to continue art work and make it into a career. In college the only courses that were offered were china painting and a course in portrait painting.

LM: Where was this?

CR: This was in San Antonio. It was during the war, and my father wouldn't send me away. He sent my sisters away to school, but he was getting very nervous about sending us out of town. He thought it would be a good idea if I went to Incarnate Word College in San Antonio, so I took the china painting and the portrait painting.

LM: Don't tell Judy Chicago about china painting.

CR: I was painting china years before Judy Chicago painted china. I got a kick out of listening to her recounting her experiences with china painting. Actually it's very stultifying. You have to paint some of those pieces as many as three times. You paint it and fire it, paint it and fire it, paint it and fire it. It can be very boring.

I married when I was eighteen, right in the midst of my freshman year, and Robby left and went to Italy; it was during the war, so while he was gone I went to the University of Texas, in Austin. They had a much better art program, and that was a real revelation to me because I was seeing things I hadn't seen before.

LM: Did you have good teachers there?

CR: Yes, pretty good. They weren't excellent. Then when Robby came back we were stationed in New York City, and I went to the Art Students League very briefly, but I had a poor teacher that I just couldn't relate to.

LM: When was this, Charlotte?

CR: This was in about 1949, just after the war. Then I transferred and started going to the School for Art Studies, which no longer exists. But

Plate 12. *A Jumping Off Place,* 1990. Oil on canvas, 41″ × 49″. Photo by Greg Staley.

by then we had a child, and I would have to wait until Robby came home from school—he was at Columbia. So I went to the night school, and the School for Art Studies was good. I had an excellent teacher.

LM: What made you think the teacher was good?

CR: He was very creative in the way that he allowed everybody to do what they wanted. The teachers I had had before were really conformist. This time I got a lot out of it. We worked from live models and from imagination, and I became more aware of art history.

LM: It's interesting that you drew human figures in those days, because your work, except for the hands, has been more of nature.

CR: I painted portraits for twenty years, but it was after we lived in New York, and I did it to make money. We left New York then and went to Germany.

LM: Was he still in the service?

CR: Oh yes, his career was in the air force. He was just getting his master's degree at Columbia in international affairs. It was a course in Russian language, and we were sent to Germany to set up a school so that they could interview all the displaced persons coming out of the Iron Curtain countries. There were ten men and five wives, and the wives went to New York University three nights a week.

LM: So you were part of the system that you were going to set up?

CR: The women weren't going to have any official part in it, but we were asked to learn Russian because we were going to be sent there eventually. When we got to Germany we lived in Oberammergau. The school was set up, which stayed in existence for about twenty years, and our group was the first to go through the school. All these people who had escaped from the Iron Curtain countries were put in a DP camp, and they were interrogated to find out what they could teach our people about the Soviet Union. And then our men were sent to the Soviet Union, ostensibly to carry the diplomatic pouch, but their real mission was to spy. Then they started sending families, but by then we had two tiny children, and the living conditions in the Soviet Union were just absolutely awful.

LM: Did you go?

CR: No. If the wife went she had to work, and they weren't allowed to take children. The people who had children had to either send them back to the States or put them in a school in Switzerland. A lot of our friends did that, but their children were older, school age, and our children were preschool. I just didn't want to do that and neither did Robby. So we didn't go as a couple. He went to Salzburg, Austria, for about nine months and commuted from there to the Soviet Union.

LM: What were you doing in terms of your art?

CR: I was taking classes. Germany was in terrible chaos when we got there. Munich was flattened. We drove to Munich to look for an art school because that had been a great art center, and there was just nothing going on. So I found a teacher in Garmisch and just took anatomy lessons. He would send me models, and once a week he would ride his bike across town and critique my work.

LM: Let me ask you something. At this point in your life, you were the wife of a career officer, you had two little children, and you were in your early twenties. Did you think of yourself as an artist yet?

CR: I still didn't define it as such. I didn't know any artists. I knew my teachers, but they were all men.

LM: So you were just feeling it out at this point?

CR: Yes. When we left Garmisch we moved to Regensburg, which is the end of the world. It's near Czechoslovakia, and aside from a boys' choir and a wonderful cathedral there wasn't much in Regensburg. There was no museum, no art scene at all that I could see. I met a neighbor, and it was the first time I had met another woman who was serious about being an artist. She had gone to the Chicago Art Institute, and her work was very good. She would do watercolor and oil sketches, and at least I could talk to somebody about art. I began working on my own, but we were only there for about nine months. Then we moved to Wiesbaden, and Wiesbaden is marvelous. Wiesbaden didn't have any museums, it didn't have any galleries, but it had more of a cultural atmosphere than any city we had been in. I had to work on my own; there was nobody to work with. And then we came home to America.

LM: Where did you live?

CR: When we came back we lived in Washington, and I started going to the Corcoran. In those days you just did all your studio work at the Corcoran, and then you went to George Washington University to get art history and other subjects, and I did that. But we had three children, and I had to commute about an hour to get there because we lived in Virginia, and it was really impossible to get all the credits that I needed.

LM: You were still working on an undergraduate degree?

CR: Right. As we moved around I always signed up for classes; in the end I attended seven colleges. The Corcoran was wonderful, and the first year I was there I won the Concourse Award, which is a paid scholarship for a year, which was a big help. I was going five days a week. We brought a German girl back home with us. I wouldn't have been able to do that if I hadn't had good live-in help because all the children were preschool. Only someone with children would understand this, you know?

LM: I certainly do. So, you were at the Corcoran winning prizes?

CR: Well, I was lucky that year. I went there for two years, and then we left and moved to Savannah, and I went to the Telfair Art School, which is part of the museum, and it was a good museum. You know, Savannah is older than Boston, and it had quite a cultural feeling about it—very lit-

tle art market, but at least they had a little theater, and they had opera, and they had some semblance of a gallery scene, which is certainly more than some of the towns we lived in. When we left Savannah we went to Lake Charles, Louisiana. It is halfway between Houston and New Orleans, and in order to go to a museum or a gallery I had to drive to either Houston or New Orleans. Each city is about two and a half hours. So I didn't get there very often. But again, there is a college in Lake Charles—Centenary College—and they had a good sculpture teacher, so I took sculpture and that was a great experience. When we left there we went to Spain, and we were in Spain for about four years. We lived in hotels for about nine months, and I finally found a house that was a great big wonderful house with a room that I could use as a studio.

LM: What town were you in?

CR: In Madrid. Robby was stationed at Torrejon Air Force Base, about twenty miles into the country. In Madrid I realized that I no longer was a student. I had a studio for the first time. By then I was about thirty-two.

LM: That was a statement in itself—to set up a studio for the first time. How did your family react?

CR: The children loved it because there were pastels or paint or something available all the time. Robby just sort of ignored it. He didn't have any input at that point. He was neither supportive nor nonsupportive— he just tried to ignore it. Up until this time I was painting portraits. I started in Savannah. I began with my own children, then I started doing other people for fun, and finally I realized that I really had something here that I could charge real money for. I had more business than I could handle, and in a place like Savannah, Georgia, everybody wants their portrait painted. It was really a booming occupation. It helped put three children through college.

LM: I was thinking of Mary Cassatt. You said you were tired of painting portraits, but Mary Cassatt painted children—

CR: A different thing. Mary Cassatt, first of all, identified herself as an artist early on. She was from a very wealthy family that sent her to France and respected her as a professional person. I didn't come from that kind of a background. Even though my father painted as a hobby, he hid his paintings. He would only show them to his family. Taking art classes was something that a woman or a man could do as a hobby. But it was not something that a nice, refined person did as a profession, and so I never was able to be like Mary Cassatt. She had a different kind of life. She

didn't have any children. She really devoted her entire energy to her art. When I finally got to the point where I was good enough, or felt I was good enough, and had more business than I could handle, I really began to do portraits that were creative. Then, once I earned enough money to build my studio in Falls Church, which is a wonderful big studio, I was able to save enough to quit painting portraits and teaching. I was really tired of people saying "Her eyes are really not that blue," or "Her hair really is blond." Somewhere along the line Alice Neel had the courage not to do it for money. She was not painting commission portraits, she was just painting people. And I didn't have that kind of courage.

LM: It compromises the artistic vision when you're doing it for money. When you're not doing it for money you have your own artistic vision.

CR: That's right. I finally got to the point where I would make very few changes, and you know I really had reached the stage where I probably could have gone on, but I was tired of it.

LM: Do you think you'll ever go back?

CR: No, I'll never go back except for fun. I have two little grandchildren, and I painted them two years ago. I hadn't done any portraits in about three or four years. It was so easy I couldn't believe it.

LM: When you did your portraits, did you work with photographs or did you work from life?

CR: I always tried to work from life because it resulted in more expressive paintings, but there were times when the person was no longer living or I could only set up one sitting with the person. Then I would go in and take a lot of photographs. I did a whole series of military people that were having armories named after them. Ross Perot, a multimillionaire who made a fortune in electronics, lives in Dallas. He went to Annapolis, and his roommate, Bill Lefkowitz, was killed in the Vietnam War. He was in the marines, and Ross Perot's secretary-agent asked me to do a portrait of him. One for the widow and one for the academy at Annapolis. So I did those two, and then I quit painting portraits. Then, in 1980, when I was building my studio, someone who represented Perot, Admiral William Bell, called and said they were going to name a ship after Lefkowitz and would I please do another painting of him. I said no because I was no longer painting portraits and I had a drawing show coming up. My studio was being built—I didn't have a studio at that point—and it was very hard to paint. Anyway, about three or four days passed, and Lefkowitz's widow called and said Ross Perot had called her. Be-

cause they only had a very short time—they only had about two months before the ship was going to be christened—they asked if I would please do the portrait because I had done two and they knew I could do it. By then the studio had gotten bigger and bigger, and the expenses had just about doubled. She said, "He will pay you anything to do it," and so I said let me think about it. I went back to the drawing board and realized that this was one way to get myself all the things I needed—the lighting and everything I really wanted in a studio. So I agreed to do it.

LM: I think it's wonderful that you were able to do something that was artistically respectable—portraits of people—and at the same time to get the freedom to paint the way you wanted to. I think it's wonderful that you were able to earn a living as an artist.

CR: The thing that pleased me was the year that I made as much money as Robby made, but I was killing myself. I was painting portraits three days a week, and I was teaching three days a week. On the days I didn't paint portraits I taught.

LM: When were you teaching?

CR: I taught for seventeen years. I started teaching when we came back from Spain. We came back and we moved into this house in Virginia Beach, and I was so desperate because I was feeling overwhelmed with being domestic. You know, every two years having to pull up stakes and move . . .

LM: How many kids did you have?

CR: Three, and by then they were in junior high school. I read in the paper that there was going to be an art show, and everybody could submit a painting. We'd only been in that house about a week and there were crates everywhere, and I thought, I can't stand this any longer. I took a couple of paintings that I had done in Spain and entered them in this show, and I won a prize and my picture was in the paper. People started calling me saying, "Would you teach a class?" I had taught a class in Lake Charles, so I thought, Yeah, sure. I had a contractor come and convert the garage into a studio, and I started teaching.

LM: So people came to your house?

CR: They came to my studio. And I started teaching at the local community college. I started teaching painting, and it just grew and grew, and then two years later we moved to Washington.

LM: You know what? We skipped over a lot of space. Did we finish Spain? You were there for four years in Madrid, and you were painting.

CR: I had an introduction to a woman in Spain. She was married to an air force sergeant, and she was bilingual. She had lived in Lake Charles, and a friend said, "You've got to look up Becky Slaughter because she's bilingual. She can help you." Once a week Becky and I would go to art shows in Madrid and to the museums and to the galleries, and she acted as my interpreter. I can only speak Spanish in the first person, present tense. If the work was really interesting she would call the artist and ask if we could come to the studio, and we got into studios of some of the best artists in Spain. They were sort of intrigued with the idea that Americans wanted to see their work, and they obviously always thought that we were going to buy. Then, through another introduction, I met the French cultural attaché, Nad Besencenot, and she had sort of a salon. She was an artist—she painted—and once a week on the weekend she had an open house. Through her I met all the really important artists in Madrid, and a lot of poets, and I also met Carlos Arian, who was the director of visual arts. It was a dictatorship in those days, with Franco. Everything was very structured, and Carlos was really a czar—he was an art czar. He adored Nad, who was very pretty and very French, so somewhere along the line he said to me, "Would you like to show?"

LM: Had you ever had a one-woman show before?

CR: Yes, in Lake Charles. The Madrid gallery was a big government gallery. It was a beautiful space, and I knew eight or nine months ahead that I was going to have the show. It turned out well. Before the show I had a chance to go away to Ibiza, which is an island with a wonderful art colony. A friend went with me—Doris Kellett—and we rented a space, a wonderful space in an old building. Ibiza was started by the Corinthians, and when the Romans were there they built a wall around this old city. Our studio was in an inn inside the old city. Ibiza had a museum and a group of very avant-garde artists. And a lot of artists who lived in Barcelona and Madrid had studios in Ibiza. Through Carlos Arian, the czar of Madrid, we had introductions to many of the artists.

 Ibiza is like a Greek island, and the main attraction is really the museum. The finest Corinthian museum in the world is on Ibiza, and that was right up the hill from us. The contemporary museum was in the basement and the first floor of the inn that we lived in, so you know it was really a good place for us to rub elbows with a lot of artists. One of the artists loaned us his studio, and he had a view that was just unbelievable. He had built the studio in a deconsecrated church way up on the very top

of the mountain, and you could look out and see the sea. I painted there for about a month and that was a wonderful experience.

LM: You painted the water?

CR: Yes.

LM: Did you do landscapes before or did you just start doing that in Spain?

CR: I'm trying to remember when I first started doing landscapes. I really don't remember. I just remember that in Spain I really began to focus on them.

LM: You had enough work for a one-woman show by the end of that summer?

CR: I did. While that show was hanging in the Madrid gallery, Mario de Olivera, who was the counterpart of Carlos, in Portugal, saw the show and he called me to ask if I would be interested in having a show in Lisbon. I was charmed by the idea. I used some of the work that was in the Madrid show and supplemented it with other work.

LM: Was it a commercial show? Could you sell this work?

CR: Yes. In fact, the Madrid gallery, even though it was owned by the government, was handled pretty much the same as any commercial gallery. I sold three or four pieces, nothing major.

LM: Did you get reviews too?

CR: I got fantastic reviews in Madrid, all of which I have in my archives, and in Portugal, because Mario had sponsored me, the critics felt compelled to review my work even in one of their magazines which only comes out once every two months. I had a great review. It was probably because Juan Carlos, the father of the current king of Spain, who lived in Estoril outside of Lisbon, came to the opening along with his wife. Mario had invited them, and they came, and all these pictures were taken of me with Juan Carlos. That was the first time in my life I had ever met royalty.

LM: So there you are having your first sort of big success, although you had had one other show in Lake Charles and it had gone well?

CR: Yes. I had painted a portrait of Anna Chennault, the Chinese woman who married Claire Chennault, the American general who started the Flying Tigers and who went to China and helped Chiang Kai-shek defeat the Communists. The base that Robby was commanding at that time, in Lake Charles, had its name changed from Lake Charles Air Force Base to Chennault Air Force Base. When Chennault died I was asked to do a portrait of him for the officers' club, and his wife came for the opening of the base and asked me to do a portrait of her also. A year later, when I finished the portraits, this wonderful lady who owned the local hotel where everybody hung out, and whose portrait I had done, asked if I would like to have a show in her hotel. In one area I showed all the portraits of people from Lake Charles, and in another area I showed, as I always called it, my own work. Lake Charles is a little town so this was real big news. At the opening they had the unveiling of Anna Chennault's portrait, and Anna came down from Washington for the opening. That was my first "real official show," so a lot of it was just luck.

LM: No, I don't think so, Charlotte. I think that even in Lake Charles there are people who recognize talent. Obviously your talent was recognized at every stage, whenever you did something serious. So there it is—don't put yourself down. After the Lisbon show you went back to Spain? Did you have any more shows?

CR: Yes. I had a show in a private gallery in Paris. My sister, who is an art historian, was living in Paris, which was handy, so she researched the galleries to find one that she thought would be a good gallery with a good reputation. Then, bless her heart, she took my slides and résumé and a couple of pieces of work I had given her, and the owner liked the work. This was just a very few months after the show in Lisbon. What a nightmare that whole thing was, trying to get the work into France, because the French had this real crazy thing about carrying art works across the border. They would confiscate fine art coming in or out of France. You had to have all of this documentation, and the fact that it was my own work didn't matter. I had just done a portrait of General McConnell's wife. He was Robby's boss, and he was also head of the Sixteenth Air Force, so he flew a lot of my work in in air force planes.

LM: That way he avoided customs?

CR: Yes, he just landed at the base, and my brother-in-law could pick it up at the base. I still had a lot of work that I had to bring. I had this old station wagon, and I had a great big wooden box made.

LM: How big were you painting in those days?

CR: Some of those paintings were really big: four feet tall and about three and a half feet wide. That's big to put on the top of a car. And I had three crates because I had to be able to manage them. Then I had some inside the car, and I drove the stuff from Madrid to Paris. It's a two-day drive. I got to Paris, and my brakes were not working very well. My brother-in-law took the car to his local mechanic, and the next day I picked up the car very early in the morning. I had to take the stuff to the gallery. The show was opening that night, and I picked up the car, loaded all the paintings on top, and as we were driving, about two o'clock in the afternoon, the brakes froze, right on the Place de la Concorde. I barely got the car over to the side.

LM: And you still hadn't hung the show?

CR: No. All the stuff was on top of the car. The only thing to do was to get a cab, and so I got out into the street and I hailed a cab and tried to tell him what had happened. We got the crates down, loaded them into two cabs, and I got in one cab and left. I just waved goodbye and let my brother-in-law stay there with the car. He had to get it towed. I got to the gallery about four o'clock. They hung the show, and it opened at six. They were furious that I would show up so late. That show got a re-view — got two reviews: one in *Figaro* and the other was in an art jour-nal which was a respectable journal.

LM: But that's wonderful, Charlotte. So you were just about thirty at this point?

CR: No, I was thirty-five or thirty-six. This was about 1963 or 1964.

LM: Were you aware at this point that there was any disadvantage to be-ing a woman or any discrimination against women in the art world?

CR: I didn't really perceive it. Subconsciously I knew that something was wrong, that very few women were having shows. I didn't really think about it, I guess. In fact, I was so busy trying to take care of a house and three children, and we had to entertain an awful lot because at that time Robby was inspector general for the Sixteenth Air Force. That in-cludes Africa, and he had to travel much of the time. When he was home we had to entertain a lot, and we had visitors from all over.

LM: Which is interesting, but at the same time it's distracting.

CR: It's very distracting. I felt almost schizophrenic because I was lead-ing two lives. In one sense I had to have real gorgeous clothes to wear to

all these events, and in the other sense I was looking like an artist and wearing old clothes—work clothes—and I had a real hard time with my identity. I don't think that any of my air force friends understood what I was doing, except my good friend Becky who went with me to Portugal and acted as my interpreter.

LM: So you were having success at the same time you were being torn in different directions, and you seem to have been having success on all fronts. In other words, you were achieving what you needed to achieve as an officer's wife, and a mom, and still making a dent as an artist— which is amazing.

CR: It was a juggling act. When we were living in Spain our oldest son, who has always been the overachiever—a member of the National Honor Society, and into everything—was taking a bus trip with the basketball team. A bunch of the boys started throwing things out of the window. The coach was sitting on the front seat and he didn't even notice, but one of the boys reported that they were throwing things at Spanish cars and Spanish buses. We had to be so careful as guests of Spain not to do anything illegal or bad. So they decided to make examples of these kids, and Robin was one of them. He was thrown out of the National Honor Society, and he lost his letter in diving; his life was just destroyed. When I came back from Paris that was the situation, and I had to go and see the principal. So you're still trying to do all the things that mothers do.

LM: Let me ask you something about when the children were small and you had studios in your house. A lot of women artists do that: have studios in their homes. Was that good or not so good to have the studio in the house?

CR: I think it was very good because they knew where I was all the time.

LM: You could combine roles if you needed to.

CR: Yes. In Madrid, when they told Robby that he had to live within five minutes of the runway, we had to give up that big house and we ended up in tiny, little quarters on the base. I had just finished painting Marie Wade, whose husband is General Wade, one of Robby's bosses, and I told him this was devastating to me, losing my studio. So he gave me a room in the bachelor officers' quarters to use as a studio. That's the first time I had a studio outside of my home, and it was wonderful. I could leave in the morning—we had a cook and a cleaning woman, and I could tell them what to do—and then I didn't have to be there in the afternoon when the children got home from school. I could come home at six or seven at

night, and I really got a tremendous amount done because I didn't have those interruptions. But in the States, without help, this wasn't possible.

LM: When you're at home you can say, "I'm working." You can tell children that, and yet, being children, they want to come in and be with you.

CR: Oh, they knew that Mom was working. They got so they really respected that. I would close the door. I always took care of emergencies, however. When they were little, of course, it was different.

LM: Do you think that it makes a difference that you're a woman, or do you think that even a man would go through the same stuff?

CR: It would be the same thing because when children are little they have needs that are very immediate. I think because my children grew up with it all their lives that they respected it. In Savannah we lived close enough so that they could walk home from school. But one time it was raining, and a neighbor had picked them up when they were walking home. She said, "Where's your mother?" And Robin said, "Well, you know she's painting, and when she's painting she forgets all about us." My neighbor told me that—and that's a guilt trip. It was horrible because I think I was the only officer's wife that was working. When we lived in Madrid, Nad, my French friend, told me that in France no officer's wife would ever have a show in a commercial gallery and sell her work. It was not done.

LM: Were there traditions in the American military as well where an officer's wife had to be available for the duties of the base and not be working in a separate career?

CR: Oh, yes. Robby was in S.A.C.—the Strategic Air Command—and there were tremendous—I wouldn't say burdens—but there were tremendous responsibilities for the women. When a man came up for promotion for a specific job, especially for wing commander or base commander, where he was responsible for a lot of people, his wife was very much a part of the equation. The supporting wife was definitely an asset.

LM: It's like being a minister's wife.

CR: It is. And it's not only being responsible to the other officers' wives, but it was being responsible to the noncommissioned officers' wives. I had to go to their activities too. The thing was, in S.A.C. the men would be gone for nine or ten months at a time, and the women were on their own. We were in a foreign country, and a lot of those women—especially the

NCOs' wives—were not educated, and the husbands didn't tell their wives anything. They knew how to get to the commissary to get food, but that's about all they knew.

LM: This was not during a war though?

CR: This was during the Cuban crisis, and a lot of things were going on. And people forget that the air force loses planes and loses people whether there is a war going on or not. We were losing people all the time because they were flying very dangerous missions, and they were refueling in the air. The women whose husbands were in commanding positions were required to be supportive of all the women.

LM: So it really was a career; it wasn't just being married to someone?

CR: You're right, and I finally quit. Robby got out of the air force after we had been in Washington about two years. I continued being hostess for parties for about a year, and then I said, "I can't do this any longer. I've done it for twenty-two years, and now I've just got to do my own work." He was wonderful—very understanding.

LM: Was he beginning to understand that you were an artist and recognize that?

CR: Yes, he was.

LM: He couldn't ignore your success in the shows?

CR: Oh, he could ignore it. He wouldn't even come to my openings. I think that by then I was so brainwashed that it didn't even dawn on me to be angry. I just accepted it.

LM: No, it seems to me that what you must have done is said, That's his life and that is that.

CR: Yes, it was very separate.

LM: Sometimes that's not such a bad thing.

CM: No, it's not. When I went to openings I didn't have to make sure that he was having a good time. You know how you always feel worried that if nobody's talking to your husband you have to go and talk to him. So in a way it was okay. But at some point, and I can't even identify the date, he just gradually became more and more understanding, more and

more involved. Now he is my total support system, he does everything. He brings me and my work to New York, and he works steadily all the time he is here.

LM: Does he go to your openings now?

CR: Yes, he's wonderfully supportive about everything now. It took a long time, but he has discovered he has great talent as a carpenter, so he is very proud of those things he can build.

LM: Can I ask you something? When did you get involved with the women's movement? I know you've been very involved with the Women's Caucus for Art. When did you get interested in the feminist ideas floating around?

CR: In 1973, when the first national conference for women in the arts was held at the Corcoran. A friend said they needed housing for people who were coming, and would I put up four or five people, and I agreed. Dorothy Gillespie was one of those who stayed at my house, and I was just astonished listening to everybody. Mimi [Schapiro] was a speaker, and Alice Neel, and Judy Chicago. Just listening to them talk opened up a whole new world to me, and I realized what I had been missing. I also realized that a lot of those women had children and they had two careers, so it gave me permission—I gave myself permission—to really be serious about my work.

LM: But you had been serious before?

CR: Serious, but I hadn't really called myself a professional; I hadn't really made any demands on the family or on Robby or anything. That was when I decided I wasn't going to be doing any of the big parties and stuff and that I wouldn't go with him to all those West Point reunions and all those other things. That was in 1973, and then in 1976 I went to Houston when they had that big international conference for women. In 1975 we began laying the groundwork for the quilt show, as a way of celebrating the International Woman's Year, and I got very involved not only with Dorothy Gillespie but with Alice Baber and a lot of other people. Then in 1978 I came to New York for the conference, the C.A.A. [College Art Association] and the caucus, when Judy Brodsky was president. She asked me if I would coordinate all of the events for the 1979 meeting in Washington. That's when the caucus was trying very hard to have a high profile vis-à-vis the College Art Association. We (when I say "we"—the people in Washington) wanted very much to figure out a way to upstage the C.A.A., and that's when we decided to have the honors for women.

LM: When did you do the hands of the artists? You did the hands of women artists?

CR: I started that real early on. I did a whole group of women, but they weren't very good. But when I stopped painting for about a year, in 1980, while they were building my studio, that was when I really focused on those hand drawings, and I was working on them seven or eight hours a day. I always enjoyed doing hands when I was doing portraits. I didn't want to do portraits of these women, only their hands. Since I lived in the Virginia suburbs, I think I was also subconsciously reaching out for community. It was a way of getting to know these women, of getting into their studios to see how they arranged everything, how they worked—that was very educational. You know, I did Jennifer Bartlett; I did May Stevens; of course, Mimi and Joyce [Kozloff]; and all kinds of people. I did them all over the country, actually. I did a whole group in Houston because I had a show there. I went there a year ahead of time and started drawing and photographing. I did some men too. That was in about 1974, and then I went back later and had the show. I did twenty-two Houston people, and a group in San Antonio, which is my home, and then—

LM: You only did artists at that point?

CR: All artists. With the hands, I always did them involved with their own work. When I did Alice Neel, I showed her doing a portrait of Olivier, and Joyce Kozloff was setting the tiles in her big tile pieces. When I really got serious about doing that I started doing taped interviews with them.

LM: What did you do with them?

CR: I really meant to do a book on them, and then I got all caught up in the quilt show.

LM: Tell me a little bit about the quilts.

CR: I had a friend who worked for Annemarie Pope, the one who started SITES.

LM: With the Smithsonian?

CR: Yes, and she started her own organization to travel shows, called Spectrum. She asked me if I would put together a show of women artists to travel. I was in New York and talking to Dorothy Gillespie and Alice Baber, and I asked what we could do to give her some kind of women's show. We

started talking about women honoring their foremothers. All three of us had had grandmothers or somebody who had made quilts, and we thought that that would be a good idea. Each of us invited two other women to see what they thought about it, and they all thought it was a great idea. At first we thought we ought to make our own quilts, but that didn't work out. None of us had ever made a quilt, and so I found two quilters, and one of them made my quilt, and I brought that to New York to show to all these—

LM: When you said "made my quilt" what do you mean?

CR: Made a quilt from one of my designs.

LM: Okay, so you were getting women artists to make designs and quilters to—

CR: Translate those designs. We came to New York, in Dorothy Gillespie's studio. I showed my quilt, and presented this to the women who were there—there were about nine women who were there—Alice Neel, Mimi Schapiro, Mary Beth Edelson, Joyce Kozloff, Alice Baber, and Dorothy Gillespie. And they saw my painting and then my quilt. They could see that this was a very hard translation because it was not a hard-edge painting, which is the way you usually think of a quilt. It was a painting of the Nile River and it has a very sensuous form. Anyway, it took ten years to do that show. It started in 1975, and it was 1983 when it opened. It closed three years later in 1986.

LM: And it traveled all over the country?

CR: Yes, twenty-two museums, and the book was a big success too. There were ten thousand copies sold in the States. It was also published in West Germany where it sold about three thousand copies. We got letters from all over the world, from artists and quilters.

LM: And you went to a lot of the openings.

CR: Oh, yes. That, I think, was more work than anything I did, except maybe the '79 awards ceremony, which was really a lot of work trying to get the president to give the awards to the women.

LM: To get President Carter to—

CR: Agree.

LM: Was that at the women's caucus?

CR: Yes. We went to his office at the White House.

LM: During the women's caucus?

CR: During the C.A.A. conference. We kept it a secret that that was going to happen. The C.A.A. people didn't know, we didn't know for sure until about three days ahead of time, because he was meeting the Chinese that very same day, for the first time in history. We kept it a secret that we were going to have this presentation ceremony at the White House, and the C.A.A. was having a reception at the vice president's house, and Mrs. Mondale was greeting them. At the same time we were at the White House with the president.

LM: How did you get the president to agree?

CR: It was such a funny story. A couple of years before that, in about 1976, Dorothy Gillespie and some other women in New York had put together a ceremony that was held at the Ford Foundation. They asked women from all over the country to send slides. When the slides were shown they had Alice Neel and four or five older women artists sitting on the stage, but none of the slides were identified. They were just flashing on and on, and then each of these women got up and said a few words. I thought, Gee, that's awfully disrespectful to not feature their work or even to identify their work. So in 1978, which is when I took that job of being program chair, I had a wonderful person—Joan Mister—who was on my committee and who was always full of ideas, and we discussed what we would do to really get attention for the caucus.

LM: You wanted press coverage?

CR: We did. Joan had been Joan Mondale's neighbor in Cleveland Park and knew her and said, "Why don't we get Joan Mondale to do something for us?" And I said, "Okay, let's get her to give awards to these older women artists, and then let's have a show of their work." So we posed the idea to Joan Mondale, and she said it would be much more important if we could get the president's wife to do it. After months of trying to get through to Rosalynn Carter, we finally did, and bless her heart, she said, "If I do it, it will be on the women's page. If Jimmy does it, it'll be on the front page."

LM: So it was Mrs. Carter who suggested and helped you get to the president?

CR: She did, and they told us from the very beginning that there was no way they could let us know ahead of time because his schedule was so

involved. We wanted publicity. We wanted to have a news release. We wanted to have it in the *Women's Caucus for Art Newsletter,* but we couldn't release it. We wanted Louise Nevelson to come, and she was the only one who was dragging her feet. The others were willing to come to let a lesser person give the awards.

LM: But she'd only come for the president?

CR: Yes. She came for the president. And of course we wanted Georgia O'Keeffe to come, but she was too incapacitated; she couldn't come, but she did send a telegram.

LM: Now, who were the people you honored?

CR: Neel, O'Keeffe, Nevelson, Isabel Bishop, and Selma Burke. She's a black woman, a sculptor, and among other things she did the design for the Roosevelt dime. Otherwise her sculpture is pretty much devoted to black images.

I think it was Judy Brodsky who said, "Research it thoroughly, and find out if any woman in visual arts has ever been honored by any president, because we don't want to publicize it unless it's really a first." So a curator at the Hirschhorn volunteered to do the job, and she called everybody she could think of, and she went to libraries—really researched it. And it turned out that there were women in the performing arts, but not in visual arts, who had been honored at the White House by the president. So it was really a first time, and I think that was what caught President Carter's attention. At the ceremony he said, "Today is the day for many firsts. It's the first time an American president has welcomed the Chinese from the Republic of China to the White House, and it's also the first time a president has honored women in the visual arts." It was a very historic moment.

LM: Do you continue your involvement with the women's movement? The artist's movement in Washington?

CR: Not too much. I had a seminar group at the Women's Center—the Art World Class we called it—that helped me with the awards ceremony. One of the students took on the job of documenting the year when the president honored the women for the caucus. They put together two wonderful notebooks of everything we did. The week of the caucus we had women's shows all over Washington and all over the suburbs too, and every one of them was documented with some kind of catalogue. We had incredible press—it was even reported in the *Paris Herald Tribune.* So these notebooks are just priceless, and eventually I'm going to give them to the Archives or to the Women's Museum. I turned over those note-

books to the president of the caucus so she could use them. One is a working notebook; it has all the proposals I wrote trying to raise money. It has the structure, the committee—I had somebody on it from every university, from every museum, from a lot of the art galleries . . .

LM: What do you think has happened, Charlotte? A lot of people have sort of pulled back—gotten tired, if you will—from the women's movement in art, and, in fact, it seems to have lost a lot of that energy, and I'm wondering why. Do you have any ideas? Is it that we ourselves—the people who were pushing it in the seventies and eighties—are tired?

CR: I think that's one of the reasons.

LM: And the younger women coming up feel they don't need it?

CR: You're exactly right. We did the conference in 1979, and then two years later, when the caucus was split because most of us didn't want to go to New Orleans, we had to have a conference again in Washington, and we were just burned out. That yearlong effort was almost a full-time job for me and for several people on my committee. It takes all your studio time. Perhaps the younger women think the battle has been won and there's no need to give up precious studio time.

LM: Is there anything I haven't asked that you'd like to add?

CR: I can't think of anything. I guess the last couple of years have been my best years as far as my own art work is concerned, my commitment to work.

LM: Do you have a gallery in New York?

CR: I'm working on it. I am having a show at Fordham on the Lincoln Center Campus next year [1993], and I am going to be in a group show in Soho, plus a large show at the San Antonio Art Institute. And of course I'm having a show again in my Washington gallery in November.

LM: What's your Washington gallery?

CR: De Andino Fine Arts. It's a very good gallery.

LM: Well, have we come to an end?

CR: I think so.

Plate 13. Ce Roser with *Arch Quartet*. Photo by Hal Roser.

Ce Roser

Education:

1951–52 Hochschule für bildende Kunste, Berlin, Germany

Selected Solo Exhibitions

1987 Benton Gallery, Southampton, New York
1986 Ingber Gallery, New York, New York
1985 Elaine Benson Gallery, Bridgehampton, New York
1976–77 Women Artists Series, Douglass College, New Brunswick, New Jersey
1967 Ruth White Gallery, New York, New York
1965 Kornblee Gallery, New York, New York

Selected Group Exhibitions

1992 Edwin Uhlrich Museum, University of Wichita, Wichita, Kansas

1987	"New Spaces/New Faces," Guild Hall of East Hampton, East Hampton, New York (catalogue)
1986	"American Abstract Artists," Bronx Museum, Bronx, New York (catalogue)
1982	"New Acquisitions," Guggenheim Museum, New York, New York
1977	"Art and Poetry," Tweed Museum of Art, Duluth, Minnesota
1975	"Works on Paper/Women Artists," Brooklyn Museum, Brooklyn, New York (catalogue)

Selected Bibliography

Braff, Phyllis. "Full-Fledged Talent in Five Solo Flights." *New York Times,* 21 June 1987.

Russell, John. "Ce Roser." *New York Times,* 20 June 1986.

Russell, John. "Ce Roser." *New York Times,* 30 October 1981.

Marter, Joan. "Ce Roser." *Arts Magazine* 54, no. 6 (February 1980): 2.

Dunlop, Lane. "Ce Roser." *Arts Magazine* 52, no. 1 (September 1977): 15.

Daniell, Rosemary. "Elegant Explosions East and West Mingle in Roser Art." *Atlanta Constitution,* 5 July 1967.

Interview

Ce Roser was interviewed by Joan Arbeiter in 1988 and 1989

JA: Let's talk about your beginnings. Do you want to tell us how you see yourself having arrived as an artist? Where do you think it comes from? Do you want to go back as far as your memory takes you?

CR: My first memory is an aesthetic memory. I remember as a baby crawling on an oriental rug, and there was a transom with stained glass, and I was trying to catch the light from the stained glass on the carpet. My mother, a teacher of English, did a great deal of needlework—knitting, crocheting, and even lace making—and she also made quilts, and there were always these marvelous yarns and threads and little pieces of material around. In order to keep us quiet, because there are six in our family, she would seat us at a table with crayons and watercolors while she was doing something else. I have painted from the time I was a small child, but we were meant to be intellectuals and not work with our hands, so it was not until I was an adult that I actually took up painting seriously. I began to paint with a friend's oil set, and it was so good I took it to be framed, and someone wanted to buy it. So the commercial aspect entered, and, of course, I couldn't possibly sell it, it was absolutely priceless, and I decided that I would study art when I got the chance.

JA: How old were you?

CR: I was already married when I decided that I would like to go to art school, but I was living in Manila, the Philippines, with my husband, who was in the American foreign service, and there was no appropriate art school. Very soon after, we were transferred to Berlin, and I took the exams for the Berlin Art Academy and began to seriously study art. I was at the Berlin Art Academy for about two years, and my first teacher was Hans Uhlmann, a famous abstract sculptor who did a huge commission for the Music Academy in Berlin. His method was to have us abstract from the real and then also do an abstraction and make something real from it. We also had the usual life drawing, portrait, still lifes, and all sorts of academic subjects.

JA: So your training—your official training—began in earnest all at once, and up until that point you were very observant and sensitive to your surroundings but did not consider yourself an artist.

CR: No. I didn't consider it. I wanted to be a writer.

JA: Is that so? Please, continue with the Berlin experience.

CR: The Berlin experience was very important because we worked very hard. There was no heat; we had to wear several layers of clothing. Many of the students didn't have anything to eat—this was in the 1950s. There was a soup kitchen for all the students. They stood in line to get soup, and sometimes they even took a pot with them and ran home and gave some soup to their brothers and sisters. We worked from eight in the morning until five at night every single day. And that was wonderful discipline for me because I took my art seriously, and I realized that at last I had something to which I could devote my life.

JA: Did you show any of the works that came from that experience?

CR: No. I never showed that work. Then we transferred back to New York, and I studied with the painter Cornelis Ruhtenberg. After that I began to paint on my own. At first I was painting in the old masters' technique of egg tempera. I was doing very realistic work of copper pots and portraits, and then I began to discover my own style. At that time I had many artist friends. I was living on Riverside Drive, and there was the Riverside Museum nearby. I had a friend named Charmion Von Wiegand, who was an American abstract artist, and she was in the museum shows of the American Abstract Artists and the Federation of the American Modern Painters and Sculptors, I believe. When they had a show

she would come to my place for tea, and she would bring friends like Burgoyne Diller, Rose Fried, Kay Hillman, and also Alice Trumbill Mason. This was in 1959–1960. Charmion said, "You cannot paint just for yourself," because I would have all the things drying on the bookcases, on the chairs, and whatnot, and she introduced me to a woman dealer named Ruth White who had a gallery on Fifty-seventh Street, and Ruth White decided to give me a show.

JA: She pushed you to becoming—

CR: To becoming a professional. My son was very young, and I was painting at home, working on what I thought of as my "devotions," but I didn't think I was ready to show yet. At that time I was painting in oil on canvas and also painting in tempera on Masonite.

JA: When did this first show take place? How do you feel about it now?

CR: It took place in 1961, and Jill Johnson said that I was "a pearl in the rough." The style was very abstract expressionist. The fireworks on the Hudson used to take place right outside my window, and every year I would watch them, and my paintings had aspects of the fireworks. In fact, one friend, Lil Picard, called them explosions in a flower garden.

JA: Yes, I can see the energy that is in both the blooming and the lifting quality of the fireworks in these paintings.

CR: My second show at Ruth White's took place in 1964, and I called that "Visionary Gardens."

JA: How would you describe the difference between the first show and second show? Were you conscious of a growth?

CR: Oh, yes. Very much so. These works were really larger, because I knew after my first show that painting would be my life's work. I was very excited. I got reviews in the *Herald Tribune* and in art magazines, and it was quite wonderful for me. Also, I sold a number of things, and it gave me great confidence to have that show.

JA: All this time you were working on your own?

CR: Yes. I was working on my own. I never studied again after that except on my own. I'm basically like most artists—an autodidact.

Plate 14. *Arch Quartet,* 1987. Oil on linen, 42″ × 60″.

JA: Between shows, did you call up friends to discuss your work, or did you wrestle with all these things alone?

CR: No. I did it mainly by myself.

JA: Did Charmion come in and help?

CR: Oh, yes! Charmion was wonderful! Later on, when I had a watercolor show, I put all the work on the floor for her to see, and she told me which ones she liked and which ones she didn't think were quite there. But then she asked me a very crucial question: "Don't you ever go back and edit your work?" I said, "No, never." And then after that, of course, I did. I continued to show at the Ruth White Gallery until she retired in 1967. In 1965, I had a show at a major gallery because I got involved with civil rights at that time.

JA: How did that come about?

CR: I had a poet friend named Sandra Hochman, and we were so disturbed about what happened in Mississippi when those three young men were murdered because they went down to help with voter registration.

JA: Chaney, Goodman, and Schwerner?

CR: Yes. We decided we would do a benefit together, to raise money—artists for civil rights. Using her poetry and my painting we did a show of twenty-nine collages. First we went to Leo Castelli's gallery, and Ivan Karp, who now runs O. K. Harris, called up Kornblee Gallery after he saw our work, and we immediately got a commitment for our own show.

JA: What made you think of doing politically motivated art?

CR: I'm sure that protest art has always been around, but we felt so bad about what had happened. We were so committed to freedom and the idea of liberty. The fact that people were being killed was just horrendous. It was anger transferred into emotion which needed to be released. We worked on that together out here in East Hampton and then we worked for another half year on it.

JA: Interesting.

CR: At the same time, Sandra and I thought, Well, we've been collaborating and it's working out. And so we decided we would take a trip to Asia together and visit artists and poets. To send ourselves off, we had the show at Kornblee, and we had dancing and it was an exuberant celebration as well as a fund-raiser. And this was one of the first art benefits for civil rights that ever took place as far as I know. We wanted the series to become a book, but no publisher wanted to do it—at least not the ones we approached—so the works were dispersed. Several were sold. I had a few, I still do, and Sandra had a few. But we did go to Asia together, to Japan, to Hong Kong, to Bangkok, Thailand, and to India, also to Nepal, and Kashmir. All along the way we had introductions. For instance, in Tokyo from Isamu Noguchi, in Kyoto from Gregory and Maria Henderson. We met painters and poets, filmmakers, tea ceremony masters. When we were in India we even met Octavio Paz who, at that time, was ambassador to India from Mexico.

I brought my slides along, and I got shows in Kowloon and Hong Kong. By that time my husband had been transferred to Atlanta, where we lived for two years, and I did the works on paper, shipped them over by air, and they framed the work. After the exhibition, they unframed them and shipped them back. It was one of the least expensive shows I've ever had.

JA: How did that trip change things for you?

CR: I think it enriched my life, and it made me realize that on my own I could be quite effective, and that was very important to me. It resulted,

actually, in several shows, because I had the shows in Hong Kong and Kowloon, and I had a show in New York City at Ruth White's gallery and at the same time at the Kornblee Gallery. I also showed some of this work in Atlanta.

JA: Where was that?

CR: At the High Museum, Illien Gallery, and then I had a large exhibition at the Unitarian Gallery, which had just been built. That included my protest work and everything else—works on paper, oil paintings, and collage. All this took place from 1965 to 1967.

JA: Seeing all your work up on the wall, including your protest work, what did that do for you? Was that a significant moment? That was the largest show you had ever had up until that day.

CR: Yes, it was. And it was reviewed in the *Atlanta Constitution*. I felt inadequate, actually. I thought it looked good, but I wanted to go on from there. In other words, a dissatisfaction with things that were old work. I was already painting something new. Then I moved back to New York City. All this time I had kept my studio in New York City. Working in Atlanta was different. I missed the pressure, the stimulation. Compared to New York, it was a small town, and the artists didn't work as hard as artists that I knew in New York City. They weren't at it all the time, you know what I mean? In New York City, you call someone up if you're free for some reason and you want to see somebody or have lunch, and there isn't anybody available—everybody's working. But that wasn't true in Atlanta. I got to know a lot of the Atlanta artists and writers, and I enjoyed that very much. But it didn't have the same air of urgency that New York had. So when I moved back then, almost two years later, I became very involved with the women artists movement.

JA: How did that come about?

CR: That came about because we were dissatisfied, my artist friends and I. We realized, for instance, that a lot of older artists could never get shows. The word out then was that if you were an older artist your art was menopausal, therefore not serious, therefore they would never show you, and there were too many people like that. A lot of my older women artist friends could not get shows, did not have documentation, did not have slides, and we could see that down the road this was obviously what was going to happen to us too. You know, we'd be serious artists and then pretty soon put on the shelf and taken out of the competition. So a number of us were talking about it, and I decided that I

should invite some of the women artists to my studio, and we could discuss it further.

JA: Who came?

CR: A fantastic group of artists and writers! Alice Neel, who lived just around the corner, Elaine de Kooning, Rose Slivka, Sandra Hochman, Barbara Guest, Joyce Weinstein, Fay Lansner. There's a whole list which I'll give you.[1] We started talking about why women artists weren't as important as men artists, and Elaine de Kooning said things like, "When money comes into it, then there is no more equality." Alice Neel said, "Well, you know, nobody is going to give up their privileges." We all got very excited and quite angry. We all decided that we were going to free ourselves, get divorces, and just work on our own work. Of course, this was not what happened. After a while we decided to organize a protest. We met first at my studio, then at Sandra Hochman's, and then we met at Elaine de Kooning's studio. There was no formal invitation, but each person told two other people, three other people, and pretty soon, when we were in Elaine's, there were about one hundred people! I remember the first meeting at my studio, when Olga Carlisle, who is a writer and poet, was there, and towards the end the famous playwright Arthur Miller was going to give her a ride home, and he buzzed my downstairs door and all the women said excitedly, "Don't let him in, don't let him in." That's how stirred up we had become. But this was a very exciting moment, and then we decided we would have a protest, and it grew and grew. We started meeting in other places as well, and it culminated in a 1972 demonstration in front of the Museum of Modern Art.

JA: I've read about that. But I didn't know that you had planted the seeds for it.

CR: Well, I was one of the founders of Women in the Arts and one of the organizers of the demonstration.

JA: Is that so? Women in the Arts took credit for this action?

[1]Joyce Weinstein, Elaine de Kooning, Fay Lansner, Linda Vivona, Cindy Nemser, Buffie Johnson, Sandra Hochman, Adrienne Scott, Nancy Menuche, Barbara Swartz, Rose Slivka, Alica Neel, Pat Passlof, Barbara Guest, Rosalyn Drexler, Olga Carlisle, Martha Edelheit, Cecile Abish—these are the eighteen women artists and writers who met in March of 1971 at Ce Roser's studio. They formed what later became known as Women in the Arts, with its headquarters at 435 Broome Street, in Soho. For a lively description of that fateful evening, see *Women in the Arts Newsletter* (February 1976).

CR: They did. They were the ones—and it resulted in our being offered the historic "Women Choose Women" exhibit at the New York Cultural Center, in January 1973.

JA: And they were active from when to when? Do you remember?

CR: Well, it's still an ongoing organization, but they were most active from 1970 to 1976, I'd say, and it's still an organization fighting discrimination against women. But it is no longer as political as it was then.

JA: So, you felt your strength as artists and as women, and that you could make a difference.

CR: Oh, yes. We hoped to make a difference. We hoped to get women into museums because we did a detailed study of how many women were in museums—only ten percent, even though eighty percent of art students were female. Lucy Lippard, at the same time, was working on this and so were various other women's groups. Most of us were involved with Women in the Arts and also at the same time in some of the other groups.

JA: The statistics are not much improved. The Women's Caucus for Art put out 1980–1986 statistics and had a march recently on the MOMA and the Guggenheim. I was there, and whether you measure solo shows or group shows, the statistics are still pretty skewed.

CR: I know. It's a continuous struggle. I don't think we can just stop and say, Now we've done this; now it's open. The door is partially open, but you have to continue to get in. You can't just let the door close on you again. And unless you keep struggling for your rights you're not going to get them. No one is handing it to you. It's a continual struggle. If you don't continue, you backslide to the old position. But we did call attention to the museum situation, and I think as a result of all of this a lot of older women artists were recognized. I remember once going to a discussion at the Art Students League, where Louise Nevelson was speaking, and she said, "We shouldn't give up anything. We should use everything that we have—I mean even our eye makeup—and use everything for our art and claim our rights." This was a crucial time. That demonstration opened up museums to women. We wrote a letter to the six major museums in New York—the Brooklyn, the Guggenheim, the Metropolitan, the Modern, the Whitney, and, at that time, the New York Cultural Center. We requested an all-women's show, and we negotiated with the various museum curators, and we got an offer almost immediately from the New York Cultural Center. They offered us a show, which we called "Women Choose Women." That

was the first show of women's work in a major museum. It got fantastic coverage in the press and media.

JA: That was a very historically significant show.

CR: Then the Brooklyn Museum promised us a show, which later became a show called "Women Artists' Works on Paper." The demonstration itself was really very special because we were all scared in a way. We didn't know what could happen, and we had to have permission from the police to close off the street in order to have the demonstration. We released helium balloons because we decided it would be a joyful demonstration, not grim like men's demonstrations, because we were women and artists. Surprisingly enough, the people who showed up were just incredible! For instance, I remember Lee Krasner showed up; Joan Mitchell, who was in town from Paris, showed up; Louise Bourgeois had taken a sheet and she had written NO on it. She had her husband, Robert Goldwater, holding the other end of the sheet with her. Of course, many, many of the artists in New York showed up.

JA: Sari Dienes marched in that demonstration also.

CR: We took over the whole street. My husband, at that particular time, was upstairs representing Exxon, negotiating funding for an exhibition with Dick Oldenberg, MOMA's director. He said to Dick, "My wife is downstairs." So we had both the upstairs and downstairs covered.

JA: Unbelievable! You mentioned earlier that you can't allow the door to close again. Nancy Azara told me that in mid-1988 the National Endowment for the Arts had a letter sent to the galleries and organizations stating that they refused to fund women's art organizations any longer. They refused to fund them because they said they were no longer relevant and that the mainstream has taken up that cause, which is not true, obviously. So, they're withdrawing support from those organizations. The A.I.R. Gallery is not getting funded, and the New York Feminist Art Institute is not getting funded. These were the N.E.A. committee's decisions, in writing: that women's art organizations are no longer relevant.

CR: Well, we have always feared co-option, and we were determined not to let that happen, but I guess time and events have overtaken us to some degree. I feel that a great deal of the support has been drawn away by the Women's Museum in Washington, which is right at the seat of power, saying they're doing everything that's necessary to be done for women artists. I now see the danger of it, although I understand the museum is becoming more sensitive to the contemporary scene.

JA: How was your own work affected by all of this? Do you remember?

CR: Looking back, I'd say that during this period the parameters of my art expanded as a result of being in contact with other artists and exchanging ideas. My eyes were opened to all the alternate spaces. I showed in many different places: Stamford Park Mall, the Women's Interart Center, Douglass College, the New School for Social Research, Fairleigh Dickinson University, Lehigh. And also a number of us did freestanding painted sculptures, called Walk-Through Triangles, that were shown outdoors: Central Park, Battery Park, Washington Square Park, Douglass College campus, and Stamford Plaza, Connecticut.

JA: Was Dorothy Gillespie in that with you?

CR: Dorothy Gillespie was in that. We had a small group, and we called ourselves the New York Professional Women Artists. And it was this small group that made Walk-Through Triangles. And we also had other shows.

JA: Please explain the triangles.

CR: These triangles were four-feet by seven-feet marine plywood panels hinged together to form a triangle and painted on both sides, and we polyurethaned them so that they were weatherproof even in hurricane weather. They were absolutely pristine. In the nighttime homeless men were sleeping in them, and in the day children would ride their bicycles through. People would sit inside for the shade and have their lunches. It was a very interesting experience because we had never realized that art could not only be shown in museums and galleries but also it could be shown almost anywhere if you could find a space.

I also designed murals for subways, tapestries, stained glass windows, and painted a screen. I produced a video documentary. It was a period of exuberance, reaching out to embrace new projects, new situations. It was a period when I participated in panel discussions and gave lectures. In the studio, I went from collages to painting watercolors on eighty-two-inch by forty-inch mulberry paper. However, when I was very involved with Women in the Arts, and I was their first executive coordinator, I really was not spending that much time on my own work. Then I heard Grace Glueck in a lecture talk about this problem, and I realized that it was exactly what was happening to me. All my energies were going into the feminist movement and not into my own work. I went back to my own work after that. I realized I'd spent a great deal of time, I'd done several things which indeed I was proud of, and I now had to get back to my inner world and my inner life, which to me is painting. So that's when I became less involved.

JA: Did you just pick up where you left off? Do you remember a shift?

CR: Well, I never completely stopped, because painting has always been so much a part of my life, but I just hadn't spent as much time in the studio. I felt the other things were more important. I did not try to get a show until afterwards. In 1976 I had a show at the Elaine Benson Gallery, in Bridgehampton, and then at Douglass College. I didn't even have a gallery, but in 1977 the Ingber Gallery gave me a solo show, and I've been there since. I started to show sometime in 1975 or 1976 in her group shows, and then Barbara Ingber asked me to have a one-person show there, and that's how it happened.

JA: Did you ever get the sense that you finally "arrived"?

CR: I've never had that sense, and I don't think I ever will. I think that there's a certain restlessness in art and in the artists themselves. That we're never going to be satisfied because we're always searching for our own image of perfection somewhere. Not our own image, but our own vision of what perfection might be, and that's never going to be reached. I mean, I think we share some sort of risk with gamblers. I think that art is a very risky business, because the chances of succeeding or winning are very slim, and I think that's what excites and stimulates, because basically we are taking a great risk, being artists.

JA: Do you mean by showing your private thoughts to the public that it's a risk or by exposing yourself to rejection?

CR: Yes, to both. But aside from that, not so much the exposure of the private self but the exposure of one's dearest expression, one's work. And of course, you're always exposed to rejection. Whereas if you'd just remain a homebody, your rejection is very private—not that you're not rejected no matter what you do.

JA: Now let us talk about the forty-three-minute, color video documentary that you produced, narrated, and edited. Tell us about that.

CR: It's about the circle of Charmion Von Wiegand, an older woman artist, who was one of the first American women abstract painters. She did not have much documentation. It was only after we had made her aware of it that she began to have more slides of her work done, and I had wanted to give a course with Fay Lansner on women artists, and hers was one of the artists' studios that we were going to visit. We were planning to document all of these artists and their studios. So, I decided that

I would get together a group of people who could work on it, and we would try to do something of quality. I got together with a wonderful video artist named Mark Brownstone, who could direct and understood music. We also got volunteers to help us, artists including Helen Miranda Wilson, and we hired a cameraman. Philip Glass allowed us to use his music. I decided we were going to do a broadcast-quality videotape that would be shown on Channel 13, even though it was the first videotape I'd ever made. It was essential that I learn something about making videos, and I took a three-day-weekend course, at the New School, on making video documentaries. Actually, it became a hands-on learning process. It took about a year from beginning to end, but at the end of this journey it really was shown on Channel 13![2]

JA: That must be a story by itself.

CR: That's an incredible story by itself because usually it doesn't happen that way with your first and only video. I knew Charmion very well. When we started to interview her I had already blocked out the story line, more or less, but still, we had four times as much material as actually appeared in the video. The editing took the most time. I learned how to edit with my eyes—it was like doing a painting or a composition. Video is an artist's medium, because you see it and you compose it. It was a wonderful experience.

JA: What was the response to this?

CR: Well, at that particular time, Barbara Crossett of the *New York Times* wanted to interview me and Charmion about the documentary, but the *New York Times* went on strike, and it was never reviewed. It was subsequently used by Vivien Raynor of the *New York Times,* who wrote a little piece about Charmion Von Wiegand when she had an exhibit, and Vivien Raynor went to Channel 13 and saw it. *Women Artists Newsletter* also wrote something about it.

JA: Did Charmion give you any feedback? Did anything happen in her life that wouldn't have happened otherwise?

CR: Oh, yes! Wonderful things have happened for Charmion. First of all, this documentary is now being distributed by Video Data Bank of the

[2]"The Circle of Charmion Von Wiegand," a video documentary that was produced, edited, and narrated by Ce Roser, was shown on Channel 13 (WNET, a PBS outlet in New York City) in 1978.

Chicago Art Institute School of Art, and the Women's Caucus for Art has seen it. Women's Caucus for Art in Florida rented it. The Albright-Knox Museum rented it. She had a retrospective at the Bass Museum, in Miami Beach, and they showed it, and she was very happy about that. Actually, she was in her eighties when we did it. It was just the last moment before she got quite ill. She was delighted with it, because as Frederick Kiesler once said, "A still Charmion and a moving Charmion are very different things." He was very fond of her. It is a perpetual memorial to her.[3]

JA: Did her work influence you or was it just her example as a professional woman artist?

CR: Her collages influenced me. Before I did collage I had a dream that I went to collage school and Charmion was teaching, and after that I started to do collages. I had not done them before. Otherwise I don't think her work influenced me that much, but her life as an independent woman influenced me.

JA: You also mentioned that Sari Dienes had a profound influence on you.

CR: Oh, yes. I knew Sari for a long time. Meeting Sari Dienes was like being vaccinated—you can never accept the banal and the conventional again. She inspired acts of defiance, challenged your imagination. Visiting with her was an adventure. You know, I saw her cook a whole meal of flowers, and when she came to Atlanta she taught me how to take rubbings of manhole covers. Now, at age ninety-three she continues to create and transform new materials into art. She's like a sorceress, a magician.[4]

JA: I know exactly what you mean. I, too, have been under her spell. In 1986 I wrote an article about her for *Women's Art Journal* at the invitation of the editor Elsa Honig Fine. I was impressed very deeply by her openness to everything.

Now I'd like to talk about the work you have produced in this past decade. Mostly you've been painting in oils on linen, although you have also done a lot of watercolor on paper.

[3]Charmion Von Wiegand died in 1983 at the age of eighty-four.

[4]Sari Dienes passed away May 25, 1992, at the age of ninety-three. She was still exhibiting actively.

CR: I start with watercolor—like practicing the scales on the piano—I loosen up and get into the mood to paint with oil.

JA: The reviews that I have read about your work talk primarily about your color: its vividness, radiance, exuberance. Would you say color is your subject?

CR: I would say that light is my subject rather than color.

JA: Great! Now, they also mention the rhythm that you set up. The energy that your paintings convey. The gesture translated into energy. Do you want to talk about that?

CR: Well, I think that basically what I'm painting is the changing light. Light, and color, and movement. Recently, I've called some of my paintings "Sky Paintings," because I feel that the sky signifies change and freedom. That's where it's freest. The uninterrupted and the unpredictable play of light and sun, and the allure of clouds in the sky, are always fascinating, always changing.

JA: Your work has been classified as abstract. You have told me that you're not conscious of abstracting directly from nature, you're not translating sky and clouds into painting so much, but that you think that they may somehow be the source of your inspiration.

CR: Yes, I do. Because my studio at Riverside Drive faces the Hudson River, and the river and sky are constantly changing. I turn my back to the window and start painting whatever it is that's inside me, my own vision, whatever that is. I don't go in with a preconceived idea, but I paint with total concentration, and I think that I drop into what I feel is eternal time when I begin painting, where there is no beginning, no end, and no me, no "it."

JA: You're lost in it.

CR: Not lost, absorbed in it, and it's almost trancelike. I must be totally alone and there must be silence.

JA: You reject the notion that you are abstracting from nature, but you did mention architecture. Do you want to explain how that comes into it?

CR: Well, that comes into it because of all the bridges in New York, and I'm aware of architecture because my son is an architect, and all of those structural elements, which I wasn't as aware of at the beginning, have come into my work in the past few years.

JA: I see.

CR: I don't reject nature; I live in nature. But I don't abstract from it. I feel that what I'm doing is completely abstract in that it's not abstracted *from* anything; it just *is*. It is an abstraction. It is itself. As a painting there's no explanation for it. Interpretation is left to others. When I do a new painting it's new to me too, and I can't exactly analyze it. I want it to communicate to viewers. I want to share certain feelings of joy and transcendence, ascendancy, and perception. This I am aware of. I think painting should be disturbing but at the same time transforming. People do have negative feelings, but there's enough of that in the world, and I would like people to feel the joy and wonder of it. Perhaps now that I have put it into words I will do something completely different.

JA: So, if you're abstracted from anything it's from your feelings, or if your subject is anything it's your feelings.

CR: It's my feelings and my thoughts, perceptions, and my sense experience.

JA: Still, you must spend a lot of time observing the changing sky and clouds.

CR: I'm not aware of concentrating on that, but I'm always examining my environment. My own thoughts and experiences and my reactions to things are constantly being examined. How I feel and how something looks registers somewhere in my mind. Slight changes, like the autumn light—how it suddenly transforms everything in a room—that I do observe, and I'm aware of textures and color. For example, I think the five-and ten-cent store is the greatest place for any artist to go into because of all the shapes, colors, and textures there. If you feel you've suddenly gone stale, you could go to a five-and-ten, or you could take a bus ride. Immediately, your view is changed. So it's based on experience, but it's not preconceived.

JA: Those are wonderful insights into the sensibilities of an artist, particularly an abstract artist. I want to talk about the reoccurrence of arches, or as you call them, bridging shapes. You mentioned something else to me about the bridges. Do you want to say that again?

CR: Yes. I'm trying to bridge cultures, trying to bridge relationships, trying to bridge sun and sky and water and land. I'm interested in linking things and connecting things. I'm also interested in going outside of boundaries, breaking them down—barriers to understanding, to feelings,

to opportunities, to freedom. Freedom is very important to me, something which I appreciate and love and want everyone to have. I want the expression of freedom and movement, not restriction or constriction, in my work. I want everybody to feel it. I think that's pure joy when you feel free.

JA: This newer work retains a lot of white canvas with bright intense color in softly focused shapes and then harder-edged arches and angles. There are leaping curves and hints of more geometric angles, so there's the calligraphic line over the space that's suggested by the more softly focused shapes underneath.

CR: Basically, the reason why I call it *The Sky* is because the white is textured like a cloud. A texture is there, but it's subtle and not perceived immediately. You really have to look. My work tends to be more for the person who wants to get into it and contemplate it than for just a quick reaction, although that can be gotten too.

JA: It unfolds. There's a color that hits you immediately, and then, if you wish to give it more time, there are the subtleties as well. You have dry brush; you have transparencies; you have stains—some of them are really drips—you have a brush stroke, which is a shape in itself. The way you use the brush you have the gesture of the human arm, and you have translucent areas and opaque areas. You've explored the entire range of what pigment can do. I don't know if that's conscious or not, but in terms of making marks, pigment marks—

CR: I'm not conscious of it.

JA: You've used just about every conceivable way to apply paint. How about your color harmonies? Do you know where they come from?

CR: I really don't know where they come from. That's one thing I had in common with Charmion, in that she liked primary colors a lot and I do too. But aside from that, I don't know where the color harmonies come from. I feel that perhaps my color harmonies are the most original thing about the work, that they're my own. When I first started to paint there was much more of the primary palette than there is now. I'm going into secondaries now, and with my last show I finally had gray. I'm beginning to use black. I've done black and white alone, but I'm just beginning to use black and gray in my work now.

JA: Are you adding black and gray to your repertoire while also keeping secondaries, or are you beginning to eliminate the secondaries?

CR: I don't think I'm nudging out the secondaries. I've grown to love them. If my palette has changed, you've just formulated it for me! I work so much out of the unconscious that it takes time for me to understand what it is that I'm doing, and that's why it's wonderful to talk to someone else who is understanding and knowledgeable, because then I can explain to myself what it is I'm doing.

JA: I hope I'm not doing you a disservice by making your unconscious conscious.

CR: No. That's impossible. It's partially possible, but the totality of the unconscious is so impenetrably dense.

JA: I'd like to go around again on how you use your feeling and your consciousness. You stand in front of a canvas in a trancelike feeling, and you reject the visible world?

CR: I reject everything that's known, more or less, or defined. I want to do something that really surprises me. I want to think I've had a wonderful discovery or exploration in my studio today—I've really seen something new, and I found it myself. You see, that's an important part of it.

JA: Wonderful! How do the titles come?

CR: The titles come later, quite often. Once in a while there will be a title that a poet has written. I have a lot of poet friends. I know I must come up with titles and I save their work. I write them down in a little booklet. Of course, when it's time to put a title down, I can't find the book. I have to invent more titles, and when I'm doing titles I will read poetry because I want something that will evoke the qualities and emotional tone of the work. I know that a lot of people are print-oriented, but recently I read a book by Iris Murdoch, and she said, "Both the work and the making of images are barriers to real experience and real knowledge and real truth." That puts us all in the same position.

JA: Let's mention your scale. You're interested in making something that's permanent. Are you interested in making something monumental as well?

CR: I want to do something that is large, and by "large" I mean in impact—say, fifty-two inches by eighty inches. For that I have to stretch and reach because I'm only sixty inches tall myself.

JA: How do you prepare your surfaces?

CR: The canvas is gessoed and then has two coats of Winsor and Newton white oil paint to give it luminosity. The undercoats are applied flatly, but when I am painting later I use texture. I use many different types of brush marks. I want to get action, variety, subtlety, but I don't want to be so subtle that I lose power.

I use tube colors as well as mixed hues. In this recent series of diptychs, and a larger painting, *Spiral,* I started using the grays and blacks and deep tones.

JA: It's strange, but I hadn't gotten around to noticing the grays yet. I'm still struck by the vivid colors. The grays enhance the brightness—give you a rest period, a contrast.

CR: That's the way it should be. I wanted to expand my palette.

JA: When you go to evaluate your picture, do you try to analyze it rationally?

CR: No, I don't deliberately. I work spontaneously. It's mostly visual. I look at it and I think, Why doesn't it work? or, Why don't I think it's complete? Sometimes I reach an impasse where I can go no further in my perceptions. I'll leave it for a while and come back and see something completely new—sometimes a color, a form—which solves my problem. It is so refreshing to finish it because I reach a point where I'm solving the problem of the picture plane, so to speak.

JA: So you don't force a result?

CR: No. It has to come naturally or intuitively or it doesn't happen at all.

JA: Are there paintings that you've never finished?

CR: No, but sometimes it takes years.

JA: How do you feel about reworking a canvas after it's been exhibited?

CR: I try not to, but sometimes I have. When it's hanging in a different place I may see something I was never happy with, but once or twice I've even ruined a painting that way. I work in watercolor a lot now, and it's often very much a matter of just stopping, because if you overdo it you ruin it very early.

JA: When did you start hugging the edges? Is that something new?

CR: Yes. I've been paying more attention to the edges recently; I've done a series of watercolors that document the beginning of that. One's consciousness evolves and you go with it. I tend to warm up by doing watercolors, and I decided the edges can be beautiful too and that there is no reason why they should all be one color. They could be multicolor, and one could do different things as well. I began to use this in my oils on canvas. Now I've begun mixed media—oil and watercolor together on gessoed paper.

JA: Do you draw?

CR: Of course I draw. I draw with the brush and pen.

JA: Did we talk about Kandinsky?

CR: Yes. People have said my work is related to Kandinsky. John Russell said my work was like Kandinsky's earlier period, which was experimental. I find his later period rather too formulary. I am always interested in the experimental. For example, this past summer—1989—I've been doing unmatched pairs that I call *Dialogues*. They're small, squarish: eighteen inches by twenty inches in diameter. I'm experimenting with these dualities.

JA: I'm struck by the fact that these canvases no longer have white spaces. They are covered with soft washes so that neutrals predominate. Instead of the great, airy, cosmic openness of the large ones, they seem to me to evoke primordial origins and oozy organic things. Your calligraphic brush marks create tremendous activity and suggest a denser space, like floating or submerged grasses. Are these shapes hidden or overt? Are they your subject?

CR: Only if it comes from the subconscious, in which case I'm not sure what they really are.

JA: Is water a reference for you?

CR: Possibly. After all, my studio is above the Hudson River, and I have always lived near rivers, oceans, bays. The significance of the saying "You never enter into the river at the same place twice" seems to exemplify painting to me—improvisation, movement, texture, color—all shifting and changing like flowing water. Art is an attempt to bring awareness to a higher state.

These are transitional paintings to some degree. The arch is becoming several things. These are experiments which lead to my present work. I'm bothered because they are so different. They don't seem related to my previous work, but maybe they are.

JA: Let's see. Have you David Salle's work in mind? His work is irritating enough to produce some response.

CR: Well, I'm trying to understand him. I've been reading about his work. Simultaneity and fragmentation as depicted in his work are very much a part of our lives. The contradictions that we all live with are difficult to resolve. That's why the tea ceremony in Japan became so important. At a time when there was great civil turmoil there had to be order, serenity, beauty, to offset death and outrage. We need stimulation, but we need peace and harmony too. I think that it's very hard to live in the city and to have any quiet or moment of calm.

JA: Early last summer you said your painting is an affirmation of the positive potential. You said you recognized that there were negative impulses but you didn't choose to paint them.

CR: Yes. I did say that. But after having said that, it seems I feel freer to bring a lot more into it, and these works have more action. I think I'm becoming more confrontational.

I just did a collage protesting the June fourth Tiananmen massacre in China. I'm familiar with blood—as women, we all are. I made it look really bloody—really awful—full of students dying—very violent, but expressing exactly what that massacre meant to me. It was so horrible and dreadful to see students being killed. You can use art to express almost anything.

Now I realize there is no unity in our lives, no unity in our environment. Should there be unity in our work? I'm not a person who changes my style with every trend that comes along in the art world. I think there is unity in my work, but it's my unity. I have some doubts about when and where I'll ever show these new works; they're so different. I think each set has a unity, but there are ten different sets.

I'm not the first person not to follow one vision. Since I'm not a beginner, and I do have a track record, it shouldn't be so astonishing. If this were my first show they might say, "She hasn't found her voice yet," but now I have found my own voice and I still prefer to experiment because to repeat things completely is deadening.

JA: I'm really excited by your direction, your ideas. Are you conscious of the speed and energy you expend?

CR: No. I'm not conscious of it, but I don't ever want to approach a canvas without feeling energy, and psychic energy at that. I don't want to do a "tired" brush stroke, ever. It's got to have life.

For me, painting is many things: memories, fantasies, thoughts, perceptions, and emotions. It reminds us that the unpredictable, the irregular, the contrasts, and the ambiguities—all are important. Perception, energy, and imagination are made visual.

Plate 15. Miriam Schapiro with her sculpture, *David*. Photo by Suzanne Opton.

Miriam Schapiro

Education:

1949 M.F.A., State University of Iowa, Iowa City, Iowa
1946 M.A., State University of Iowa, Iowa City, Iowa
1945 B.A., State University of Iowa, Iowa City, Iowa

Selected Solo Exhibitions

1993 "Miriam Schapiro," A.R.C. Gallery, Chicago, Illinois
1990 "The Mythic Pool," Bernice Steinbaum Gallery, New York, New York

1988	"Ragtime," Bernice Steinbaum Gallery, New York, New York
1986	"I'm Dancin' as Fast as I Can," Bernice Steinbaum Gallery, New York, New York (catalogue)
1982	"Invitation and Presentation," Barbara Gladstone Gallery, New York, New York
1980	"Miriam Schapiro: A Retrospective, 1953–1980," College of Wooster Museum, Wooster, Ohio (traveling exhibit; catalogue)
1974–75	Women Artists Series, Douglass College, New Brunswick, New Jersey

Selected Group Exhibitions

1993	"Dolls in Contemporary Art: A Metaphor of Personal Identity," Marquette University, Milwaukee, Wisconsin
1990	"Definitive Contemporary American Quilt Show," Bernice Steinbaum Gallery, New York, New York (traveling exhibit; catalogue)
1989	"The Eloquent Object," Orlando Museum, Orlando, Florida
1988	"Committed to Print," Museum of Modern Art, New York, New York (catalogue)
1985	"The Artist and the Quilt" (traveling exhibit, 1983–86; catalogue)

Selected Bibliography

Kuspit, Donald. "Images of an Innocence That Never Was." In *The Edge of Childhood*. Huntington, N.Y.: Heckscher Museum, 1992.

Gardner's Art Through the Ages, 9th ed. Edited by Horst dela Croix, Richard C. Tansey, and Diane Kirkpatrick. San Diego: Harcourt Brace Jovanovich, 1991, 1086–87.

Broude, Norma. "Miriam Schapiro and Femmage: Reflections on the Conflict Between Decoration and Abstraction in Twentieth Century Art." In *Feminism and Art History: Questioning the Litany*. Edited by Norma Broude and Mary D. Garrard. New York: Harper and Row, 1983, 315–31.

Bradley, Paula Wynell. "Miriam Schapiro: The Feminist Transformation of an Avant-Garde Artist." Ph.D. dissertation, University of North Carolina at Chapel Hill, 1983.

Womanhouse. Valencia: Feminist Art Program, California Institute of the Arts, 1972.

Interview

Miriam Schapiro was interviewed by Joan Arbeiter in 1988

JA: Miriam, according to your résumé, your first exhibit was back in 1958, which gives you thirty-plus years of a professional career. Thank goodness the past seems fairly well documented, so I thought we might go forward. Before we do, do you feel that your career, up to this point, is documented to your satisfaction, and that whatever you wanted to say has gone on record with your meaning attached to it? Or do you feel like there's something you want to add, correct, change?

MS: Well, actually, the heavy documentation came up to the point of the show that I had at the Bernice Steinbaum Gallery in 1986.

JA: "I'm Dancing as Fast as I Can"?

MS: Yes. The documentation since 1986 has not been as full, partly because I have visibility for two aspects of art making. One was the aspect of feminism, and the other was the aspect of pattern and decoration. Once the excitement over pattern and decoration was over, some of the attention died down a little bit. However, I have some incredibly loyal people who keep following my work and writing about it. The last bit of writing was done by Thalia Gouma-Peterson and was in my catalogue for the show called "I'm Dancing as Fast as I Can," which was the beginning of a new departure for me. Having been one of the inventors of pattern and decoration and having seen it to its fullness, and also witnessing the manner in which P and D seeded the entire 1980s and 1990s, I myself moved to a different place. I began to put human beings back into my painting.

The "Ragtime" show at Bernice Steinbaum, in 1988, I consider transitional. In fact, the show displayed two different kinds of work, because I create on simultaneous tracks. One of these is the "cutout" track, which comes out of Matisse. My large paper cutouts eventually led to my sculpture. That whole track is only about five years old. The newer track that I'm on now deals with the painting of women artists. It's about women in general, and it's about myself. I feel it coalesced in the painting you saw at the Vered Gallery, which is called *Conservatory*.

JA: *Conservatory*—thirteen feet long, six feet high, three panels, wasn't it? Tell us in what way that painting is a coalescence, a coming together.

MS: When I started this series, I had a lot of friendly criticism on these new works, because people had become accustomed to what I did in the past. When I had heroized the hearts and fans, when I jumped the scale up and made these huge, delicious paintings, people knew that I was celebrating women's lives. And then, when I went into figuration and began to make strange images, my friends, the feminists, looked at it all with raised eyebrows. I said very little about these new works. I use myself as a medium, because I really don't know all the time what it's about. I have confidence, and I know that ultimately it will come together and the message will be revealed to me. Thalia writes well, I think, about the particular female image in *Master of Ceremonies,* who has a palette in one hand and in her other hand brushlike things that burst into flowers. That woman is dressed in a dress I made up using a Sonia Delaunay sensibility. But everyone objected to the head on that figure. They said, "Why did you make a Raggedy Ann head? Why didn't you make a powerful woman with great presence?"

JA: Wasn't there a vamp on the other side?

MS: There was a vamp on the other side.

JA: So you were trying to make a point about the relative strengths— playing one against the other?

MS: The vamp, in terms of the head, is a much stronger woman. But, you see, I wanted to say that when women artists begin to live their lives, they designate themselves as women artists, but it isn't as simple as that. They go through long periods of acclimatization—believing in themselves as women artists, so that they're no longer shy about calling themselves professionals. My whole involvement with these female figures in the paintings has been the description of coming to consciousness.

JA: That's a clear statement, I think.

MS: So that if she has a Raggedy Ann head, she hasn't got it all together yet, no matter how much of a stance she takes. No matter how much she knows about color, no matter how much she's got her correct costume on—meaning her palette, her tools, her technology and her involvement—she isn't assured of "having it together," and that's what I was trying to say in that painting. I was a witness to my *own* recognition of subject. I had to watch myself emerge with what I really wanted to say, and that came out in *Conservatory,* because what I did there was to use Frida Kahlo, an artist who I admire very much. It was very easy to make her strong, and her face was identifiable.

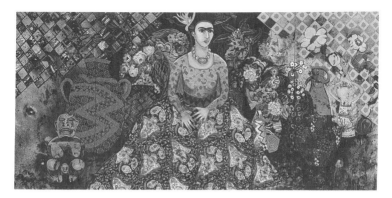

Plate 16. *Conservatory,* 1988. Acrylic and fabric on canvas, triptych, 72″ × 152″. Photo by Noel Rowe. Courtesy of Steinbaum-Krauss Gallery.

It's interesting. Thalia talks about these faces I make as "masks." And I think it's an interesting thing to say. I mean, I personally don't think of it that way, but the idea of talking about women and masks seems natural to me because I think that's what we're all about, and I think the whole idea is to *wait for yourself as the artist to remove the final mask, and that's when you know you've arrived.* And whether you've arrived financially or whether you've arrived in terms of your own centering, you've arrived.

JA: I can understand that. That's very important, and I like the image it conjures up. Now, in *Conservatory* you put in pieces of historical reference. Wasn't there a bit of the Renaissance in the upper left?

MS: Yes, in that particular painting, it's about culture in general. It's a collage. You know I work with fabrics, and I got this terrific fabric that had all these urban and historical graphics on it, and I loved it so much that I wanted to use it, but didn't want to use it literally, so I broke it up into squares and rearranged them.

JA: And the other pieces where you have references to Paul Klee, and you have a van Gogh image in another painting, is all that homage to your heroes?

MS: Not so much my heroes, because I don't care that much about van Gogh. It's more about a world I came from, because of my father, an artist, and most of my male teachers who taught art in the traditional Eurocentric, patriarchal manner.

I'm digressing here for a minute, but I want to share one of my favorite stories about teachers with you, because I think it's wonderful. An art student from Rutgers told me this. She was an older woman, and it was the first day of the new semester. She had a male teacher, and he seemed very nice. He told all about his requirements for the class. He said that he really wasn't rigid about what kind of medium they worked in, and he felt comfortable with the idea that they might express themselves in different ways, and he looked forward to working with them, and so forth and so on, and went on in a very nice vein, and then he reminded himself of something, and he wagged his finger at this class, and he said, "But I don't want any of that girlie stuff." You know the story?

JA: No, but as a grad student I witnessed the same thing happen to female undergraduates when I was an intern in their senior painting class. I had been sitting in that class all year, and I had been impressed with the teacher, when one day he began raving at a young woman because she brought in a canvas with these pinkish internal-looking forms, and at another woman for her pattern painting. He had them both in tears. He just disallowed it! It was a big lesson for me too. This was in 1980, and it was still going on!

MS: Well, one of the things that's been hard for me in my career is that I've taken a public stance against these masculine art types, and a lot has come down on my head. I've been rewarded too; I've been rewarded by women. But I have paid for this too. For example, everyone thinks I'm a Guerrilla Girl. I'm not a Guerrilla Girl. I mean, I don't belong to their organization, but I'm with them in spirit. How could you not be? What do they do that's so terrible? They print the truth. At the Guggenheim Museum, in the last forty-five years, there have only been about five women who were given one-person shows. Anyway, what I'm trying to say here is that a woman pays for going up against the more derisive male college art teachers. Just because we've been designated the second sex doesn't mean that we have to accept it. We women do have a history, not only in high art but in the world of what I call the artist makers, referring here to the domestic locus of art making, *traditional* women's art. I don't like to use the words "arts and crafts" because I find that when you start using those words you're also using other persons' ideas. And I don't want their ideas. I want my own ideas, which have to do with an ennobling of women as opposed to continuing worn-out attitudes of what's good and what's bad, what's high and what's low. I have been lecturing, since 1971, all over this country. When I started, I used to go out for less than a hundred dollars, and all you could hear were my knees knocking. Well, I must say, it's a little different today, but I often find myself on a campus with faculty made up of men I went to college with. These artists never come to my lectures. Never.

JA: So you still feel the hostility?

MS: I get it quite a lot. But I only had one direct confrontation. I'll tell it to you for your amusement. I was in Kansas; my retrospective was there, and they asked me to speak extemporaneously in the gallery. I began to talk, and then I said, "Are there any questions?" And a young man who must have been waiting for me said, "Miss Schapiro, I understand from reading Judy Chicago's books that she has multiple orgasms."

JA: Oh, my! That was a question or a statement?

MS: No. The question was, What about you?

JA: That's really wild! How did you handle that one?

MS: I said, "Doesn't every woman?" Anyway, that was, I think, the funniest confrontation. He was gunning for me. It was obvious that he wanted to embarrass me. But the audience was on my side. You do get a lot of sexist stuff when you take this position.

JA: But when you started P and D you weren't traveling exclusively in female circles.

MS: No, there were male artists who were pattern and decorative artists as well. But the men in P and D didn't fare very well themselves. I mean—it's interesting—we took a survey once. The Museum of Modern Art has many Robert Kushners, but no Miriam Schapiros from that period, and the same at the other museums. I mean, I get punished for being a woman and for being a pattern painter too.

JA: You still feel it?

MS: Oh, yes. But I accept it. I accept it because the way I want to live my life is more important to me than ultimately pleasing the museums. I mean, I cannot allow myself to become victimized by people in museums who are sexist in orientation. I can't do that to myself. I think that the fact that the women were leaders in the P and D movement and that we enfolded the men into the movement didn't soften our positions. Joyce Kozloff is one of the foremost artists in decorative, architectural installations—public art—but she did it by guts and tenacity: just sticking to it and taking on incredible amounts of hostile people who were on committees, who tried to unnerve her and so forth. I mean, she was one of the first people to go public in that sense. We took a lot of aggravation. They didn't like our work.

JA: Going back to you and Joyce Kozloff, did you develop this interest in decorative pattern around the same time?

MS: It was the *zeitgeist,* and I think many people were experiencing the same thing at the same time. The point is, it takes more than just making art to make your mark in the art world, and those of us who were the female leaders in that group already had been schooled in what bonding meant, in what organizing meant. We were feminists. I mean, we'd gone around, we'd spoken, we'd organized. I can't tell you how many women I've organized in my life, or Joyce has, or any of the other women. We knew about newsletters, data banks. We actually invented information processes early in the 1970s at the time of the emergence of the feminist movement. When Judy Chicago and I had the first conference of women artists, in Los Angeles, California, women came from all over the coun- .ry and showed their slides to each other for the first time. They invented data banks because they were going back to separate parts of the country, and there had to be a way of organizing women artists geographically, since the one thought in our minds was that the worst thing for an artist, regardless of gender, is to be isolated. So we had to find ways in which people could come together, discuss mutual problems in their art life, and find methods of exposure for their work. So, having been schooled that way, people like Joyce and I could go out and organize again. When Robert Zakanich came to me and said, "How do you make a movement?" I told him, "You get on the phone and begin by inviting artists of like mind to a meeting." Later Zakanich visited me in California during a semester when I was teaching, and I said to him, "Well, don't make a meeting until I get a break and can come to New York," and so we did that—we started to become a real group. And the funny thing was everybody heard about it, and we immediately became visible; the dealers started showing our work. That's how it began. Later, dealers from Europe as well as the United States bought the work because they already sensed that we were a new movement. The Americans resisted us more than Europeans did. The irony of this story is that even though the Americans resisted, after the movement had gained momentum and after it was beginning to diminish because all of us were starting to go other ways, that's when it seeded the whole East Village, and this other incredible explosion happened out of the P and D impetus. Then all the strange art appeared about the beginning of the 1980s, when the East Village came into being in New York City.

JA: Are you talking about neo-expressionism? Antiformalism?

MS: I'm talking about every picture that exploded with primary color, pattern, stripes, things glued on—all of that wild kind of art. It seemed

as though it was done by naives or nonliterate people who'd never been to school. Don't you remember that people were so shocked at it? It was called "bad" art, and it was antiformal. They showed it at the New Museum, and there was a whole period of this and then it went into expressionism, and ultimately it went into various other things. Historically it was called the great pluralist era in art. And what we did was once again—after feminist art—we broke down the canons of mainstream art.

JA: It gave permission for everything? Funny. I didn't see that in the 1980s because of my own perspective. I was in graduate school, and what I remember about that time was seeing *Dinner Party* and "Women Artists, 1550–1950," both at the Brooklyn Museum, and that was the first time I'd ever heard of all the women in art history that we are so familiar with now. For me it was a time of coming to consciousness. I didn't have an overview. By the time I was aware of what was going on, I guess I just thought it was developmental in general.

MS: It was. It was developmental in general.

JA: Okay. But, you're making a point here that the origin of pluralism— which we still have with us today—was in feminism. That the feminists unleashed postmodernism?

MS: Art before the feminists was elitist. The origin of pluralism was in feminism, was in black art, was in ethnicity, but feminism was the first strong movement of "others" to be able to say, Look, we have a point of view; we make art; this is how we do it. What I'm saying now is very subversive. It is not something which is accepted in any way at all. Because if it were to be accepted you would have to acknowledge that women have brains, they have moxie, they have ability, they can move forward in this world, they can be philosophers, and that *they can* influence other people. The world is not ready to say this yet. They're not ready to say it.

You asked me before, did I think anything was left out. *That's* what I think was left out!

JA: Good. Thanks. I think young artists will be very grateful for this perspective. Now, can we talk about your first sculpture? And then I want to talk about *Rondo*. Did you document the development of the *Anna and David* sculpture?

MS: Let's see. What happens: sometimes real events make you do things or change things. I had prepared the 1986 show, "I'm Dancing as Fast as I Can," and I got a call from New York University asking me if I would

do something for their gallery, Windows on Broadway. I thought about it and came up with the cutouts because I didn't want the paintings in those windows. I had already made images of dancing figures, and what I decided to do was extract them from the background. I made sets of dancing figures; I depicted them as moving, as kicking legs or throwing up arms or twisting necks, pushing heads back—like Fred Astaire in motion. I received a lot of comments on those windows. People wrote to me about the cutouts, they called me, and they loved seeing them there, and I liked them too. And then, one day, a man who collected my works wanted me to make a sculpture based on the cutouts. He is a real estate developer, and he commissioned me to site them in front of his new building in Rosslyn, Virginia.

And so I made the maquette and decided that they should be thirty or thirty-five feet tall. The piece was fabricated at Tallix, in Beacon, New York. I went up there and worked in a special building set aside for the painting. The only part I participated in outside of making the model was the painting itself. I was very particular as to how it would be painted. I worked with a crew; I used automotive paint and we rolled it on. We documented all those processes.

Later Joey Kempfer, my patron, created the most incredible opening I've ever seen in my life, to unveil this sculpture. I was given a chauffeur-driven limousine, which brought me to the site in real style. And there were 2,500 people there and three chamber music quartets. Senators came to it. Washington people came, and Mrs. Holladay, of the Women's Museum, said to me, "Well, Miriam, it would be very nice if you got someone to donate a sculpture like *Anna and David* for the National Museum of Women in the Arts." I said, "Yes, it would be. The only problem is that it is hugely expensive." Needless to say, it was a very exciting moment in my life, but if women read your book, I think the most important part of this is that I was sixty-four years old when I started something new, and it wasn't any miniature, you know?

JA: Can we name your dealer? Are you enjoying your association with her? Isn't she wonderful?

MS: Bernice Steinbaum. Oh, yes! You know, I've had a long career and had a number of dealers, and there's no question in my mind that she is in a class by herself.

JA: I think we should give her credit in the book because she's done so much for the feminist movement and for just humanizing the whole process of representing artists. She is so enthusiastic. When I bring student groups around to her gallery, she doesn't have to come running out from the back and hug me and meet everyone, but she does.

MS: She likes to.

JA: She called me in to show me your paper cutout pieces. Something else was being shown out front, and she said, "Come in, I must show you this." This was before she even knew about this book, before we began this project.

Speaking of new directions, how is your book, *Rondo,* fitting into this? Is it a summing up or a going forward?

MS: I think it's very definitely a summing up. It's about ten feet long when you stretch the accordion fold out. On the front side are the dancers and on the back are some of my decorative works. It's very joyous. I wanted to come out of all those years of dealing with the oppression of women with a sense of joy, and a sense of strength, and a sense of individuality, and a feeling for movement—going somewhere. I was reading about dance, and somebody said that dance is the oldest of the arts. Think about it. It's the first thing that people do to celebrate—to shift and move their bodies. Can't you just see people falling on the ground and clapping because the rain has come after a drought? If you pick up any book on the history of dance they start with these great representations of the Minoans in Crete—bull dancing—and even before that. There is just an incredible culture of dance! Images of women mourners swaying back and forth while grieving. They chant, and they keen, sounding and moving.

Sometimes I am criticized because my dancers are not political. Some feminists feel that because there are terrible social injustices in the world that one should illustrate these ideas, but I don't feel that way at all. I mean, I think people who need to express themselves this way should do it, but I don't feel that way. My life, which started with enormous difficulties, was a life of facing myself and finding the strength to move—literally move—out of the bed onto the floor and up on my feet. All of that was very meaningful to me in terms of developing my interest in dance.

JA: Well, you're very happy with your life, with your work, with yourself, with your relationships, and you're expressing this joy. I think it's not anything borrowed; I think it's directly from the same gut that made all the other pieces.

MS: Well, I forged out my own life in the way that I wanted it. Now look on the reverse side of *Rondo.* On the back of each sheet of the dancers is a sort of summing-up, an intensification of all my decorative impulses. This side has images of flowers, and kimonos, and throbbing hearts, and masks, and fans. They are all original for this project except for this last one, which comes from a print I made. We reduced the print. It shows a

doily that says, "Tea's here." It's a drawing done in needlework of a cup and saucer—very simple, very elegant. I love it. And that's actually the end of the book. It says, Okay, you've read this book; now you can go have a cup of tea.

JA: How long did this take?

MS: I worked intensively on this for about three months. I had a group of assistants and I would choose the colors. We would cut the boards, we would make swatches of paints, we would color all the boards, and then I would position all my pieces.

JA: Can you work with an audience?

MS: Well, a lot of the conceptualizing was done at night when the assistants were gone, but during the day, when they were here, they would glue the colored papers, magazine papers, and wallpapers, etc., onto the painted boards, which served as backgrounds.

JA: Where are the originals?

MS: They're all sold.

JA: No wonder you're so happy! Look at you! You're thirty-five feet high, you're ten feet wide, and you're sold out, and it's all you. What more can you say? So, what's next?

MS: Well, I'm working on maquettes for other sculpture now. When I sleep I dream of my new paintings, which I'm really looking forward to doing. Then I want to write a book based on the six lectures I gave at the University of Michigan on feminist art and on my ideas and my life; so I'm getting a computer in December, and I'll probably work two hours a day on that. I also contributed a chapter to a very interesting book by Katherine Hoffman titled *Collage: Critical Views.*[1]

JA: Now, how far do you want to look forward?

MS: Well, I think what I'd like to do—but I can't hold myself to this because I could change my mind—but basically, I'm very much looking forward to making a series of paintings on Frida Kahlo. I want to do

[1]Edited by Katherine Hoffman, with a foreword by Kim Levin (Ann Arbor, Mich.: Studies in the Fine Arts, Criticism No. 31, U.M.I. Research, 1989).

Frida's whole life because she was very fascinating to me, as a private person and a public person. You know, all of us who have received any visibility at all have that as an issue in our lives. Where does the private person end and the public person begin? She was very political. She was a communist, and she and her husband, Diego, were very close to Leon Trotsky. They hobnobbed with the international jet set, and the Rockefellers commissioned him to do the U.S. murals. She lived a fascinating public life. She had an incredible image of herself. She herself was a work of art, and in her paintings, in the most expressive way, she talked about her own private hell, which had to do with her physical condition, her inability to have children, her miscarriages. I want to point out something that belongs in the middle of this interview. In the "Ragtime" show there was a painting called *Time*. That picture, *Time,* has Frida in it. She's slightly more disguised because I gave her a bald head.

JA: She was working her way into your consciousness?

MS: Yes. Frida sits in Diego's clothes. You know, Frida and Diego broke up at one point, and he seduced her sister. She was brokenhearted; she cut off her beautiful hair, which he loved. She was left with short hair. Well, I totally took it off in the picture, made her bald, but she is seated in his clothes.

JA: She did a painting like that, didn't she?

MS: Oh, yes, a very famous painting, wearing his suit. That's where you see it; that's where you see that she's cut off the hair. The shorn hair is represented all over her painting. *Time* has no hair in it. She's sitting in the dark, and to one side of her is a much younger woman whose section of the painting is pervaded with light. She is a sort of insouciant person. She tips her hat, carries a palette with red paint only. *Time* is about an older woman thinking about death, menaced by a younger woman who has come to replace her. In the painting an older woman artist is seated looking at a painting of hers on the easel. There are two themes in this work; the older woman is devoted to her painting, is surrounded by abstract black dreams, the younger woman could be a performance artist with a different sensibility. You see, I think of us as moving in two different times now. I think of the way that I was raised, how I thought it was a privilege to be an artist, to be idealistic, and I thought I had a tremendous responsibility to do the very, very best I could with my art because I didn't think making art was given to everybody. Today I don't think that people feel that way. I think that people see not art but image. Image appears on television, in magazines, in newspapers, all over, and we're used to looking at these images very quickly.

JA: Yes. "Throwaway" images.

MS: I just attribute throwaway thinking to the Reagan era. I mean, it happened in the Reagan era that we lost a tremendous amount of idealism, and art is no longer spiritual. In other words, one doesn't have communion with art the way we used to. One now looks at art as part of the whole commodification situation, and it's about investment. What people will pay for art is astounding.

JA: Art as object, more than process, more than meaning.

MS: So, this painting, *Time,* is about change, and about difference, and about the ying-yang of things, you know, and it's about feeling, and yet nothing is really illustrated in it. I can tell that because nobody knew what to make of that picture. I think that that picture is a little bit ahead of its time in terms of the way women really see themselves. The picture is also about envy between two women. I'm very involved with psychological depth; my show "Ragtime" was about that. The women that I painted in "Ragtime" were all very strong women. They stared at you and had very strong bodies, and yet I was criticized because they weren't idealized portraits of women. They were portraits of women who seemed to be throwing their bodies at the observer. Feminists shy away from works about prostitutes — women who decide to use their bodies for commerce. I don't paint these women as "slaves to men" but more as people *in charge* of their destiny.

Remember I told you things are revealed to the artist? Let me tell you what happened to me the other night when I went to a symposium at the Whitney on Marxism and feminism. Eunice Lipton, an art historian, told a story. In her research on Manet's *Olympia* — remember the woman who is spread out on the bed, displaying her body — well, that woman was a *painter!* Victorine Meurend is known in history as a whore, but she was a painter. She came to America and exhibited her paintings. She was reviled everywhere. They spit upon her because she was considered more of a whore than a human. That's the way Manet painted her. She was his model; she was his lover.[2] The point that I was trying to make in those paintings where I made women who looked like prostitutes, for example, in *The Blue Angel* — people don't understand that picture — my point is that behind this *pose* is a woman, and that woman is very strong and very much herself, but all we know about her is that she is *The Blue Angel* and that she has been given a designation by society. I find it very interesting that one of my students, a brilliant woman about forty-five

[2]Eunice Lipton, *Alias Olympia: A Woman's Search for Manet's Notorious Model and Her Own Desire* (New York: Scribner's, 1992).

years old, said of her, "That's a very violent crotch." As though it had a way of speaking, as well as the eyes, as well as the stance, because it's a sexual stance. You know what I mean?

JA: It's strong, but sexual.

MS: No. Strong *and* sexual! We've always been taught that women's sexuality is a passive part of women, but we know better now. It's a strong part of women and can be assertive as well. One of the arguments that goes on among feminists is, Which side are you on? Are you on the side which says women are socially constructed, or are you an essentialist who says that women have an innate womanness to them? Well, I think that my paintings are supposed to be about socially constructed women who are yet, at the same time, essentially women. One sees this in their strength and their manner of being. In *Ragtime,* another painting from that show, a whore sits arrogantly on a chair; her stance is arrogant and sexual. So that's my point, and when Eunice Lipton showed the picture of Victorine Meurend I felt as though someone understood what I was talking about. These prostitutes have had descriptive titles which came from men's eyes, a designation by society. Simone de Beauvoir says that the truth is the truth as *men* know it. That's what a patriarchal society means. In my work I present the complexity behind clichés about women.

JA: Whoever writes the definitions—

MS: Yes—defines the truth. But the point is, if you're a woman you're already schizy, because in order to graduate college you have to give the truth back as it was given to you, but you know there's another truth down deep.

JA: Right. Yes. Absolutely.

MS: Okay. That's what these paintings of mine were about: the feminist truth as I see it. We all see it differently.

What I hope to do in the future is continue with this idea of women artists, and as different psychological thoughts come to me I'll embed them in these images. For example, another one of my paintings from that show is called *Incognito.* That has a madwoman and is an interesting painting to me personally. In *Incognito* the woman has an absolutely idiotic face, she just looks out of it. Her body is painted as a sort of tour de force on cubism. It's an attempt to "cubisize" the body, so that the garment that she's wearing represents painting itself. Now she is surrounded by painting which is totally gestural or abstract expressionist. And then,

the floor is altogether another form of art. What—I don't know. I made it up.

JA: So, *Incognito* has a madwoman with a cubistic body in an abstract expressionist field?

MS: Yes. *And therefore she is victimized by painting itself!* That's what I felt, you see, when I was growing up as a painter. I felt victimized by painting itself. I said, "This isn't *mine* yet. What's mine?"

JA: Could I ask about technique? In addition to your content, and your historical and psychological consciousness, when you make a painting, such as *I'm Dancing* or *Ragtime* or *Conservatory,* are you at the same time cataloguing how to make a painting?

MS: You mean like Jennifer Bartlett did in *Rhapsody?*

JA: Well, I guess she made that her subject, but in addition to your subject, it seems to me you're very conscious of the act of painting and that you try to diversify your touch.

MS: Oh! Yes. That's interesting, that you would notice that. Yes. In *Invitation* that's particularly true. I don't know if you remember that painting. I made three very large quilt paintings, one of them is at Boston Museum of Fine Arts, one of them is on tour, and one I still have.

JA: Are you consciously making a painting about painting?

MS: Yes. That's a good question. How come you ask me that? I mean, could you be a little bit more specific?

JA: Well, after you walk in the gallery and you're knocked over by the scale, and by the subject, and by the color and movement, then you begin to notice that there is great diversity in technique—sort of cataloguing the many ways one can apply the medium. I've noticed that you have glazes, and dry brush, and impasto, and multiplicity of color and dots—

MS: It's fun. It's fun to do that, and the dots are decorative. When I put dots in, it's deliberately decorative.

JA: I don't think that there's any kind of mark making that you've overlooked.

MS: And the fabric. Don't forget that I use fabric.

JA: You've also glazed over the fabric, and painted on top of the fabric, and painted images to resemble the fabric. So you explore the physical potential, the formal potential of your media.

MS: Although the funny thing is that I usually say I'm not interested in technique. I hate technique, I really do. I get bored, and I keep moving from one thing to another. But I only do what I feel impassioned to do because the painting needs it. You know, I don't make art easily. It comes hard to me because it's so important for me to correlate how I feel with what I'm doing. As a result, I just can't accept anything that doesn't *get* to it, you know, that doesn't—

JA: Come from you?

MS: Yes. Come from me. I've gone through a long life in art, and I had some very interesting experiences. I've had the experience of having people on waiting lists for my work. Now, a dealer in that situation really wants you to turn it out. I was never mechanical. I couldn't do it. I knew immediately that this was going to limit the amount of success I could have. I had to live with it because that's the way I am. I made as many fans as I could make. That was it. When it was over, it was over. I made only five of those huge fans—six feet by twelve feet. They're all in museums.

JA: Where's the big kimono, *Anatomy of a Kimono*?

MS: Switzerland. That was bought by Bischofburger, the biggest dealer in Zurich. He bought my entire production for 1976. He still owns the kimono. He's going to make money on that someday, not me.

To know about the world of art, the inner workings of it, how corrupt it is, how competitive it is, how much emphasis there is on money—these are all things that, as a person of integrity, you have to deal with if you want to be recognized. When I teach women or speak to women who are younger, who have fantasies about being famous in the art world, they haven't got the slightest idea what it's all about.

JA: I don't think the men do either. But I know women have been more naive.

MS: And sometimes even men don't have the capacity for it. Not all men do. But this guy Serra [artist Richard Serra] is a cutthroat, and that's the nature of his personality. So he's bound somewhere to be successful. I think the most cutthroat thing he ever did was to put up that sculpture near the federal office building in New York City.

JA: *Tilted Arc?*

MS: That *Tilted Arc* is the most hostile thing ever engendered upon a community.

JA: And it took all those people in the building to say so.[3]

MS: All those people. They absolutely have the right to talk about the environment that they work in every day. Do you know when this became clear to me? When they started to call me and write me about *Anna and David,* my sculpture. I got letters which said things like, "Dear Miss Schapiro, I work in the neighborhood of *Anna and David.* I didn't know what I was missing until your sculpture went up and I realized that I was looking forward to passing it on my way to work every day." And it continued, "The color, the way it captures the light"—which is very much a part of making that sculpture—"it buoys me up." Just what you said before. "It buoys me up, and it gives me a feeling to move with into the day."

JA: Isn't that wonderful!

MS: When people started to tell me things like that, then I began to ask myself about the *Tilted Arc.* And I said to myself, "That was hostile on his part to think that 'Art' was that important." Art is not that important. It's only important as it is beheld in people's eyes, as it does something for them.

JA: I agree. In my artist's statement about my portraits, I write that the people are more important than the paintings.

MS: But power and the act of ennobling people was what art partially used to be about.

In the Renaissance the world was emerging into cities, states, and so forth. When I go to Florence now, and I walk through that city, I can understand why all of this meant so much to the bourgeois, the emerging capitalists. Architecture and painting empowered the bourgeoisie, gave them status, and pointed to their new wealth.

JA: It meant that they had arrived.

MS: Yes. They had arrived. When you look at art in a social way—I'm not a Marxist, and I don't want to overdo it because there are other things

[3] A petition signed by 1,300 office workers initiated a process that resulted in the removal of the sculpture in 1989.

that come into art as well—but if artists just get out of this bind of "art for art's sake" so many interesting things can happen.

JA: The "art for art's sake" notion, from the perspective of history, is really a relatively recent notion, and up until then people were very comfortable with the idea that the artist was in the service of the church, or the state, or a private patron.

MS: People were also comfortable with the idea of the artist as an artisan. Until the romantic notion of genius emerged in people's consciousness, artists were workers who did *work,* just like other people. I like that idea.

I also like the idea of being rewarded for what I do. When I won the Skowhegan Award I was really very proud. I was particularly proud of the fact that one of the reasons I won it was because a very interesting group of people made the choice and rarely are women nominated.

JA: Was that for inventing *femmage?*

MS: Yes. They didn't call it that, but that was really what it was for.

JA: For making the idea—

MS: For making the historical idea that women on their own contributed to the history of art, and the code word for that was *femmage.*

JA: Shifting it from lower to higher art?

MS: All of that. But also, recognizing that women had played a part in humanizing civilization, and so my collages, which I called femmage, were singled out for that and recognized for that. But I wasn't the usual kind of person to give that prize to. They usually give it to the blue-chip artists, like Rauchenberg, Johns, and Lichtenstein.

JA: It must be extremely satisfying to be understood and appreciated.

MS: I told you when we first started talking that one of the great rewards, even though I've had to put up with a lot, was that I learned what it meant to be bonded to women. That we women can serve as the "good mothers" for each other is really important, because it means that there's always support and one doesn't need to be isolated. You know the women are always out there, and you know they're going to recognize what you do, and you understand and respect who they are and what they do.

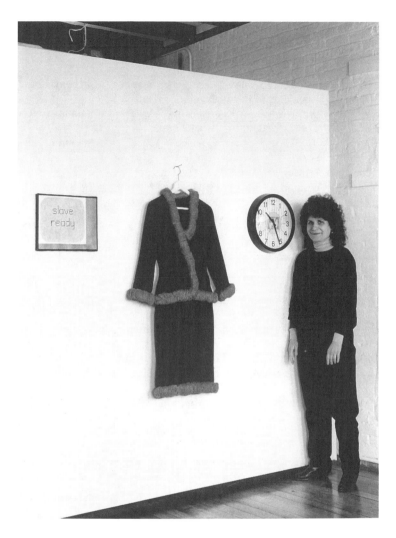

Plate 17. Mimi Smith in front of *Slave Ready,* 1991. Painting, steel wool and pin-stripe suit, clock, 50″ × 75″. Photo by Burt Lieberman.

Mimi Smith

Education:

1966 M.F.A., Rutgers University, New Brunswick, New Jersey
1963 B.F.A., Massachusetts College of Art, Boston, Massachusetts

Selected Solo Exhibitions

1994	Institute of Contemporary Art, University of Pennsylvania, Philadelphia, Pennsylvania
1993	"Mimi Smith: A Retrospective," Valencia Community College, Orlando, Florida (catalogue)
1990	"Books and Small Objects," Bound and Unbound, New York, New York (catalogue)
1980	Art Center, Waco, Texas (catalogue)
1978–79	Women Artists Series, Douglass College, New Brunswick, New Jersey

Selected Group Exhibitions:

1993	"Women at War," Ledisflam Gallery, New York, New York
1992	"Ten Steps," Muranushi Lederman Gallery, New York, New York
1991	"Artists of Conscience," Alternative Museum, New York, New York
1990	"Television Apparatus," New Museum, New York, New York
1989	"Clock Work," Massachusetts Institute of Technology, List Visual Arts Center, Cambridge, Massachusetts (catalogue)
1988	"Committed to Print," Museum of Modern Art, New York, New York (catalogue)
1986	"Let's Play House," Bernice Steinbaum Gallery, New York, New York

Selected Bibliography

Princenthal, Nancy. "Artists Book Beat." *Print Collectors Newsletter* (January-February 1991): 235–38.

Harrison, Helen A. "About Time Examines Approaches to Temporal Themes." *New York Times* (Long Island Section), 1 March 1987.

Artists Books: A Critical Anthology and Sourcebook. Edited by Joan Lyons. Layton, Utah: G. M. Smith, in association with Peregrine Smith Books; Rochester, N.Y.: Visual Studies Workshop Press, 1985, 52, 54, 76–78.

Smith, Mimi. *This Is a Test*. Rochester, N.Y.: Visual Studies Workshop, 1983.

Mimi Smith: Television Drawings. Essay by Paul Rogers Harris. Waco, Tex.: Art Center, 1980.

Interview

Mimi Smith was interviewed by Joan Arbeiter in 1988

JA: How did you get to Rutgers in New Brunswick from Boston?

MS: I went to Massachusetts College of Art as an undergraduate and decided I was going to come to New York and be a painter. I was not planning to go to graduate school, but after a series of absolutely terrible jobs, I realized I was not going to be able to do what I wanted to do, which was to do my painting. So I thought going to graduate school would save me for two years. It would just give me a place that I could do my work. Actually, it did. When I got to Rutgers, the work that I was exposed to was incredibly different from anything I had ever seen. It was just shockingly different.

JA: You didn't expect that?

MS: No. No. It had a huge impact! The undergraduate school that I went to was rather conservative. When I first started as an undergraduate the work I did had content, and I used to do a lot of realistic paintings. I liked Käthe Kollwitz and the German expressionists. That was the kind of work I really liked. By my senior year, I started to do abstract paintings and drawings just because, I think, that's what everyone was doing. I wanted to try everything. I was open to almost anything that fell in my lap. It was one of those schools where you had a little watercolor, a little architectural drawing, a little engineering. Everything I did was exciting to me, although the school wasn't a great school. Afterwards, I realized that as far as training *women* in fine arts, it was a terrible school. One drawing teacher said, "Well, you're a really great draftsman, but we're not going to have to worry about you because you're going to get married and have two kids." Years later, I wondered how he knew.

Before I went to Mass. Art, I had never gone to any art school, except one year I took a Saturday afternoon class at the Boston Museum School, when I was about twelve. I would wander around the museum, and the things I liked to look at the most were the rooms with the period costumes. Maybe that had something to do with why I thought clothes could be art. I'm not sure, but much later, after I did the clothes, it kind of clicked somewhere.

Anyway, by the time I came to New York I was doing pretty much abstract art. Big paintings and small paintings. I moved in with a man who

was eventually to become my husband. We lived in a tiny little apartment, and I was doing these big paintings. I had a series of awful jobs for one summer and then went to graduate school at Rutgers.

JA: In other words, you really had the kind of courage that you read about, where you left home and struck out on your own.

MS: Yeah. It was either courage or stupidity. I'm not sure which. I wanted to be an artist, but I didn't know what being an artist meant. I was going to be an artist, and I wanted to *really* be an artist. That was what I wanted to do. So I came to New York to be an artist.

JA: You encountered Bob Watts and Fluxus at Rutgers?

MS: Yes. Bob Watts was my teacher, and he eventually became my thesis advisor, and it just blew my mind, the things that I saw. But in addition to Bob Watts, I was in a seminar class that was run by Robert Morris. The combination, I realized afterwards—although I didn't at the time—was so exciting. They would take us to all these happenings and also to lectures at the Ninety-second Street Y, where we got exposed to Marshall McLuhan, and Norman O. Brown, and Buckminster Fuller. So, the combination of Bob Watts's Fluxus, where you could do anything, and Robert Morris's intellectualism was really what determined my work, I think. There was a period—it wasn't the last year I was there, it was before that—where I was doing sculpture in Bob Watts's class, and I had made an abstract sculptural thing out of fabrics. I was using a lot of fabric; I was adding fabric to paintings and flat surfaces. I was kind of making three-dimensional collages and hanging things, and I was using sewing in them. I'd always liked to sew. I used to make my own clothes, which I guess a lot of girls did at that time, and I remember doing this piece that I had worked on quite a lot. I showed it to Bob Watts, and he made some kind of comment that it was like a cleaned up Kaprow, because my work was always kind of meticulous. We had a talk, and I said, "What I'd really like to do, instead of making these abstract shapes with sewing, is make clothes or something like that." I might have even seen Oldenberg's *Big Shirt*. I don't remember if I had seen it before or after, but I somehow wanted my art—and I have a thesis that I wrote about this—I wanted my work to somehow say something about my life. I felt that my life was kind of ordinary, but I felt that it was the same kind of background that everyone had.

JA: It's interesting that you didn't feel the need to hide this ordinariness, or try to be sophisticated.

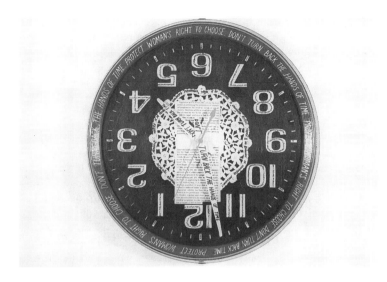

Plate 18. *Don't Turn Back,* 1985. Acrylic paint, paper, ink, xerox on clock, 15″ diameter × 3″ deep.

MS: Oh, no. I wasn't trying to hide it. I was trying to use it. I thought that if I could pick up some chords in my own background, since everyone else had the same experiences, people would respond to what I was doing.

JA: So, in other words, you wanted to have a dialogue with an audience. It wasn't art for its own sake.

MS: I was interested in communication, very interested.

JA: Do you think that it was Rutgers' input, or was that something that you brought with you?

MS: The female part of it was obviously something I brought with me. There was nothing to do with females at Rutgers, that was for sure! I mean, there were things to do with females, but we won't go into that. There was nothing to do with female art at Rutgers at the time, and I was just kind of working off my own experiences, I think.

JA: The need to be understood, the need to share—does that come from . . . ?

MS: It might have been from my initial involvement with German expressionism. I'm not quite sure. Whereas in Fluxus I don't think they cared about being understood at all. They thought of themselves as an "in" club.

JA: Right. The elitist versus the everyday.

MS: Yeah. I didn't want to be an elitist. I wanted my work to really go out; I wanted someone's mother-in-law to look at my peignoir and know what I was talking about. I guess that was what I wanted to do.

And I started fooling around with different fabrics. I lived in New York, and I would take the train to New Jersey with these clothes that I kept making, and I'd bring them in Bloomingdale's boxes or some kind of big clothing boxes. For my thesis show I did this big plastic wedding environment, all in white. I felt that the wedding gown was a real symbol of American girlhood. It was even before we called girls "women," it was something that really symbolized what it was all about, growing up as girl or woman in this country. I had this big plastic wedding gown, and thirty feet of trains made out of carpet runners, and there were all these satin ribbons and doilies. The veil was made from plastic film reels with tissue paper, and I took plastic lace tablecloths and cut around the lace and made all this little fancy stuff. I did show the train later at the Douglass show, in 1979. By the way, I did not have a wedding gown. I got married in City Hall, so maybe that was my wedding gown.

And then I did a number of clothing sculptures. I did a very thin plastic dress which was like a model's dress. I did a see-through bikini, which was enormous, for a heavyset woman—I guess I always thought I was too fat. Another piece, *Steelwool Peignoir,* a fancy dressing gown made from sheer nylon and trimmed in steel wool, was nearly five feet high. This was done after I had gotten married, so I was really put into this new role. The peignoir, I thought, represented the reality of my situation versus the fantasy of what I thought it was going to be. I was one of those kids who just loved the movies; even now, you can say any word and I remember a song from the 1940s—they just pop out of my mouth. I always had boyfriends from the time I was a very young girl. I was always looking for romance. Then, no more. I'm not sure what I expected would happen, but I was looking for something wonderful.

JA: You bought the whole fifties sensibility.

MS: I bought it. I bought it. I had this theory at the time: I wanted to say something about being a girl and growing up. I felt that in our society girls especially, but even men, had more experience in looking at clothes than they did in looking at art. So I felt if I made something that looked

like clothes already they could understand half of it. My notion for doing the clothes was based on that, and that idea has been recurring in my work for a very long time. In fact, in all my work I like to pick things that I feel are already used as visual objects. When I did the furniture it was because I was in a house with two children surrounded by all this furniture, and that is what I looked at all the time. People look at furniture all the time. When I started to do work that was based on television news I did it because I felt that we spend an enormous amount of time just staring at this essentially square box. And yet, the message wasn't coming out from the square. I mean, we were just looking at this thing and kind of being doped up and not really absorbing the information that was being sent out because it's the nature of the medium to dope us up. I became a little obsessed with time at one point, and I felt you look at a clock but you don't really get the implications of time. And I feel it's the same thing with the houses and computers that I use in my work.

JA: Did the input from graduate school include the other female art students?

MS: I remember talking to Joan Snyder and Jackie Winsor. We talked about our work, but at that time feminism wasn't something you even thought about. I don't think the actual word was ever used. It wasn't a conscious thing. You might talk about wanting to do something because this was what you had experienced. You didn't say it was feminist and you didn't say—

JA: You didn't recognize it as a political statement.

MS: Not at all.

JA: So you came in as an abstract painter and you left as a—how would you describe yourself?

MS: When I did the clothes I thought of myself as a sculptor. I felt that I was making sculpture. I never ever thought of the clothes as clothing. I thought of them as sculpture that had taken the form of clothing.

JA: When did you think about entering the professional art scene?

MS: There were a number of people who came to see the students at Rutgers—talent scouts, I guess you'd call them. The art world was expanding at a rapid rate then, and if you knew what you wanted to do, you probably could have hooked into a system then, if you even understood that there *was* a system, which I certainly didn't.

There was a Fifty-seventh Street gallery owner who was interested in my work; this was at the very end of graduate school. He particularly liked my plastic clothes, and he had me come up to the gallery. He even wanted me to model some of them, and he wanted to send information about them to Eugenia Sheppard. This was not what I wanted. I didn't think of them as fashion, and I didn't think of them as some pop-art fashion thing. I basically took my clothes and went home. I mean, not that I had ever been promised anything, but I didn't feel comfortable, and I didn't go any further with it. And I went home, and I'm not sure any of this is in the exact order, but I went home, and I got pregnant and—

JA: It was safer.

MS: Yes, I think that probably was it. I mean, I didn't realize it at the time. I rationalized my pregnancy by saying I was involved with work that represented the life of a woman, and here I was, furthering my work. But I also felt I needed more time. I remember thinking that I could have kids and spend five years or so developing my work further before I started getting into commercial galleries. I thought that having a child would give me a ton of time, that I could stay home with this baby and work on my art work. I read in a book that they only had to be fed every four hours, so I thought I was just going to feed this baby and have these huge four-hour stretches to work on my art. I was wrong, needless to say.

It was a very different art world in 1966. There weren't too many galleries, and the pressure was not to be commercially successful. That idea was just starting. Also, I don't think that women were as ambitious then, or even recognized their own ambitions. I know I didn't. Of course I *am* ambitious for my art, but I had never thought of myself as that. I identified with the male artist, as an artist. The feminist movement changed the way women saw themselves and even the way they spoke to each other on a professional level.

JA: What year was your son born?

MS: The very end of 1966. Bruce recently graduated from college.

I kind of stayed out of things for a number of years after that. Not because of my son particularly, although my son and what was happening with my life did start influencing my art. I still wanted my work to be influenced by what was going on in my life. A few months after Bruce was born, I became pregnant, not planned, and I had a miscarriage. But then I convinced myself that it would be nice to have two children close together. Unfortunately, I proceeded to have a number of miscarriages late in term, so I ended up spending a lot of time in bed and did some "knit-baby" sculptures. There was a sculpture I made of a knit-baby, and I

made the instructions to go with it. I saw these women knitting sweaters, which I never did, but I thought of pregnancy as knitting a baby. I thought it would be far easier to knit a baby than go through this, certainly. I made a little undershirt for this knit-baby, and then I had the miscarriage, and so I embroidered on the front of it, "the baby is dead." And years later, when some feminist women saw this sculpture they interpreted it as a feminist statement. It wasn't. It was personal. My life changed, needless to say. I stopped seeing people because I was forced to spend all that time at home.

And then my daughter Jenny was born in 1970, and that freed me from pregnancy, and I started working more on my art work. While I was pregnant I was doing work besides the knit-baby, but because I couldn't really do much, I did some very, very small wood engravings of kitchen appliances and babies.

After that we moved. My husband got a new job, and I found myself in Cleveland with two small children and this big house and all this furniture and appliances surrounding me, and I decided I wanted to somehow do something with this new subject matter, and I started to make knotted string and thread drawings of the furniture.

I subscribed to art magazines because I was out in Cleveland. I was reading all these articles about process art, and I began to make these string drawings. They were two pieces of string repetitively knotted together. I felt that it made an interesting visual line that had compacted energy. Earlier, in the 1960s when I was doing the dresses, I made what I called *The Basic Black Dress*. (In the 1960s everyone had a "basic black dress.") It was just the seams and the zipper, and I made the seams by taking two pieces of thread and tying them together. Now, using what had become the processes of my life, which I felt was machinelike and repetitive, I did the kitchen—the stove, the sink, the refrigerator. Then I did the bedroom—the bed, the bureaus. I did the fireplace, I did the television, sofa, stairways. You name it, I did the whole house.

JA: And this was the 1970s? Did you show these to anybody?

MS: I was in Cleveland for just a year and a half, but I went to what was the only gallery in town at the time; it was run by two really nice women, Nina Sundell and Marjorie Talalay. I went because I noticed that Keith Sonnier was in a group show there. Keith was someone I was quite friendly with in graduate school, and I was really starved for some connection with art. They had a lot of interesting shows. Somewhere towards the end of the year I decided to ask them if I could just show them my work, and they said, Sure. So I came in with a little suitcase. I brought some of my clothes and some of the string things. They were very portable. They always untangle, and they always stretch out to be the

same shape. You could put them in Baggies and take them anywhere. That was one of the wonderful things about them. I was moving around a lot so I liked the idea that I could pack them up and just go. I brought them those things, and they were doing what was going to be the last show in that big space.

They had picked five male artists to do room installations, and, incredibly, they also asked me if I would like to do a room installation. I did a room installation of my bedroom. After that, they introduced me to a couple of people. Patterson Sims came out, and he said I should contact him if I came back to New York. When I did come back I went to see Patterson Sims at O.K. Harris, and Ivan Karp came to see my work, and I eventually had a show at 100 Acres. I showed some of the string pieces at Artists Space. It was one of the early Artists Space shows.

At that time my work was changing again. For one thing, the impetus that had caused me to do these compacted knots in the early 1970s changed. I was no longer stuck in this house with this furniture. I was now living on West Broadway, and I was becoming more verbal. One thing about me, I was incredibly quiet at that time. I don't think I really verbalized to others what I was doing, except in my thesis. It wasn't something that too many people did, actually. So it wasn't just me, but I don't think that artists verbalized that much about their art at the time.

With every one of the pieces, before I actually made them in string, I did a drawing. A little later—1974—I was starting to do pieces that didn't have strings, that were just drawings on paper, but instead of the knotted visual line, the line had become sinuous words flowing almost like a stream of consciousness. In the early ones the words just identified the object. I did a drawing of my telephone—just made of my telephone number. I did a drawing of the television—just made of the word television, television, television, over and over again—and from there, they eventually became phrases.

One of the first pieces I did using phrases was at 112 Greene Street. I ran into Keith Sonnier, and he had to pick an artist for an exhibition at 112 Greene Street. I showed him some of my new things, and he asked me if I wanted to show there, and of course, I was happy to do it. I walked into the gallery, and what impressed me was the space. I did a show that just consisted of five drawings of windows on the five back windows, which was the entire back wall of the gallery. Three of them were on plastic and two of them were on paper. The two on paper were drawings of my own windows, and the three on plastic were drawings of the gallery windows. They were kind of minimal-looking outlines of windows made up of words and phrases. One of the drawings of my own window said "Please open the window, I'm going to faint" over and over again, and the other one said "Please close the window, it's freezing cold." The three plastic drawings said, over and over again, "Don't go

outside, it's dirty outside, don't go outside, it's noisy outside," and then I took these drawings and read each one of them into a tape recorder. I had five different tape recorders that had different lengths from about eight minutes to about twenty minutes, depending on how long it took me to read that drawing. The tape recorders were placed just under the windows, and a viewer could come in and push the buttons and play one or all or anything themselves. That was my show at 112 Greene Street.

JA: Now, were you just being ironic? How conscious were you at the time of being political?

MS: I'm really not sure. Yes. As it turned out, I was being political. I had verbalized that I had wanted this work to be relevant, to be about issues that were meaningful. But I was never part of all the early 1970s political art movement, probably because I was lying on my back trying to have a baby. In fact, early feminism didn't approve of having children, and it was politically incorrect to have both a child and a husband.

JA: When you said, "Don't go outside, it's dirty," are you quoting what your mother might have said to you?

MS: I was quoting myself, what I might say to my kids. This was the first piece that I did about the environment. In the television work, which came up right after that, I started to do that because the television was on a lot in my house. My kids were getting a little older, and the television was constantly on in the background. I've always been a person that really is interested in the news, and so I always had the news on, and somehow it seemed like the outside world was invading my inside world, and that's what I started to do the television pieces about. I would take notes from a newscast, shape the text to make a drawing of it, and then combine that with either one word, or my news, or a phrase that I myself might say.

JA: So you were giving yourself a voice.

MS: I was giving myself a voice in the news, and I was saying things from my day-to-day existence, which I thought were probably good things to say. I did some performances at that time too, and those performances came right from that. I didn't do too many performances because I found it just too nerve-wracking. In my performances I would read one of my news drawings, and at the same time I would have the live television on with the news of that day. It was always a performance during actual news time, and I'd have a soundless TV newscast on from that day. I'd have audiotapes that kept talking while I was talking. They

would say either things that I'd want to say or things that I might actually say around the house, and I thought that these were things that you should say in the context of the news. Things like "Just sit right down and stop that fighting," which I said a lot in the house; things like, "Get up," "Wake up," "Shut up," "Pay attention," "Stop fooling around." Just things that I wanted to say to these people who were conducting these international affairs, things that I thought were valid.

JA: You were taking on a role as a mother to the world.

MS: Right. I mean, if I could say, "Sit down and stop that fighting" to all those guys that were fighting out there then it would be a better place. These were definitely, consciously political, although I don't think I ever used the words "consciously political" at the time. Even the "Shut up" meant "This is enough of that."

One piece I did do at the time, which I showed at Franklin Furnace, was slightly different. It was called *Television News One Day,* and I took the morning news broadcast, noon news, and the evening news, and I had their news in the drawing, and then I surrounded it with things that happened in my news, and I had a double-track tape that had their news. I started with the morning, saying things like "Get up," "Wake up," "Come on, eat your breakfast," "Let's get going," and it continued on to "Eat your lunch," and at night I was saying "Sleep tight," "Good night," "Good dreams." Those were the pieces I was doing at that time. Then they got a little more complex. Instead of having the drawing with the news I started to turn them into installations. I did one at 55 Mercer that had thirty news drawings, and I lined them up in rows like television monitors in the studio, and I had a tape with three selected drawings that included background comments of my own. Then I did another one the following year that had color television drawings. I had bought a color television and started to add color. My work became more visual, and I would notice the predominant color for each news broadcast, and that would be just another source of information that I would add.

JA: And this was in 1978? You used a third track?

MS: Right. And then I did the installation at P.S.1, in which I took advantage of the schoolroom aspect, and it was also a news broadcast. It was the anniversary of the dropping of the atomic bomb and the world's largest oil slick. I combined that with some things from educational television, some things from "Sesame Street," some things that said "Read." Then I had this other tape that said, "Pay attention; no daydreaming allowed," which was from my earlier days of sitting in school and daydreaming. I thought that was something that one could say in a school.

JA: This was the first time you said "Pay attention"?

MS: Well, no. I had said "Pay attention" before, but now I was getting to "No daydreaming allowed; this is Monday." Just getting into things you would say in school. I thought those were also good things that you could say to people that were conducting international affairs, since they seem to be daydreaming pretty much of the time.

JA: As if you were a teacher addressing the people responsible for all this mess.

MS: I thought of these as very conceptual pieces since I *was* using words. I was using information. And, formally, the drawings were made up of a monitor shape that contained a continuous flow of words. The words were composed of the TV news and my own phrases. I wasn't drawing an image of a television set that had pictures on it. I was using a television not as something that gives you pictures but as something that gives you information.

JA: And your form was advancing your content.

MS: Right. I thought of it as very conceptual. And then I did a show at 55 Mercer, called *House with Clouds,* that was about a house inspired by Three-Mile Island and by a documentary on pollution that I had seen on Channel 13 [WNET-TV, a PBS outlet in New York City]. It had to do with pollution and people getting sick in their houses. I had drawings on the wall that looked like clouds, and they said "Dirty air, dirty air" all over them. In the house, in one of the windows, was a drawing that had the news broadcast from Three-Mile Island. I took phrases from the tape. I also had the drawing from the documentary of people who were made sick in their houses by pollution. In another window I had three tapes. All over the drawing, where the text forms lines, words were written that said over and over again, in a singsong fashion, "Please get your pollution away from our house, just get those oil slicks out of our house, we don't want smokestacks near our house, etc." The thing about the Three-Mile Island newscast that got me, and also this other newscast, was that no one wanted pollution near their house. You know, no one does, and their children were getting hurt, and they said things that I picked out in the three tapes. One of them was this singsong tape. The other one said things like "We didn't know what to do; we just grabbed the kids and ran." The third one had more medical stories about kids that had gotten sick from pollution in their houses, and some of them had died, and about women that had miscarriages.

JA: I've noticed the introduction of the word "please." I don't know if that just came naturally to you, but it changes it from an angry command to a plea.

MS: It's also very female. I was pleading. It's more female to be polite than angry.

JA: Exactly. And well-behaved.

MS: Very well-behaved, and you had to really listen to it. That's also, I think, a pretty female thing; it's neat, it's clean, no real angry images. Even when I started to do more angry pieces I did them on grids, and they're very —

JA: Controlled?

MS: Controlled. Right. Then I did a number of antinuclear house pieces and an installation at Chase Manhattan Bank.

JA: Let's see, I have a list of your house pieces: 1980, *House With Clouds;* 1982, *Home Sweet Home* and *Bless This House,* which had a TV monitor; and from 1983, *All Through the Night,* also with a monitor. Now, I see the image of the woman with the raised arm used a lot after that. Do you want to describe her and where she came from?

MS: She was one of the first images I did on a computer when I was fooling around with digitizing my own image. I'm the one who is screaming. I'm shielding myself.

JA: Your children were very vulnerable at this age. Do you think that had anything to do with that? Feeling their vulnerability?

MS: Definitely. The antinuclear and pollution issues came from being a mother—for me, anyway. I did other antinuclear pieces, this was in 1983.

JA: Where do the clocks and the artist's books fit in?

MS: From the mid-1970s on. I was also always doing clocks and artist's books, and I have continued to do them occasionally, right up to the present time.

JA: Are the books related to each other? Do you see them all as a series even though they're not done in one short span of time?

MS: I do, yes. I liked doing the artist's books. Some of the earliest artist's books were mainly calligraphic. I also did an artist's book on news, that I showed in Franklin Furnace in 1977. It was called *Television News One Day,* and I did another antinuclear book, *Stop Before It's Too Late.*

JA: I didn't realize *Television News One Day* was a book. It's so large.

MS: Yes, it's a large size, sixty inches by twenty inches, but it is a book, although it has only three pages. I did a separate series, little calligraphic books. I called them "Dear Art," and I kind of thought of that a bit like a diary, but more; I almost felt like I was having an affair with my art. It saved me. Without my art I probably would have been stuck in the suburbs. That series was very special and something aside from everything else. It was something I could talk to. I could say all these things to *Art* that I couldn't really say to anyone else. Some of the words you can decipher and some of them are intentionally unreadable, and each one of the pages has something to do with that day. That was a separate series that I did from 1976 to 1980.

I also did foldout books, accordion pleated. What I liked about making those foldout books was you could put a whole lot of images in one little, contained, compact package. I thought of them almost like a one-person show. You could get a whole idea across using a lot of different pages, and that was what I used them for.

I basically did two kinds of early foldout books. One series dealt with TV news information and one series was antinuclear. The book *This Is a Test,* which I published in 1983, was a combination and culmination of the books on these two themes. I got a grant for that from the New York State Council on the Arts. In that book I told the story of five fictitious nuclear bomb blasts and what happened to five cities around the world. I used "This is a test, this is only a test. Had it been . . . " which they use on the broadcasts, and I ended saying, "This was only a test, had it been an actual emergency"—and the next page is totally black, and that's the end of it.

JA: Tell us about the clocks now.

MS: I began to do clocks in 1975. The first clock had written all over it "Time is passing." The early ones just were concerned with time, and they said, "20 years ago" and "What will happen tomorrow" and things like that. By 1982, they had become political, and most of them focus on particular subject matter. Some of them are antinuclear, like *Zero Hour.* Some are antipollution, like *Time Is Running Out.* I did a pro-abortion clock in 1985. That's the one that is upside down. It's called *Don't Turn Back.*

JA: There is also a clock from 1982 which is titled *She Spent Too Much Time in the Kitchen.* Is that a personal statement?

MS: Right. But also, I guess, political. Feminist political.

JA: Then in 1983 you had a clock called *Zero Hour*?

MS: It's against Star Wars and putting arms in space.

JA: In 1983 you also had a window installation at Printed Matter. Was that a clock?

MS: Right. It had a bomb at the time of the Hiroshima explosion, then another bomb at the time of the Nagasaki one, and it says, "Time heals nothing."

JA: Then in 1986 you had a clock called *Her Time, Their Money.*

MS: That's basically about the fact that women made two-thirds of what men made. I took these dollar bills and cut them in thirds and two-thirds.

JA: And in 1986 you did another clock piece called *Another Year.*

MS: A picture of me screaming. I did it at the beginning of the year. Another clock is called *A Woman's Work Is Never Done* and also has a picture of me. I'm holding my hand over my head like—Oh! woman's work is never done—like—Oh, no! And this is also a computer printout picture, and at each hour there's another thing to work on—like poverty, racism, sexism, nuclear disarmament, antiwar. And in 1989, I did other clocks: *Time Is Money,* and the AIDS clocks: *Dead Before Their Time, The Days Are Long,* and *By the Year . . .*

JA: So your clocks, like your books, and in fact all your pieces, are continuing vehicles for your basic concerns. And the latest inspiration comes from the computer image?

MS: The computer image and the computer medium. I started to do that work in 1982.

JA: Always with the intention, the conscious intention, of making art from it?

MS: Conscious intention, or just seeing where it would lead me in my art. To see if it would be fun, if it would be interesting, if I could use it. I was more interested in how society is absorbing this new machine than in fiddling around with the machine itself. I'm not a person who easily fiddles with machines.

Color Screen is a piece I did in 1985 on the monitor, but then the monitor is covered with a Plexiglas frame that has a drawing on it. In all the computer pieces I did there were no wire pieces sticking out—everything was always hidden. And when I did the big drawings of houses with the monitor inside they were essentially like the houses I did with the TV drawings, but instead of having a drawing in the window I had the monitor in the window hole, and the computer was always something hidden. In those pieces I sort of envisioned I was making a little movie. I would throw images and words on the screen. Both of them were antinuclear: *Bless This House* in 1982 and *All Through the Night* a year later.

JA: Right. The drawings are large. Ten feet tall by six feet wide, and the monitor shows through as if it were a window.

MS: Then there was a sort of digitized sequence of pictures with me screaming with different scream faces.

JA: I see. You have used the digitization, especially your face, in other forms?

MS: Yes, I'm using the digitized images in more conventional pieces of artwork. I paste them into the clocks, or I put them on paintings, or I use them in books. But in the beginning, I was more interested in the computer, how it was affecting society. It was political and conceptual. The same thing. How this new image, and its new language, was invading our space and what implications it had, if any.

JA: I remember that people had similar fears when television was first introduced, and some, in fact, still do.

MS: The language really interested me. It was loaded, psychologically. I found it interesting that the machine was coming back to me with these words that had psychological implications. I've done wall paintings of computer error messages. When you make a mistake on the computer, this error message comes up, and from the very beginning, since I made a lot of mistakes, the messages that came up amazed me. They were sort of in English, but they weren't really.

JA: The language became the subject.

MS: Yes, but also I was interested in the digitized image and how it was made up of dots, and I thought of it almost like electronic needlepoint. It was very similar to my earlier drawings and my string pieces in that it was meticulous, repetitive, and sort of gridlike. I could really get into it,

and again, I was using the image of the screaming woman. I was using pictures of women that I found in the news, particularly women who had things happen to their children. Like the *Arson* one. The *Middle East* one is another one—that was a picture of a woman from Lebanon. *Civil Defense* was another one. I did one called *Save the Baby*. One was based on the fact that when my son turned eighteen and had to register to get his financial aid, he started getting all kinds of mail from the Marines and the Navy . . .

JA: Why did you decide to use your own face as the screaming woman? Were they meant to be self-portraits?

MS: No. They were never meant to be self-portraits. I used my face only because I was available.

JA: You were your own model.

MS: I was my own model, but I never thought of it as a portrait of myself, or even as a portrait of these other women. I just thought of it as the expressions of a face. Since the digitized picture was kind of abstracted anyway, it seemed to me that by moving a few dots here and there you could change what came across in an expressive manner in the face. That's why I was using my face, and the reason I was using such highly charged images was because it seemed to me the computer was such an impersonal, cold thing.

JA: It works to personalize the political.

MS: I have a series of three house paintings. It started in 1986. The title of each one of the paintings is the number that's in the door of the painting. What I'm doing in these paintings is using programming language to tell a narrative. I don't even know if this is a program that would run, you know; I'm not writing a program. I'm taking language that you would find in a program and using it in its double meaning, as vernacular English, so anyone would understand it. The first painting is called *10 Home, 20 Normal.* When you start a program in BASIC, you just put "home," and I found that kind of interesting that you start at the home. In that particular painting, in the window, I have five drawings of a woman, a man, a child, an automobile, and a television, and I'm representing a normal home, or what is or was considered in our society a normal home. The next painting is called *30 Syntax Error,* and I used that just because "syntax error" is a phrase that's used in programming language, and that I think has certainly invaded society as a whole. It's not something that only programmers know about. I mean, "syntax error" is

a phrase that most people have heard. It means that you made a language mistake or something like that. And in this painting, in the window, I have a picture of a computer keyboard, two robot hands, two human hands, and it kind of represents the technology taking over the hand.

JA: Yes. That I understood.

MS: And *40 End, 50 Delete* is the end of the program. And at the end of a program you "end," and "delete" just means that you're going to erase it and start over again. In that painting, starting somewhere at the middle of the painting, everything begins to be destroyed. At the bottom it's going into an abstract checkered pattern, which represents the potential of technology to blow us away. I'm saying "delete" and let's start over again, like maybe we've approached this technology in a wrong way. While there is humor and irony, this painting is more scary and political than the other two.

I also did an installation piece for a subway station in which, again, I used error messages to tell a story. The name of this piece, *The Changing Face of Soho,* was the name of the show, curated by Art Makers.

JA: In these, you seem to have a woman doing three things, or you have three—

MS: Three separate stages. The changing face. The first one is a woman who is kind of happy, and it says "run program and draw," and that's when you first come to Soho. The second one is a woman who looks kind of horrified, and it says "dollar errors." There's a dollar sign which means something in programming language that I'm not even quite certain of. Help, question mark, dollar sign, errors—those are a reference to the commercial, what's happening in Soho. And the last one's face is self-explanatory, and it's "erase, retype" and was "let's start over again." As someone who's lived in Soho for a long time—we moved here in 1973–1974—I've seen the changes. That was my changing face of Soho—when I first came here there was excitement. I thought of it as a comical piece, in a way.

JA: I could see that there was humor in it.

MS: Graphically, I wanted the faces to stand out whether people understood what I was saying or not. I thought it didn't matter whether they understood that it was programming language. I thought they'd understand the dollar signs and question marks and arrows and erase and retype and all that sort of thing. Even though I'm dealing with programming language, which is kind of sophisticated, I think I'm dealing with it on a basic level.

JA: I think this brings us up to your Error Message series.

MS: Those are based on programming mistakes that I pick up. I collect error messages from friends. I mentioned that I'm so amazed at the loaded quality of the language: "Press escape" is something that every-one has wanted to do at one time or another and "fatal error" is mind-boggling! I also did a piece on the error messages in the I.B.M. system: "abort," "retry," "ignore," in which I used pictures of myself. I guess I'm responding to those words.

JA: You continue these themes in your latest book, *Technical Error 31,* which you just had published. You've taken your computer-generated art, along with hand-drawn images, turned them into photo engravings, and then had them printed in relief by letterpress.

MS: Yes. I'm contrasting Gutenberg and post-Gutenberg technologies and then packaging each copy as electronic equipment in cut-to-shape foam and plastic.

JA: So your sculpture, books, clocks, paintings, drawings are all contin-uously evolving from your basic concerns, and it seems that your real medium is the media itself.

MS: Yes. That is why I decided to stick it out with the computer. When I first started, I got a headache every time I sat in front of it. I felt this wasn't for me. But then, I thought, since I'm so into media, I wanted to at least understand it, just figure it out a little bit.

JA: Now it seems that every schoolchild has some computer literacy.

MS: Yes, and I'm concerned because of the impersonal or maybe per-sonal ways that one relates to the computer. I'm interested in the inva-sion of the digital image and computer language into everyday life. That's what I was trying to get at.

JA: Similar to how you felt about the television. But you have tamed them, made them work for you. Do you still feel threatened?

MS: No, I don't feel threatened, but I don't approve wholeheartedly. It's not that I'm against progress, just concerned about some of the things technology does. I'm not sure we are going in the right direction.

JA: Your work has certainly made a case for integrating humanistic sen-sibilities into technology. I wonder if people who read our book ten years

from now will be amused at how archaic our anxieties are. By being timely, by expressing your concerns about contemporary problems, you run the risk of becoming obsolete.

MS: Yes. I understand that. On the other hand, I think people will still be worried about the same things, even more so.

* * * * *

Addendum, 1993 (from the artist): Over the years there have been certain forms that I return to again and again in my work. These are clothing pieces, clock pieces, artist's books, drawings and paintings, and installations. In the eighties I started to make clothing pieces again. Some of these were more abstract and based on the notion of armor; others combined various elements, such as clothes with clocks, in an installation.

In 1988, by the time of the interview, I had begun work on a number of pieces, including the work *Slave Ready,* which is shown in my photo. I didn't mention these pieces during the interview because they were works in progress, and I wasn't quite sure where this work would go.

Slave Ready is an error message that someone had given me. I combined a painting of this error message with a woman's pinstripe fabric and steel-wool suit and a clock piece. I have been working primarily on clothing pieces since the interview, and I am currently working on a man's version of *Slave Ready.*

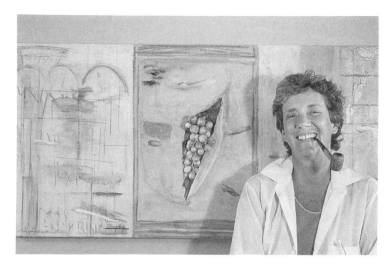

Plate 19. Joan Snyder in front of *Loves Pale Grapes,* 1982. Mixed media on canvas, 24″ × 48″. Photo by Janet T. Swanson.

Joan Snyder

Education:

1966 M.F.A., Rutgers University, New Brunswick, New Jersey
1962 A.B., Douglass College, New Brunswick, New Jersey

Selected Solo Exhibitions

1992 Hirschl & Adler Modern, New York, New York
1991 Nielsen Gallery, Boston Massachusetts (catalogue)
1990 Hirschl & Adler Modern, New York, New York (catalogue)
1988–89 "Joan Snyder Collects Joan Snyder," Santa Barbara Contemporary Arts Forum, Santa Barbara, California (traveling exhibit; catalogue)
1988 "Joan Snyder: Cantatas and Requiems," Compass Rose Gallery, Chicago, Illinois
1979 San Francisco Art Institute, San Francisco, California (traveling exhibit; catalogue)
1978 Neuberger Museum, SUNY at Purchase, New York (catalogue)
1971–72 Women Artists Series, Douglass College, New Brunswick,
1975–76 New Jersey

Selected Group Exhibitions

1990 "The Image of Abstract Painting in the Eighties," Rose Art
 Museum, Brandeis University, Waltham, Massachusetts (cat-
 alogue)
1989 "Making Their Mark: Women Artists Move into the Main-
 stream, 1970–1985," Cincinnati Art Museum, Cincinnati,
 Ohio (traveling exhibit; catalogue)
1987 Corcoran Biennial, Corcoran Gallery of Art, Washington,
 D.C.
1981 Whitney Biennial, Whitney Museum of American Art, New
 York, New York

Selected Bibliography

Cotter, Holland. "Joan Snyder." *New York Times,* 30 October 1992.
Pacheco, Patrick. "The New Faith in Painting." *Art and Antiques* 8 (May
 1991): 65.
Jones, Bill. "Joan Snyder." *Arts Magazine* 64, no. 10 (Summer 1990):
 76.
Ratcliff, Carter. "Notes on the Line." *Art in America* 78 (June 1990):
 152–57.
Perl, Jed. "Joan Snyder." *New Criterion* 8 (April 1990): 52–54.
Tucker, Marcia. "Anatomy of a Stroke: Recent Paintings by Joan Sny-
 der." *Artforum* 9, no. 9 (May 1971): 42–45.

Interview

Joan Synder was interviewed by Sally Swenson in 1992

SS: When did you know you wanted to be an artist? Were you studying
sociology first?

JS: I only knew I wanted to be an artist when I was a junior in college. I
had taken an introductory painting course, and four months into the
course I realized that I had found something that I had never found be-
fore in my life—a way to talk about my feelings, a way to speak—and
that was the beginning. I was a sociology major, which I made very good
use of over the years, because to support myself I worked with teenagers
and children in different kinds of social programs.

SS: Which artists, teachers, and others influenced you in your develop-
ment?

JS: Billy Pritchard was my first painting teacher. He introduced me to the German expressionists who I had a major link to in my own work. I didn't have a lot of teachers who influenced my development. I think that this was a journey that I took, with some guidance, pretty much on my own. One day Billy dragged me up to the slide room and said to me, "How do you like Yavalenski?" I had never heard of him. He showed me paintings by Yavalenski and other German expressionists, and that opened the door. It's never closed since.

SS: Please talk about the influence of children's art on your work. Of music.

JS: I always loved children's artwork. I had been working with children for years, on and off. They're great artists. They never make mistakes in their artwork, and before they're inhibited they do beautiful major work. I love children's work and it has always influenced me. Music influences me a lot. I learn from music. In my work I'm interested in beginnings and endings, resolutions, ups, downs.

SS: Please discuss your earlier works using female imagery and materials.

JS: I'm not interested in looking at a painting and seeing one image and one idea. It's the narrative that interests me. I like to have many things going on at once. I use what I called at the time, in the late sixties, female imagery, using lots of different material—flocking, beads, beans, threads, wallpaper, collage, string, silk, all kinds of materials to do my work and the imagery I thought was feminist imagery, which at that time wasn't being discussed at all. But the dialogue really began around then and got hot pretty quickly.

SS: Do you still think women make a different kind of art than men? If so, why?

JS: I do think women make a different kind of art than men. I think that's another whole book, so it would be hard for me to discuss it now, but I think that our lives are different, our bodies are different, our experiences are different, our development is different, our vision is different; we make different art. How could we make the same art? Sometimes the sensibilities overlap. A lot of times they don't. I see it very clearly; I've always seen it.

SS: Did the women's movement help or hinder you?

JS: I was part of the early women's movement. I think in some ways it hindered me because I've gotten the label of a "feminist," and it's a dirty

word in most art circles. But I think I am a feminist, and I think I am an artist. I don't know if I make feminist art. I certainly have female imagery in my art. It helps us all and it hurts us all. I don't think I'm unique in any of that experience.

SS: Although much of your painting is filled with personal and political pain, some is funny. Please comment.

JS: Some of my paintings are funny. Some of my life is funny. I don't like the idea of just using one idea throughout your lifetime, or one kind of feeling or one sensibility. I think that parts of our lives are tragic, parts of our lives are concerned with politics, parts of our lives are humorous. Some of our life obviously concerns eroticism in different kinds of ways. I put all those things in my paintings. That's what I like to do. I would get bored otherwise.

SS: Where do your symbols come from? They seem so personal.

JS: They are. They come from my unconscious, which I believe in and I trust. When I had a miscarriage, suddenly totems and fish bones and ladders began appearing in my work, and I later read that those are symbols of death. I never knew that or thought about it, but there they were. I think that this happens if you just allow it to happen. Images can come from anywhere.

SS: Do you work all year or take breaks?

JS: I take breaks—some longer than others—usually after shows. My mother's very sick now, and I am working but it's not easy. I think that the work takes its natural breaks, and I trust my process to do that. I don't feel like I have work block. Sometimes I just don't work. Sometimes I have to be at my desk for weeks or days. Sometimes I have to be at the orthodontist with my child.

SS: What role does landscape have in your work? And the use of written language?

JS: I love the land; I love the country; I love looking at it. I think nature doesn't make any mistakes, just like children don't make any in their artwork. When I look at nature I learn so many things from what I see— how it goes and how it falls, how it changes. So, landscape does have a big place in my work. As for language, I've written in paintings when I have to write, when I have to say something that I feel like I can't say in the painted images alone.

Plate 20. *Small Symphony for Women, II,* 1976 (central panel of 24″ × 72″ triptych). Mixed media on canvas, 24″ × 24″. Photo by Libby Turnock. Courtesy of Rochelle and Bob Gluckstein.

SS: Now that you have been a painter for many years, do you find yourself reexploring old images and feelings?

JS: I have to think about that. Old images and feelings—well, we make the same painting over and over and over again our whole lives basically, but then it changes and you have to allow it to change. You find yourself going back and rethinking, maybe looking at old paintings and saying, "Wow, look at that. Maybe I could go back to that and grow on that a little bit," because that was interesting. But I don't sit around thinking about my old work. When I do a slide lecture and show my old work I'm always amazed by seeing it, and it's usually overwhelming to me to see all my old work, so in a way I like to keep my mind clear more often than I like to be thinking about past work. If my mind is clear and I'm not thinking about anything, it's usually better for me and better for my work.

SS: What advice would you give to a young artist?

JS: Keep working; keep working. I used to say keep working for about ten years before you even think about showing; now I say maybe six because things move faster now. It's good to go to school. It's good to find people to look at your work and respond to your work and know you and know your work. I think to be an artist you really have to be obsessed by it. You really have to want to be an artist and absolutely nothing else, because it's not an easy thing to be or to do unless you have good financial backing, and then anything's easy—easier. Most artists don't have that kind of luxury. So, you have to be obsessed. Otherwise maybe you should do something else.

SS: When you were at Douglass College you had a wonderful idea of using the library as a gallery space for women artists. Would you discuss this briefly?

JS: The statement that I wrote for that, for the catalogue that Douglass College did for the twentieth anniversary catalogue, was exactly what happened and how I feel about it. So, I refer you to that:

> Has anything changed in the art world over the last 20 years? Has anything changed for women artists? Are we still discriminated against by curators, critics, and dealers? Do we still need to have women's shows? Why did the Women Artists Series begin in the first place? Why is it still going on?
>
> I entered Rutgers' M.F.A. program in 1963. The years I spent there, at that point in my life, were the best years of my life. My classmates were an intense, talented, generous group. The faculty consisted of some old blood and some new blood—all male blood. The irony of this situation was inescapable for the M.F.A. program which was on the Douglass campus, a women's college, had never had a woman teaching a studio course. These were the years right before the dawning of the women's/feminist art movement.
>
> Some years later, a new consciousness had awakened within me. Having moved to New York City in 1967, I was aware of the wonderful work being produced by women who had few places to exhibit. I was also aware that students at Douglass had no role models. The creation of the Women Artists Series was the solution to both problems. Daisy Shenholm [formerly Daisy Brightenback], director of Douglass Library, willingly provided space so that women artists could exhibit and students could see art that they would not have seen otherwise. I curated the first few years. I remember choosing artists either because I felt the students needed to see certain work, or the artist herself needed the exposure, or I simply loved the work and wanted it shown. It was very exciting.
>
> Did it need to be done then? Did it have meaning for the students, and for the artists? Yes, to these questions. Does it have meaning now? Proba-

bly yes. Women have more access to show now and they are taken more seriously. Are we discriminated against by curators, critics, and dealers? More frequently than not, but in the most subtle ways.

I believe that women artists pumped the blood back into the art movement in the 1970s and the 1980s. At the height of the Pop and Minimal movements, we were making other art—art that was personal, autobiographical, expressionistic, narrative, and political—using word and photographs and as many other materials as we could get our hands on. This was called Feminist Art. This was [what] the art of the 1980s was finally about, appropriated by the most famous male artists of the decade. They called it neo-expressionist. It wasn't neo to us. They were called heroic for bringing expression and the personal to their art. We were called Feminist (which was, of course, a dirty word). I offer a quote by Hilton Kramer as an example of how women artists are cut out of history:

> The whole phenomenon of New-Expressionism, and particularly the American aspects of it—Schnabel, Salle and Eric Fischl, and people of that generation—really has to be understood in relation to minimalism and colourfield abstraction, which by the 1970s had established a standard of visual anemia in art. There was a longing for a kind of art that was richer in visual incident. It was an invitation to the next generation to say, We're going to fill up those surfaces with everything we can lay our hands on.

> Except that it was women who did that. Nancy Spero did that, Faith Ringgold did that, Jackie Winsor did that—WE DID THAT. Is there still a need for the Women Artists Series at Douglass College? Yes. Perhaps another need is for a series which could be called "Setting the Record Straight: The 21st Year. The 21st Century."[1]

But if you want me to talk about it a litte bit, I will. It all began one day when I was walking across Woodlawn with Emily Alman, who is an ex-teacher and at that time a good friend. She was on the faculty at Douglass College, teaching sociology, and somehow or another I said to her it would be good if we could have some women's shows on this campus. And for some reason she said to me, "Why don't you talk to Daisy Brightenback," who was the head librarian. And I did that. I went to Daisy and she was immediately excited about the idea and immediately supportive. The idea of course was that at that point there were no women teaching studio courses in the art department at Douglass. And I felt like the women students needed to see some artwork by women. It had to be 1971. Daisy was immediately excited. I curated the shows for the first few years. Most of those people were people I knew. I felt like

[1]Joan Snyder, "It Wasn't Neo to Us," Journal of the Rutgers University Libraries 54, no. 1 (June 1992): 34–35.

they needed exposure, and that it would be great for the students to see their work, and I invited them. The one thing that I really remember was that we began by trying to have teas and discussions, and I'll never forget that at the first few there were probably less than a half-dozen people at any event that we tried to do. What's so moving to me is how it turned into such a major kind of a thing at Douglass, through a lot of very hard work and through necessity, I guess. Daisy, if I remember correctly, almost immediately assigned Lynn Miller to the task of whatever her title was, and Lynn and I worked very well together for years. And then I guess Lynn took over where I left off. That's about the story. The space wasn't great, but obviously it did the job and I think it made the point to the art department. It'd be interesting to see what happened, to look at the facts, but not long thereafter I bet that they might have hired a woman to teach. Not me—I was a thorn in their side—but some woman.

SS: There is almost a religious sense in many of your paintings. Please discuss.

JS: Maybe there is. I feel like my paintings are my religion. I made a statement in the catalogue for the Corcoran Biennial:

> Making art is, for me, practicing a religion. Our culture, such as it is, takes so much away from us and we get little in return. I am of Russian-German Jewish heritage. My grandmother Cohen (a key person in my life) was an Orthodox Jew. All of that is gone now, with her. There is no place to go back to for second generation Americans. And anyone who is living consciously in this world is suffering, some much more than others . . . so much is taken from us . . . so much of our heritage, our roots, our meaning, our identity, our sense of struggle, our beauty, our pride.
>
> My work is my pride, creates for me a heritage. It is a place to struggle freely at my altar. I want my work to be strong, available, generous. I need it to be joyous and sorrowful, complex and meditative, all at once. To be vulnerable, to have a feeling of transcendence and in this state to give meaning . . . go beyond structure and meaning, and content and offer something to people as a reminder and a gift.
>
> For the last few years I have gotten back to ideas in nature as a starting point, a way of initially thinking about or structuring a work. I am living in the country again. So much happens from the beginning of a painting to the end. It is hard sometimes to explain to someone that this is a bean field but means so much more to me . . . this is a moon but you see I have transcended the moon or was trying to.
>
> The act of painting is not unlike the act of making love. When you begin you hope for a certain ending, not knowing exactly what will happen in between but trying always . . . working at being conscious of what is happening and letting go at the same time. In painting (as in love), trusting your instincts or choices before you start is necessary. Choice of size,

materials, subject matter . . . a knowing of what you need to reach the end and why . . . how to touch it and when. And the subject is important because it is that which you are trying to transform . . . to work with and into and through to the finale when the work reaches the end. And a new painting comes alive . . . a painting offered to the collective "us" who I feel have been denied so much.[2]

[2]Joan Snyder, in an interview with Ned Rifkin, *Fortieth Biennial Exhibition of Contemporary American Painting* (Washington, D.C.: Corcoran Gallery, 1987).

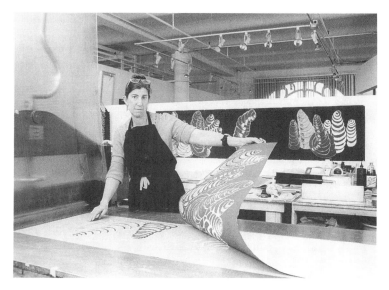

Plate 21. Master Printer Judith Solodkin in Solo Press Shop with work-in-progress by Louise Bourgeois (untitled, 21 1/2″ × 96″, lithography and woodcut with hand coloring), 1995. Photo by Sarah Lewis.

Judith Solodkin

Education

1974	Tamarind Master Printer, Tamarind Institute, Albuquerque, New Mexico
1967	M.F.A., Columbia University, New York, New York
1965	B.A., Brooklyn College, Brooklyn, New York

Selected Exhibitions, Solo Press

1992	"Sense and Sensibility"
1991	"Michael David: The Georgia Series"
1990	"Christian Marclay: *The White Album*"
	"John Hejduk: *Zenobia, Danse Macabre*"
1989	"John Torreano: *Gemlike Prints*"
	"Komar and Melamid: *I Bayonne*"
1988	"Howard Hodgkin: *Solo Prints*"
	"Robert Kushner, *Prints: A Summary*"
	"William Wegman, *Man Ray: Commemorative Prints*"

1976–77 Women Artists Series, Douglass College, New Brunswick, New Jersey

Selected Bibliography

Howard Hodgkin: Hand-Coloured Prints, 1986–91. London: Waddington Graphics, 1991.

Fine, Ruth E. "Judith Solodkin and Solo Press." *Tamarind Technical Papers* 13 (1990): 54–57.

Ross, John, and Clare Romano. *The Complete Printmaker*. New York: Free Press, 1990, 2, 82, 220–22, 291, 307, 316.

Ahrweiler, Helene, and Judith Solodkin. *Françoise Gilot*. Paris: Berggruen, 1989.

Gilmour, Pat. *Lasting Impressions: Lithography as Art*. Sydney, Australia: Australian National Gallery, 1988.

Gilmour, Pat. "Thorough Translaters and Thorough Poets: Robert Kushner and His Printers." *Print Collectors Newsletter* 16 (November/December, 1985): 160.

"Printing Today: Eight Views." *Print Collectors Newsletter* 13 (January/February 1983): 89–200.

Interview

Judith Solodkin was interviewed by Joan Arbeiter in 1988

JA: Judith, you began your fine arts career as a printmaker, and then you became the owner and director of Solo Press, a shop which prints and publishes fine arts prints. You have a very impressive list of accomplishments, and you have acquired an outstanding reputation as master printer. Your name is mentioned no less than eight times in *A Graphic Muse*.[1] Yet your profession is not easily understood by people like myself who are accustomed to talking with individual studio artists. Could you begin by explaining what your role in all of this is?

JS: You can think of my role in terms of filmmaking, where you have producers, directors, actors, gaffers. You have a lot of people involved in a production. Well, I'm involved in the production of prints. I'm working with other artists in a creative manner, and I feel that this is my studio work.

[1]Written by Richard S. Field and Ruth E. Fine; published by Hudson Hills Press, New York, New York, in association with the Mt. Holyoke College Art Museum, 1987.

JA: It's a collaboration?

JS: Yes. I am a collaborator and also a producer. I have to choose the artist, to think of what kind of imagery that artist does that would be translatable in the printmaking medium. I have to think about edition size, marketing, how best to display it, and how best to present it. I have to think about the reactions that I'm interested in the world having to that particular work — or in learning what reactions the world has to that particular work. I feel very absorbed and very involved in what I'm doing, and I feel it's extremely creative. In filmmaking, they give producers and directors prizes and awards for what they do. In prints, you have a number of people who have started and operate their own shops, who have gotten similar kinds of respect and attention, like Ken Tyler, June Wayne, Tatyana Grosman. I think of myself in that way.

JA: I want to ask you how you choose your artists, but before I do that, let's get some background. How long has Solo Press been in existence? Where and how did it begin? How did it get its name?

JS: The word "Solo" comes from "Solodkin." Solo Press has been in business since 1975. It began in New York, in Chelsea, at 201 Eighth Avenue. It was a very small loft space, a second-floor walk-up. I had a living area in the back and the press area was in the front of the studio. The press area certainly was much larger than my living area; the whole space was about seven hundred square feet. So, we're talking about working on a ship.

My first project was with the A.I.R. print portfolio. I'd printed for Petersburg Press from 1974 to 1975, and I worked on Jim Rosenquist's print, *Paper Clip,* and when that edition was completed, I purchased a Brand press, which is a press for stone work, and installed it in my shop. This press, by the way, replaced a very old handpress that I had owned previously — a Fuchs and Lang press. Once I finished the job at Petersburg Press, I just started asking around if any artists were interested in having prints made, and there was a grant to the A.I.R. Gallery for a whole print portfolio, and so I started working with many of the artists there. Interestingly enough, I've recently done another print, with Howardena Pindell, that the Metropolitan Museum Mezzanine Art Gallery published. Howardena was one of the first artists in the A.I.R. portfolio, so I'm still working with some of the same artists, and it's really very nice.

JA: Your expertise in printmaking was developed mostly at Tamarind Institute?

Plate 22. Judith Solodkin, Arnold Brooks, and Nancy Bressler with artist Françoise Gilot and work-in-progress.

JS: Yes. I was at Tamarind from 1972 to 1974. I trained as a Tamarind master printer and master lithographer, and I was the first woman to go through the program.

JA: For our younger readers, what's the significance of that?

JS: Well, there were times when women weren't thought of in terms of machine shop or anything to do with mechanics.

JA: Do you mean women getting their hands dirty was sort of against tradition?

JS: I think it was more about heavy lifting and the machinery apparatus. Because certainly women have gotten their hands dirty for years and nobody's complained about it.

JA: That's for sure.

JS: So June Wayne had been running the Tamarind program in Los Angeles, and when it moved to New Mexico she was also becoming in-

volved in feminist politics and realized that she herself didn't have a master printer who was a woman. Joyce Kozloff, who had been my roommate in graduate school, was invited to Tamarind to do a series of prints and told them about me and my shop in New York, and she then told me about them, so I applied. Also, at the time, I was working at Pratt Graphics Center and doing printmaking on my own, so I sent them a very comprehensive portfolio and was admitted in 1972.

JA: Was the growth of Solo Press a gradually evolving process?

JS: Well, I worked at 201 Eighth Avenue for a while, until I became too large for that small space. I realized I needed more than one press because work was backing up on the one press. I didn't have any more storage space, and it was hard to carry things up and down two flights of marble stairs, so I located a space on Park Avenue South at Thirty-first Street and converted it into a living and working situation. My kitchen area was a general area for the staff during the day, and then it was my home at night. I had a private living area in the back.

JA: Did the fact that you were literally living with your work overwhelm your private life?

JS: No. The decision to live and work in the same space was made to cut down my overhead so that I could afford to have a shop in Manhattan. Now I'm living within walking distance, so I'm close enough to work, yet I keep a separate place.

JA: Do you find yourself working on weekends?

JS: Going to other galleries is as pleasurable as it is professional. My life is very involved in the art world, and when I think of enjoyable things to do I think of going to a museum, or going to galleries, or meeting friends who are artists. So, the two aren't separate; they're very much enmeshed.

JA: That seems a very healthy situation—when your work, art, and life are all connected. The organization known as Solo Press—has that been a one-woman operation all along?

JS: Well, it started out as a proprietorship. I was running it, but I also had an assistant. Lithography, as a process, is very difficult to try to do by yourself, and usually you need a person on the other side of the press as a sponger, and so, initially, I hired someone who worked for me for many years. Her name is Victoria Sclafani Hays, and Vicky started to work for me almost immediately. She came in from Rye, New York, daily, very

punctually on the train. So I had to be up and about when she came in. That was always good discipline. So, from the very beginning I had another person to pay, and I had to approach things in a businesslike fashion. Then I hired one or two more people to assist me, to do curating, to do some handwork on the prints, and I think at one time we had about four or five people in that tiny space.

JA: You said "curating." Do you mean going out and looking for people to invite?

JS: No. Literally, "curating" means going through. In the printmaking sense it's going through the edition and making sure that you number them—that there is a cohesive quality to the edition. In other words, it's checking on each piece of paper to make sure it's up to standard—that it matches the *bon à tirer* proof, which means in French "good to pull"—and then, afterwards, documenting it.

JA: Now, why do you need a curator? I'd think you would want to be the one to do that.

JS: Because I would be busy printing. I mean, I curated some editions, and then I trained a curator to do that. In order to be efficient you start to specialize. So I hired a number of people, and I decided that it was important to move. When I moved to Park Avenue South, in 1979, I also got a second press, and eventually I added the third press in the back room. So then I had three litho presses. And toward the end of my stay on Park Avenue South, I added two Vandercook letterpress presses. At the time that I moved again, which was six years later, I had five presses that had to be moved also.

JA: Now, what brought you downtown to 578 Broadway?

JS: Well, this was 1985, and the rents were escalating in the midtown area, and it was obvious that I wasn't going to be able to buy that space and live there. Also, I had grown like a vine out of control; the spaces weren't efficient; and I decided that I didn't want to be off the beaten path. Also, two years before I moved I had started to work with Joe Fawbush.

JA: Would you explain this connection?

JS: Well, Joe Fawbush worked for Brooke Alexander for many years at the Brooke Alexander Gallery. Brooke had a reputation for publishing prints and also for showing unique works—paintings and drawings, which he still does. Joe had trained with him; Joe also had an in-

terest in fine books, which I was beginning to develop at the time that we met.

One of our first projects was a book, with Judy Rifka and the poet Renee Ricard, called *Opera of the Worms*. That was very exciting because I was able to do what I wanted to do, which was print a fine book. Then we did a second book, with Donald Sultan and David Mamet, and then we started to do prints as well. So he was starting to sell the prints that Solo Press had published. That was how the idea of operating a gallery developed with me. When we made the move down here to Broadway and Prince Street, it seemed like the right choice for him to have a gallery space adjacent to my shop where he could show works that came out of the shop and also show other things that he was interested in. Then I would be able to produce work and have a sales outlet. That lasted for four years or so; then Joe extended his interest into more unique works, so he pursued his interests and I pursued mine.

Now I'm operating the Solo Gallery. It shows the work that represents the shop, the work that represents my skills and also my eye. It allows people to come in off the street and see the work in a neutral setting.

JA: Who else shares credit for the direction you took?

JS: Well, I had a number of people working with me over the years, one of whom is Cinda Sparling, who's still here with me. Cinda's a curator par excellence. Not only does she go through the editions and choose prints of consistently fine quality, but she also does a lot of hand coloring and handwork, especially on some prints that we did with Howard Hodgkin, which were very complicated.

Arnold Brooks is also a printer that I have been working with over many years, and he's also worked with me on the Howard Hodgkin prints. There are several others I'd like to give credit to. Arnie Samet is a printer who was with me for many years. Besides being a lovely person, he is a fine printer. And Pamela Moore, Jennifer Hilton, Anne Sekelsky—and I would say I've affected a lot of young people who've been through the shop. We had two Japanese printers who were on grants from their government, and both have opened their own shops in Japan. So it's been not only a place for me to have work produced but also I've had excellent talent helping to produce it, and these people have gone on with their careers in art.

Right now I have a lovely crew also. Let's see—we have Ed Archie, Jon McCafferty, and Peter Kruty, who is in charge of letterpress. And I also work with another printer in the back, who used to work for me, whose name is Dan Stack. Dan and I have a very interesting arrangement. He has an etching shop called Copper Plate Editions, which is independent of mine, but he rents space from me in the back of the shop

and has an etching press, which is his interest and his love; that amplifies what I do in terms of having etching facilities here.

JA: So you can farm out what you need done that you don't do yourself.

JS: Exactly. And in the Howardena Pindell print it's a combination of lithography and etching, so Dan worked with her part-time, and I worked with her part-time.

JA: I want to make sure that we have covered the full extent of what you're doing. We have the fact that you are doing lithography—

JS: Yes. I have one press whose capacity is forty-two and a half inches by ninety inches—that half is very important because Arches roll comes forty-two and a half inches—and two smaller litho presses. We have lots of litho stones that I've invested in at various times—large stones—and one of the most recent sections of the business is the letterpress room.

JA: Okay. Before we get to the letterpress, do you do lithography on anything but stone?

JS: We use aluminum plate and we use stone, both.

JA: What about an acetate plate? I recently made a litho on acetate.

JS: You still are working from an aluminum plate, because you're taking the acetate and then photographically translating it onto an aluminum plate. Aluminum is your matrix—that's your substructure—and whether you get it on there by drawing directly on the plate or by translating it photographically, you still have to use an aluminum plate.

JA: Oh, I see. Now, to the letterpress.

JS: The letterpress is run by Peter Kruty, who has a background in type design, type printing of fine bookmaking, and art printing from the University of Alabama, where they set up a special program for the book arts.

JA: So between the gallery, and the copper plate, and the lithography, and the letterpress, you have tremendously varied capabilities. What is it you are looking forward to doing?

JS: Well, I want to do more publications. By publications, I mean my shop putting out new prints under my auspices.

JA: Could you please explain the difference between publishing and printing?

JS: When someone else pays for it then it's *their* publication, although I may have done the printing.

JA: I see. This is a good place to talk about how the artists get selected.

JS: Well, if an artist comes to me with a gallery behind her, and she wants a print produced, the gallery can pay for the printing of the edition, which is fine; then the gallery gets all the prints, and owns that edition, and may sell the prints. The gallery may have a reception for the artist and may send out a mailing about the print that has just been produced, and then, of course, the production costs have to be made and the gallery shares some profit with the artist. I work with artists in a collaborative way; I'm trying to get the best out of them creatively. This is called contract printing. Now, publication, which is different from what I just described, is when *I* choose the artist. I suggest to them various things that they might do. I have a different kind of budget because I have some kind of insight into what they might be able to produce, and I act as their publisher, as the person who writes the checks. I'm paying for labor, I'm paying for the materials and overhead, and I'm also working with them on a collaborative basis, and then *I* get the prints to sell.

JA: And these might be people who have never made a print before?

JS: Yes. They may not have made a print before. But a publisher has to initiate the project. It has to be the publisher's idea that an artist will do a beautiful etching, a beautiful linocut, or that ideas would be stimulated by doing a woodcut.

JA: You started to say that you would perhaps approach an artist if you had seen the potential for a print in something they've done.

JS: Exactly. I see a lot of artwork. As I go around looking at shows I'm also thinking, is this artist at the right time in his or her career? How interesting would it be for them to do prints? Maybe I ought to talk to them about it? Is it advisable for me at this point in my career to do something with them? And these questions are always going through my mind. When I eventually approach the artist it's with a very specific idea. Now they, of course, have their own very specific ideas, so it becomes a sort of getting-to-know-each-other. I may go to their studios and talk with them, and discuss how they might work their ideas out, and try to give

them some options—the best way to approach it. And then, usually, it's a joint conclusion in terms of what we do.

JA: Do they help to subsidize the project?

JS: Well, they do in the sense that they give their time, and they give their talent, and those are two very valuable components of the print. I don't pay a fee up front to do the work. If I'm fortunate, at some distant point I would like to do that. Then there's a profit sharing as soon as production costs are met. Then we share a profit with the artists, but they may have to wait for quite a while until that happens.

JA: But *you* are the one who makes it possible for something like that to occur.

JS: Well, yes.

JA: Without your part they wouldn't have the potential for that exposure.

JS: It's two bonuses for them. One is that their work gets spread out to a wider audience. They're able to get more works into shows because they do get some artists' proofs as part of their initial effort, and then, some time down the line, they also get some checks.

JA: I see that you have 108 artists listed on your roster. Is that a lot of work to be handling?

JS: I may have done only one or two prints with each artist in all these years, and I have six presses—so no, it's not a lot. There are a few artists who I've done many projects with over the years—such as Joyce Kozloff, Robert Kushner, Howard Hodgkin, Howardena Pindell—and some that I worked with once and basically not again. But any artists that I publish I'm frankly interested in working with again. But I've published only a handful at this point, and I'm looking forward to expanding that.

JA: Do you feel you have added any aesthetic or technical innovations to the printing process?

JS: Well, we've done a lot of handwork. We've done a lot of *chine collé* and added various kinds of collage papers—a lot of hand coloring and handmade papers.

JA: So, is this where you feel your shop has excelled?

JS: Well, I think where I feel competitive is in the artist's imagery. I think I use whatever choice of technical expertise I have for that effect. Now, for example, with Steve Keister we're doing something that's very minimal, with no embellishment at all. But this idea has always interested me, so we're keeping everything restrained. I think I feel competitive in terms of the art and the artist that I work with and the kind of imagery they produce. Because, after all, I'm making art — I'm not making a decorated sheet of paper — although the artist may be Robert Kushner, and he may use decorative motifs, but then those motifs are to that end.

JA: Do you see yourself being more drawn to content or technique?

JS: I see myself as being drawn to the art. I don't know how to separate it into content and technique. I just look at a piece of work and say, Hey! that would make a great print. Now, whether I think it's because the artist used a certain kind of handwork or gesture in drawing —

JA: Are you partial to gesture because of lithography?

JS: No. I think of that as one kind of lithograph. But with the Steve Keister print we're doing something with a grid, which is all done photographically, so there's no gesture at all, yet I think that also makes a great print. I suppose it has to do with what ideas are interesting to me at the time.

Another factor is how established an artist's career is, because if I publish work by someone who's not known I have to do two things. I have to develop not only the marketing for the print but I also have to develop the artist's career. If I publish someone who is better known I have an advantage. Also, the same amount of labor that goes into the production of the print can get a higher reward because I can charge more for the image. I mean, it's a practical aspect. We're on a very expensive corner of Broadway and Prince, and we have overhead. I have a staff of eight people — it has to continue.

JA: Suppose a promising younger artist came to you?

JS: There are a number of places — like the Printmaking Workshop or the Manhattan Graphics Center — for a young artist who's starting out. Occasionally I'll print someone's work who is not established, but because I have to carry overhead I can't do that too often.

JA: So you would characterize this as being a shop for established artists.

JS: I think on the whole, yes.

JA: Now, we were talking about the aesthetic dimensions that you have added, and you mentioned you felt that imagery was your specialty. Do you make an effort to understand where the artist is coming from so that you could—

JS: I don't want to understand where they're coming from. I know their work, but what I do want to understand is how they're going to translate their work into print. In other words, what can I offer them, and what would they then respond to if I offer them a whole selection of materials? If I say, Look, you can do a woodcut, a linocut, an etching, a lithograph, a silkscreen—and of those we have an infinite variety—it's too much of a smorgasbord. Now I start narrowing it down. What is it of this technique and this application of it that would interest you? And this is what *I* suggest, this is how I narrow it down and then see how they respond. Because we can only do a certain number of things per print. Otherwise the technique overwhelms the idea.

JA: Might you ever give somebody advice—say, that it's too pale, that it won't read? Do you push in any kind of direction for clarity? Are you big on clarity?

JS: Well, I speak my mind. I tell them what I think. I push them into the direction that would best translate their work.

JA: So sometimes it's clarity and sometimes it's ambiguity.

JS: Yes. If their work is very pale and the colors are too strong, I may suggest toning them down. Like Howardena's work is very pale, and so the suggestion is to use very transparent colors. Where someone else's colors are very bold, it's the opposite. I don't think it's across the board; I think the important thing is responding to that artist's work and making the appropriate suggestions.

JA: Then that's your role. You help the artist translate the visual idea into printmaking, and in so doing you enhance the imagery.

JS: That's right.

JA: Could you explain the mechanics of this process?

JS: Well, I try to schedule it so that I can work with the artist for a period of time in the proofing session, along with one of my printers, who also helps, and then the artist can take over. Then when the editioning comes, the printer who's been working with me understands enough

about the print to be able to take over the editioning; plus I oversee it, make sure that it's coming out to the artist's specifications.

JA: We're talking about several separate stages here. Do you mind if we review the stages? First, you have the collaboration with the artist, when you agree to make a print together. Then you work at the press with the artist; the artist has to draw the plates or somehow get the plates made.

JS: That's called proofing. Then it's printed. The edition size is usually between thirty and a hundred. Then we curate it. And after curating is signing.

JA: Once the artist leaves, what happens?

JS: Then the work goes into the gallery, and usually we make photographs, and we do a mailing to all the print dealers across the country and around the world: Solo Press announces a new publication and lists the artist and the title. It's basically a printed announcement; then if anyone is interested, and if they want any visuals, we send out slides.

JA: All right. Now, once you have sent forth the news, do you feel it's a question of waiting for results or do you still go around to the galleries?

JS: Well, galleries have their own way of working. I have a director, whose name is Katherine Maloney, and she does what has to be done. In other words, she makes calls, she answers people's questions, sends them price lists, sends them work.

JA: Are your publications in a catalogue of some sort?

JS: Yes. Rutgers has the archives. I'm a member of the Rutgers Archives of Prints, and they keep catalogues of everything we've done.

JA: I notice that you have been involved in a lot of other professional printmaking activities. For example, you were a director of the Ariana Foundation?

JS: I don't think that's as active as it used to be, but that was a small, private foundation giving grants to young artists, and I was helping them choose the recipients.

JA: And you act as the treasurer of the American Printing History Association?

JS: The American Printing History Association is an organization that concentrates on letterpress printing and type printing. And that's a hobby of mine more so than a commercial interest. It's something that I'd really love to know more about. They have a big conference once a year. That's something I thoroughly enjoy, and then they have meetings throughout the year.

JA: Is this an old, established organization?

JS: Yes. And now that we've set up the letterpress shop it makes sense to get more involved in it, but I've been involved for a long time now.

JA: Also, for the record, I think we should note that you have always had an apprenticeship program for colleges and universities.

JS: Well, I work with all kinds of interns who come and put in a semester at the shop and get college credit. They basically observe, and do errands, and clean up, and assist, but they sometimes get to do very major things because I need an extra pair of hands, and there they are.

JA: And you have opened your shop and lectured to a number of organizations, such as the print associates of the Museum of Modern Art and the Brooklyn Museum—just to name a very few.

JS: New York University sent a connoisseur group and I did a lecture for them. So people contact me and then they come here, and I do an hour or hour-and-a-half talk, and show them work, and explain the process, which is really very helpful because when people are looking at prints they're very confused about what they're seeing.

JA: I know, and it seems to be getting more complex all the time. Now, besides bringing people into your studio, you have been out all over the United States and Canada. Do you still accept speaking tours?

JS: I'll be doing a day's talk at Ohio University in Columbus. I call them gigs. Every artist has that happen: where you get invited for a day and the honorarium is usually very good. You get to meet new people, and it's good publicity, but I'm really not that interested in doing this anymore. I used to do this quite a bit when I was younger and it was a way of supplementing my income, but now it's really more important for me to be in the shop. I think what I prefer to do is more traveling in terms of gallery sales, meeting other dealers and meeting directors.

JA: Are there conferences or trade shows for that?

JS: It's called being on the road. It's making appointments, calling people and showing them your work, and having lunch and talking—just familiarizing them with the work I do.

JA: How far afield have you gone for that?

JS: I've done that a little bit but not as much as I'd like to. I'd like to do more traveling for my own sales, and my gallery director will probably do some of that also.

JA: Now that we've pretty well covered your professional responsibilities and your shop work, could we go back to the training that you undertook to get you to this point and the experiences surrounding this? Who or what in particular helped to shape you?

JS: As a student I was very interested in drawing and wanted to continue drawing, but I also wanted to be able to change colors in the drawings. I had seen Alber's *Homage to the Square* series where he used the same format but with many different color relationships. Basically the color became the subject matter. I thought his use of color was wonderful.

I started taking classes at Pratt Graphics Center. First I took silkscreen and loved the multiple idea, and then I loved the presses; I've always been mechanically minded. And then I got interested in lithography and especially in drawing on stone, which has a very sumptuous quality. Andy Stasik was my first teacher at the Pratt Graphics Center, and Jeff Stone was a teacher who helped me pursue lithography and encouraged me to apply to Tamarind.

JA: When you returned from Tamarind in 1974 you were very ambitious. You founded Solo Press and began teaching at several places.

JS: Yes. I taught at Pratt Graphics Center after I returned from Tamarind, for about six years. I also taught lithography and photo techniques at the School of Visual Arts at that same time.

JA: During some of that time weren't you also teaching printmaking at Rutgers?

JS: Yes. And also during some of that time I was master printer at Petersburg Press.

JA: And you never considered all of this too laborious?

JS: Well, in each place it was mostly part-time. But when I was at Petersburg Press and teaching at Pratt, that was quite a bit of work. Fortunately, when the Petersburg Press job printing a Jim Rosenquist lithograph was finished, I had scheduled private work.

JA: Judith, as I review your earlier education, I think we see that you've never been afraid of an extraordinary work load. For example, at the same time that you were an undergraduate at Brooklyn College, from 1961 to 1964, where you received your B.A., cum laude, you also managed to take sixty credits, leading to a degree in Hebrew letters, from the Jewish Theological Seminary. Incredibly, you also took some painting and drawing classes at the New York Studio School and the Art Students League during those same years.

And then, I think it's also relevant to note that during the two years you spent at the graduate fine arts program at Columbia University, on scholarship, where you received your master of fine arts, you were a substitute teacher in the New York City school system. And, after one year as a full-time teacher, you became chairperson of the fine arts department at Joel Braverman High School and held that post for four years until you were accepted into Tamarind; and during all that time you were studying printmaking at Pratt Graphics Center.

This is a history of someone who is obviously very disciplined and focused. Did the feminist movement provide any impetus for all this?

JS: Well, I've never been a joiner in movements, but I know feminism has certainly affected me a great deal because I knew I was capable and qualified and could use my muscles, but I felt that I didn't have a place to show this. The whole movement allowed me that opportunity. It verified my ambition, and I think the way I participated is by my own example—by being capable, interested, and having a decent sense of humor—to be able to show by my example that this can be done. It's not something that's gender related, but it's interest related, and if you want to do something it takes a lot of work, but there's no reason not to.

JA: Going back to your being the first woman to graduate from Tamarind. At the time, were you very conscious of what you were going through, or was it later, in retrospect, that you realized . . .

JS: No. I was very conscious during the time. I had been accustomed to New York, which was a more forgiving place in that you could be whoever you wanted to be. By contrast, New Mexico is much more conservative, especially in the shop. It was very conservative, and one of the ways I combated this was by getting a Betty Crocker apron with lots of

frills for my shop apron, so there couldn't be any question that I was a woman and was allowed there, so they'd better just notice!

JA: Were you flaunting?

JS: I was just making fun of it, showing them how silly they were. I remember one incident when I had a huge roller and I was rolling up a print, and someone who was conducting a tour group through the shop came over to me and asked me if I was the printer. I was flabbergasted because what else could I be? I was standing there with this inked-up roller, rolling it. Who else was I if not the printer? So people's expectations were short of what was possible. About lifting: there was always concern about lifting, and the fact is I am not as strong as a man and can't lift the same amount.

JA: How heavy do the stones get?

JS: About four hundred pounds. But there's a hoist, and with the push of a button the stone could go up or down or wherever, so that compensations can be made. And the men, in fact, don't want to lift those big stones either, and two of us could usually lift them together, so that was never much of an issue for me.

JA: Did you get directly involved with the apparatus of the women's movement?

JS: No. I did belong to a consciousness-raising group when I was starting out, but I wasn't that active in it. I've always been more interested in pursuing my own way, meaning I like to print, and I wanted to learn more about it and had a happier time pursuing that.

JA: Your own personal printmaking career was off to a good start in 1976 when you had three one-woman exhibits, one of which, entitled "Roots of Creativity," was at Douglass College in the Women Artists Series. Would you comment about this work?

JS: "Roots of Creativity" was the title of all those exhibits. My own title was "Cartusche Lithographs." They're abstracts, and they are round images on handmade paper using tusche washes. I gave them the word "cartusche" as a double pun. One is that I used tusche washes, which is a lithographic wash, and the other reference is that I used certain elements of architectural cartouche and also Egyptian cartouche. So they are a series, and the color changes. Do you remember when I explained that I went

into printmaking because I love color and love drawing? Well, in these I was able to change the colors in the drawing by changing the inks.

JA: Judith, as we end this interview, I'd like to ask if you ever miss these kinds of studio experiences? Or, is there any kind of imagery or effect that you need to see expressed that perhaps the other artists with whom you're working cannot fathom or cannot see for themselves?

JS: No. Usually I work with artists whose ideas interest me, and I feel very resolved by their expression. *These* are my images. These are Judith Solodkin images, and I enjoy collaborating with the artist on the press. I still love being on the press. That's my favorite of all.

* * *

Solo Press, Inc., in the spring of 1992, moved its shop and gallery to the eighth floor of 520 Broadway. Judith Solodkin is still master printer and president, but various new people have joined the staff.

Other artists represented at Solo Gallery include Louise Bourgeois, Robin Hill, Peggy Cyphers, David Kapp, Lesley Dill, Robert Lobe, Michael David, and Lynda Benglis. Judith looks forward to at least another seven productive years in her new location.

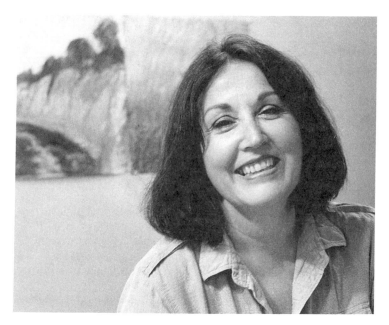

Plate 23. Kay WalkingStick, 1985. Photo by Gary Schoikert.

Kay WalkingStick

Education

1975 M.F.A., Pratt Institute, Brooklyn, New York
1959 B.F.A., Beaver College, Glenside, Pennsylvania

Selected Solo Exhibitions

1992 Morris Museum, Morristown, New Jersey
1991 Hillwood Art Museum of Long Island University, C. W.
 Post Campus (traveling exhibit)
 Heard Museum, Phoenix, Arizona
 Elaine Horwitch Gallery, Scottsdale, Arizona
1990 M-13 Gallery, New York, New York
1988 Wenger Gallery, Los Angeles, California
1983 Bertha Urdang Gallery, New York, New York

Selected Group Exhibitions

1992 "Land, Spirit, Power," National Museum of Canada, Ottawa, Ontario (traveling exhibit)
1991 "Shared Visions: Native American Painters and Sculptors in the Twentieth Century," Heard Museum, Phoenix, Arizona (traveling exhibit; catalogue)
1990 "The Decade Show: Framework of Identity in the 1980s," New Museum, New York, New York (catalogue)

Selected Bibliography

Rushing, W. Jackson. "Contingent Histories, Aesthetic Politics." *New Art Examiner* 20 (March 1993): 14–20.

Pyne, Lyne. "Artist Wants Her Work to Whisper." *Phoenix Gazette,* 23 September 1991.

Kay WalkingStick: Paintings, 1974–1990. Brookville, N.Y.: Hillwood Art Museum, 1991.

Lippard, Lucy. *Mixed Blessings: New Art in a Multicultural America.* New York: Pantheon Books, 1990.

Braff, Phyllis. "A Special Regard for Nature's Forces." *New York Times,* 14 April 1990.

Jones, Kellie. "Kay WalkingStick." *Village Voice,* 16 May 1989.

Interview

Kay WalkingStick was interviewed by Sally Swenson

SS: When did you decide to become an artist?

KW: There was never any question about it. When I was a little girl I was given paper and pencil to draw with in church—we spent a lot of time in church—so I always say that I learned to draw in church. But, in truth, I drew and made things all the time. I have always seen myself as an artist, and everyone else did too. Of course they all thought they were artists also.

SS: Then there were other artists in the family?

KW: Yes. Two of my siblings—a brother and a sister—eventually became professional artists; two of my mother's brothers and two of her uncles were artists. My father's grandfather Osborn was a professional photographer in Indian Territory before the turn of the century.

SS: Then art making wasn't alien at all.

KW: Not at all, although you'll notice that most of the people I mentioned were men. It is in my generation that the women became artists.

SS: Let's talk a little about your training—where you went to school and what artists and teachers were an influence on your future work.

KW: I went to Beaver College, outside of Philadelphia, and I studied with Ben Spruance, the lithographer. In some ways, it was an excellent basic education, and yet I never learned how to etch a stone or pull a print, even though I studied with a printer and took lithography classes for three years. Ben never let us handle the acids. It was the 1950s, and "girls" didn't do things like handle acids. It seems very strange now, but I thought nothing of it then. Ben actually gave me a lot of encouragement. Once, in a critique, after lauding my painting skills, he said, "Now all you have to do is have something to say." That concept terrified me at the time, but it has never left me. I still expect myself to "have something to say."

I took my M.F.A. at Pratt thirteen years later. I married two weeks after graduating from Beaver, moved first to State College, Pennsylvania, and then to the New York area and became a suburban mother of two. That sounds very traditional, and in some ways it was, yet I was also teaching, painting, and taking critique classes during that time. I was teaching at a small college and actively exhibiting my paintings in New Jersey when I decided that my work was going nowhere and I was in a dead-end job. So, I decided to go to graduate school. I applied for and won a Danforth Graduate Fellowship for Women, which paid all of my expenses to attend Pratt. Everything. The goal of the fellowships was to train women for college teaching at a time when there were very few women on college campuses. It did that for me but it also opened other doors because it forced me to examine my art in relationship to what else was happening in the contemporary art scene. I became a more analytic artist and thereby a stronger artist. My painting started moving again.

SS: Were there any good teachers there?

KW: Oh, yes. Gerry Hayes was excellent. He let you go your own way yet forced you to articulate why you were going that way. He pushed, as a good teacher should. We looked at and discussed the current art scene, which was very minimal, formal, and reductive at the time (early seventies). Gerry's own art fit into this very conceptual mode. It is still the concepts expressed through formal means that most excite me in the art that I make and that I see. His teaching style has influenced me also, although I think I push students even harder. I have always pushed myself pretty hard too.

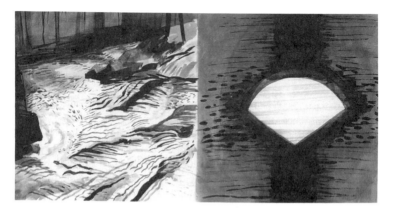

Plate 24. *Minnesota Cascade,* 1991. India ink on paper.

SS: That was the height of the women's movement. Did you think that women would be taken more seriously in the future than they had been when you were an undergraduate?

KW: I had always taken my own painting very seriously, and I expected other people to do so also. I wasn't very active in the women's movement, but I had been raised by working women and had never considered not working myself. I was raised to be a feminist. There were a number of very gifted women at Pratt, some younger and some older and with families, like myself. Before I was accepted at Pratt, I had been turned down at a couple of graduate schools. I honestly think that this was an example of ageism not sexism. You'll notice that I can't believe it was because they might not have liked my work! I enjoyed Pratt tremendously. I think I used Pratt more efficiently than some of the other students. I pushed the profs to share their thoughts and ideas. It would have been useful to have a strong female role model then, but there was no one there with whom I could identify. It is appropriate that the colleges and universities are now forced to hire women and minorities to better balance their faculties. Pratt was then dominated by white males, which does narrow the education that one receives.

SS: You are a teacher as well as an artist. Do you think art can be taught?

KW: It's possible to teach the techniques of art making and to present ideas that extend students' vision. We are forced as artist-teachers to articulate ideas—to think things out clearly in order to articulate them— and that's good for the teacher as well as the student. I believe that habit has helped me to develop as an artist. You can teach people ways to think

about their art and themselves. You can analyze works of art, and teach technical skills, but you can't give students something to paint about. Ultimately, the content must be personal to the student. Art speaks visually of things that cannot be adequately stated other ways. This must be understood in a visceral way—this can't be taught, per se, but it can be engendered.

SS: Where do you think the emphasis for your own work comes from?

KW: I am not sure what you mean by that, but I will assume you mean by "emphasis" both content through image and content through formal means. I think a lot about why I'm doing these diptychs right now, why I'm trying to combine geometric abstraction with real imagery.

Let me tell you a bit about my personal background. I was born during the Depression, raised in a white Protestant culture with four siblings and no father. He and my mother had separated while she was pregnant with me. They were living in Oklahoma at the time. She and her children moved to Syracuse, where her parents and siblings lived. They were a large, warm, extended family for me. All this is not so unusual, but in addition, we were raised to think of ourselves as Indians. Although I never knew my Cherokee father, I have a Cherokee name, and my mother reminded me daily, with pride, that I am an Indian. There were no other Indians that I knew in Syracuse, but my mother talked often about her experiences in Oklahoma and our Cherokee relatives there. I was not raised in an Indian culture, so I'm not bicultural, but I do think of myself as a biracial woman.

These paintings that express a binary view make perfect sense to me. For me they have an intrinsic rationality. I see the parts of the diptych as two kinds of "memory": one portion has to do with the momentary, fleeting memory and the other with the more spiritual, long-term memory. I am not trying to paint realism or naturalism, but I am painting a kind of illusion, a kind of memory of things in combination with an idea of the universal. Uniting these two kinds of "memory," these two kinds of perception, is important to my psyche. It offers not only a personal wholeness but also a wholeness in the continuum of humanity—that is, one side refers to the present while the other side refers to both the past and the future. They are not landscapes but paintings about my view of the earth and its sacred quality.

The content of all of my paintings is mythic, if one understands myth to be that which expresses the unknown, the inexpressible, or the incomprehensible. They are an attempt to unify the present with eternity and to understand in a mythic sense that unity and balance.

SS: Are they then two different ways of looking at the same thing?

KW: Well, yes, but I don't see one as the abstraction of the other. One is the extension of the other, rather like the two portions of a European ecclesiastical diptych. I want the portions to relate in a way that transcends simple abstract analysis. I've had an ongoing interest in primal imagery, transcendent imagery, and I think a lot of that interest was stimulated by my early religious education, which forced one to deal with primal things—beginnings, life, and death—and the meaning of existence. No doubt, everyone deals with these questions eventually, but these questions have been part of my thought bank and therefore my paintings all of my life; my paintings are not so much a dialogue with God as a dialogue with the mysteries of life.

SS: You talked about your earlier work being influenced by conceptualism. Do you think this newer work, with its binary views, is postmodernist?

KW: Postmodernism in the visual arts implies reusing, or appropriating, past formal ideas in new ways and combining them in a new manner. You could say that I do that. But postmodernism also implies lost hope, lost belief in humankind, lost belief in the future, and certainly a loss of spirituality. In that sense I am very much in the modern camp. I still have hope for the future.

SS: Yours is a pluralistic view. Sometimes your paintings seem utterly masked.

KW: I understand masked to be hidden, covered, secret. Certainly my abstractions of the seventies could be described that way; there were many contradictory emotions in those works. They were full of pain and anger, but also sensuality, and pleasure, and the joy of painting. Perhaps it was these contradictions, in part, that made them seem masked. In truth, I like mystery in paintings. I am very interested in what is implied rather than what is stated explicitly; on the other hand, art is a language that I hope speaks to many people.

SS: Each side of the diptych is done in a different technique. Let's talk about that.

KW: I have been working at abstractions for years, and I developed a way of working with layers of saponified wax mixed with acrylic paint. I think it is very exciting to have all of the layers suggested but not fully showing through. The painting was very much an object, a tactile thing with dimension, but also space—nonillusionistic space. The paintings are designed on a grid, and although the grid is not seen in the finished

work, it is implied. The quiet calm of these works is due, I believe, to this underpinning of geometry. These abstractions are very primal, very earthy. They look like they arose out of the primal slime or were created with the original big bang. And they have a very thoughtful quality. I really go for all that. I do like a certain complexity of intent.

Very often the abstractions were about landscape—landscape from three thousand feet up, perhaps, but landscapes nevertheless. When I decided that I also wanted to make more specific landscapes I found that it was very difficult in that same medium of acrylic and wax. I just couldn't do it, so I switched to oil, which one can manipulate with ease and obtain more varied and rich colors. It is simply a more flexible medium.

SS: Do you start with a coat of thin paint and work up to a thicker coat?

KW: Yes, that's the way I was trained years ago, but I do the entire oil portion in one shot, one day, so that it has a very immediate look.

SS: Then you work back into it?

KW: No, I try not to. I just do it and walk away from it. If it doesn't work I discard it. I want the oil portion to be like a snapshot, like a momentary singular experience. I think in order to express that immediacy you have to act it out; I am very aware of the act of painting. I think the physical act itself is very important. It has a magical quality and that is where we really live. I try to teach students to believe in the act of painting, that the painting can lead you. You can't make the painting in your head, you have to do it. You must do it before you completely think it out. Painting is a sensualist's labor.

SS: I was speaking to a ceramicist a few years ago. He said, "Making the ceramic is like a dance. You do something to the pot and the pot does something in return."

KW: I think that I learn from the paintings, that they teach me, and the ideas I have about painting have come from the paintings themselves. In other words, I do something, then I understand it more fully. I think the ideas often come out of the doing rather than the doing coming out of the ideas.

SS: Do you think the studio space you work in affects your work?

KW: Yes. I worked in a brown-walled attic for a while and the paintings were all very dark. When I was in the Manhattan studio the work was very

involved with my thoughts about things—the inside of my head—and not about the world. When I went out to the Southwest the paintings were about the world around me, very visual; and when I went to Montauk the colors changed dramatically, reflecting that beautiful light.

SS: You were at an artists' colony in Montauk, New York. Would you say something about that experience?

KW: I have been to many artists' retreats. All of them were useful to me because they gave me an opportunity to focus completely on my work at a time that I couldn't otherwise do so. There is a period in one's life when that is most appropriate. It is also useful to have a change of surroundings at any time in one's life. Sometimes you make friends, sometimes you don't, depending on the mix of people, but that isn't the real purpose of going. The purpose is to let your work develop in isolated and convivial surroundings.

SS: Do you think there is a feminine sensibility, point of view, in art?

KW: No, I don't. Although most of the artists working today whose work I truly admire are women.

SS: Women's lives were really restricted, and now we have the problem of separate museums; separate is still not equal.

KW: I honestly think women can do anything. The last few decades have proven that. There are, of course, gender differences, but most of the differences are created by the way we were raised. We need to raise our daughters to have self-confidence. Many women still do not take themselves and their work seriously. We are not born with ideas like that! When I graduated from college I wanted everything—a fascinating career, a home with husband and children, and a long life of art making. That was very unusual, even radical, thinking in 1959, and I have had all that and more.

SS: Women have to fit in what they want to do, what kind of career they want.

KW: Oh, I think today women have many options. Although the statistics in the art world show that women still are under-exhibited and under-hired in tenure track positions, as are minorities, the situation has improved over the last twenty years; but gender inequality is still an important issue in the art world.

SS: Let's get back to the artwork. When you are conceiving your works, do you do drawings or is it out of your head?

KW: I do drawings, rough sketches first, then very finished drawings in oilstick or charcoal on paper. By the time I actually do a painting many of the problems, compositional and otherwise, have been solved. My paintings evolve from there. In the black-and-white drawings I can work out the value problems, and once that is solved then the color is easy. Drawing is a way to think.

SS: The one thing students have trouble with is that they paint and paint and don't stand back to look enough.

KW: I like having my studio at home so I can come in here and look at the painting after I've finished for the day. I like to sit and watch the painting to see where it is going.

SS: Some artists prefer having a studio away from home.

KW: I like it here, but the important thing is to have a studio. Nobody has a perfectly arranged life. It isn't easy to spend your life as a painter. I suspect that if I hadn't gotten married right after college I would have taken some dumb nine-to-five job to support myself. It still would have taken years to become established as an artist. I've always worked part-time at one job or another, but because I had children I was at home and painted all the time, even when they were little. I never stopped. I'm really very unhappy when I'm not painting. It doesn't seem to hurt kids to be brought up by an artist. They do come to understand what persistence and discipline can accomplish.

SS: How important is it for an artist who is trying to show in New York to live there or have connections there?

KW: If your ambition is to exhibit nationally, it is certainly useful to live in New York City so that you can be out there seeing everything, meeting people, and developing your art in that electric environment. For some people this is possible, for others impossible, and for still others unbearable. There are different paths for everyone; some people need to live outside the city to stimulate their art. To those people I would suggest that they make some hard choices and spend some money on being in New York at least part of every year, even if only for a week or so. But there are some excellent galleries outside of New York that show local artists. And very often regional museums make an effort to exhibit

local artists in juried group shows. These venues are an excellent place to start. Some of the best graduate schools are not in New York, but don't rush to New York right out of graduate school. Stay put and give yourself some time to develop. Each year the regional art institutions seem to become more important. And some of the most valuable art awards are not in New York. Take advantage of some of these perquisites.

SS: How do you think your art will affect young artists coming along?

KW: We would all like to think that young artists will be influenced by our ideas and our works. I hope they see the risk in my work, the willingness to take chances, to make something that speaks on the deepest levels. My work has always been highly referential, even when it was otherwise quite minimal. It was loaded with meaning, even when all else was reduced to a minimum. I don't see a lot of difference between abstraction and realism. There is weak abstraction just as there is shallow realism. Nevertheless, realism alone is simply not enough for me. The language of abstraction—what it says about our era—is crucial to thinking about art. It informs all of today's important art.

I would like young Indian people to express who they are in their art but also enter the mainstream of world art and to know that they can make art out of their own experience—personal art—and still make important mainstream art. I would like them to see that in my work and to therefore realize the potential in their own work. I travel around to different schools and Native American exhibits so I can see and talk to young people about their futures as artists. I often exhibit in various Native American venues. One of the reasons to do that is so my work can be seen by other Indian people. My work is not stereotypical in any way, yet it has to do with sacredness of the earth, and it is very contemporary in its approach. I would like Native young people to recognize and accept the idea that one can be a contemporary artist and yet still deal with issues that are a concern to Native Americans.

I hope that my work speaks in a sufficiently universal way, that it conveys meaning to everyone who takes the time to look at it with thoughtfulness. Someone called me a contemporary mythmaker. I liked that!

Plate 25. Faith Wilding in her Vermont studio with *Iron Body,* 1992. Photo by Robert McClintock.

Faith Wilding

Selected Group Exhibitions

1990	"Sex and Subtext," CERES Gallery, New York, New York
1989	"Symbolism," Cooper Union School of Art, New York, New York (catalogue)
1987	"Passages," Fresno Art Museum, Fresno, California (catalogue)
1981	"Feminist Art of the Eighties," Center for the Arts, Muhlenberg College, Muhlenberg, Pennsylvania (catalogue)
1980	"A Decade of Women's Performance Art," Contemporary Arts Center, New Orleans, Louisiana (catalogue)
1972	"Womanhouse," Los Angeles, California (catalogue)

Selected Bibliography

Gadon, Elinor. *The Once and Future Goddess: A Symbol for Our Time.* New York: Harper & Row, 1989.

Cadet, N. "The Mind/Body Split." *High Performance* 11 (Spring/Summer 1988): 84–85.

Lippard, Lucy. *Overlay.* New York: Pantheon Books, 1983.

The Amazine Decade: Women and Performance Art in America, 1970–1980. Edited by Moira Roth. Los Angeles: Astro Artz, 1983.

Askey, Ruth. "An Interview with Faith Wilding." *Women Artists' News* 6, no. 8–9 (March 1981): 13–14.

Interview

Faith Wilding was interviewed by Beryl Smith in 1991

FW: I've been working on a series of "Mermaids." Essentially they are collages stitched together out of different pieces of things—my gallery of freaks here, female freaks. Actually I was working on these while I was listening to the Senate hearings on Clarence Thomas.

BS: Did you get very angry?

FW: It worked really well because I was so angry, and I was doing all these freakish, painful things about women, and so I was kind of stitching and suturing them together. In some ways they're funny too. I think of how they always used to show women as freaks in circuses—you know, freak shows—the woman with the calf's head, or the fat lady, or the woman with one leg or whatever.

BS: So, where does it all come from? You've been working with this for a long time?

FW: Well, in one way it comes from feminism, and in another way it comes from my childhood—from my upbringing—and only fairly recently have I made connection with it in a more personal way. I used to think of it more politically, in a way. I grew up in a commune, a religious commune of refugees from the Nazis, mostly Germans, in South America. The commune started in Germany shortly after the First World War, and then when the Nazis persecuted them they fled by night and ended up in England, where my father joined them. My father is British; I'm British also, at least by nationality. I'm multinational, really.

My father was a pacifist during the war, when he was in England, and it was very difficult. So he was looking for a group to join. He had actually been searching for a while, and then the war put more pressure on that. So he found this group, called the Society of Brothers, or the Bruderhof, from Germany. They essentially lived like the first Christians—that was their aim: to live in complete brotherhood, sharing all goods. They didn't have any money or anything. Everybody worked together. They raised the children communally, more or less, and they lived very simply. They were pacifists, and they wore clothing that was like medieval peasant garb—long dark dresses, long pants and jackets, and so on. It was very puritanical.

They emigrated to South America in 1940 because the British were locking up all the Germans in camps in England because they were suspected of being spies. So I was born in South America, in Paraguay, on this commune, and I lived there for twenty years—the first twenty years of my life. We were out in the jungle. We raised all our food, made all our own clothes. In a way, it was like some of the sixties communes that sprouted up in America. The emphasis was on making everything yourself and living completely organically. They did this both out of necessity and a belief that one should earn one's living by work, and one should be poor, and everything should be done for God. It was a very wonderful childhood in many ways. I learned incredible handwork—weaving, leatherwork, pottery, building furniture, agriculture. Also most of these people were intellectuals. Many had gone to German theological seminary, and so I had a very strong kind of European intellectual schooling. Our school was all in German, and there was music, and poetry, and singing, and reciting, and reading. At the same time I was also doing all these crafts, and so from that point of view I had a very rich background, besides being trilingual.

There was the dark side to it. I always sensed it as a child, and I eventually had to escape. And I really think of it as escaping, because from the time I was an adolescent it became very clear to me that I had to leave. But you know, that was very hard to do when you're in the middle of Paraguay and you have no money of your own, your parents don't have any money, you're a girl, you've been brought up to fear everything, to be very

Plate 26. *Iron Body,* studio installation, 1992. Ink, paper, sculpture, 9′ × 25′. Photo by Robert McClintock.

puritanical, you've been brought up in a completely nonmoneyed situation where you've never handled money, and essentially, you don't know how to live in the outside world. You're completely dependent on this commune. It's worse than being completely dependent just on the family, you know, because the family was completely under the governorship of the commune, and my parents couldn't make decisions about my future.

BS: Did they support your feeling of a need to get away?

FW: Well, not at the time. Eventually my parents did leave because all of us kids left, one after the other. Fortunately, when I was about nineteen or twenty, the commune went through a huge internal upheaval. A sort of purging or whatever—I'm still not completely clear. Apparently a lot of members rebelled, and a lot of people left, and then they decided to move the entire commune—everybody that was left—to America. I could see this was going to be my chance to get out. They sent me to college to be trained as a teacher, and when I was in college, that's when I decided, Okay, I'm going to break loose now, and I did.

BS: And you went to college in this country?

FW: Yes, I did. I went to the University of Connecticut. The Society of Brothers settled near there. They're now very successful; a lot of people

have joined them and they have opened up several new branches in America, in England, and in Germany.

BS: This is a very large group then.

FW: Yes, quite a large group. I think there are close to two or three thousand people now, and they have a lot of children because they don't believe in birth control. All the families have ten or twelve kids. Fortunately our family didn't. As a child I was very much a dreamer and a loner. I was very interested in art, and painting, and fantasizing, and I sort of dropped out of this whole thing—mentally and psychically—as a child, always sort of immersing myself in a dream world, in a fantasy world. Only lately, in therapy, in looking at this, have I seen that was my salvation, to live a parallel life to the official life which was very coercive in insidious ways. It wasn't like whipping the children, although we did get punished in awful ways sometimes—like seclusion, for example. You became an invisible person and nobody could speak to you.

BS: Like the Amish, which also have German derivations.

FW: Exactly. And the costumes we wore were almost exactly like those the Amish wear. Now I realize that every natural instinct of sex and sexual curiosity and wanting to explore and wanting to feel my own powers and celebrating my own gifts was punished or suppressed. And so, for my own survival, I had to set up a fantasy world, or parallel world, in which I lived as my true center, while seeming on the surface to get by very well in the commune. I learned this as a survival tactic. So, you know I'm interested in a lot of things.

I think what drew me to feminism was the first thing that I did in college in the sixties. I'm very marked by my upbringing, and I'm a confirmed pacifist and conscientious objector, and I immediately joined the peace movement, of course. You know: ban the bomb, that was first, and then on to Vietnam—protesting the Vietnam War and going to all the marches in Washington. I was very socially concerned and interested in peace in the world and all these things. And that was very much from my training, very much the positive part of my training, both from my father and from the commune. I had been brought up to be concerned with the world and issues of good and evil, so it seemed natural to join the peace movement and the anti–Vietnam War movement in the sixties. It was through that, of course, that I got involved in feminism. I was a member of S.D.S. [Students for a Democratic Society] for a while, and I met my husband through that. We had a printing press in our basement, and we issued underground magazines and pamphlets. He was a graduate student at the University of Iowa where we were both studying. He was a

Ph.D. student and I was still trying to get my B.A. He joined an organization—the New University Conference—a faculty branch of S.D.S. It was very radical, very Marxist and radical socialist, and I think out of that group came the first organized educational impetus to feminism. People like Naomi Weisstein, Florence Howe were part of that group, and these were the people, of course, who one thinks of as the founders and the theorizers of academic feminism. They were the first people to start caucuses for women at the Modern Language Association, and they were very interested in women's educational issues. I remember being in several meetings with them, very early on, in 1968 or 1969—something like that—where they were trying to organize women's caucuses of academics within schools, and I was feeling kind of resistant at first, thinking, Oh God, I'm not going to get involved with all that; I've just discovered men.

BS: You were not ready to write men off?

FW: Right. I think that really was part of it, because a lot of these women were so angry. Of course I was incredibly angry too, because I had really been screwed over by this heavily patriarchal commune which was led by men who were complete patriarchs. For the first ten years, where I grew up, women had to sit in different parts of the room than men, and women weren't allowed to speak at meetings. Then there was sort of a little internal revolution and they loosened the rules a little bit. But you weren't allowed to show any flesh, and you know as a woman you had to be completely modest, and so I was tremendously angry at men, but on the other hand—

BS: There was this whole new world out there—

FW: Yes, and I was allowed to explore sex, which the sixties gave permission for. And I really went in for that, and I was living with the man I am now married to. So, I was very wary of feminism at first. But then I could see, intellectually of course, that there was a lot of necessary stuff there. The year after—1969—we married and then went to his first job, and we lived in Fresno, California. I started a consciousness-raising group with a woman who was a psychology student. Her name is Suzanne Lacy; she's a well-known performance artist now.

BS: I read about this in your book.[1]

[1] Faith Wilding, *By Our Own Hands* (Santa Monica, Calif.: Double X), 1977.

FW: So I probably don't have to go through all of this now.

BS: Let me ask you this: In one of the things I read, you said that you didn't consider yourself a well-trained artist, but yet you are very definitely an artist. When did you first identify as an artist?

FW: Well, very young. I was always drawing or painting. When I was four and five I was making books. My parents still have them. I was reading avidly and making my own books because we were somewhat limited in getting books. I mean, we had whatever people had brought with them from Europe, but out in the boonies there was no bookstore, there was no place to go to buy books. Fortunately, I had an aunt who sent me books for every occasion—birthdays, Easter, and Christmas. She sent me the whole Flower Fairy series, and all of these wonderful English children's books with wonderful illustrations, which I loved. I think that sort of got me going on making my own books and drawing extensively, which I always did as a kid or as far back as I can remember. I drew a lot of princesses and fairy tales, of course, and my father was away a lot, and I sent him illustrated letters. I drew what my family was doing, how the kids were growing, and how we all looked, and I would draw family pictures. We didn't have a camera and—they still have some of those—and it's kind of interesting to see how I was very involved in depicting the family and showing him what we were all doing. And then I had an art teacher in that commune. She was a Jewish woman whose mother had been in the camps, and they had come over to America, and she was highly trained. She'd studied at the Art Institute in Chicago, and she'd gotten a degree. Her husband joined the commune, and she came along with him and became our art teacher. She would take us out drawing in nature and did lots of art projects with us. That was probably the most formal art teaching I ever got. I worshiped this woman; I was glued to her. She would show me her drawings of nude models and stuff which was, of course, totally taboo. And the sad thing is this woman went mad, and I think this is something that very much marked me also, because she had a rapid succession of three or four little kids, and she just went crazy. She couldn't do her art anymore—you know there must have been other reasons too—she did eventually commit suicide. But I watched her go crazy, this woman whom I revered, who was the only artist I knew. She was the model for me, I guess, as an artist. She was a very passionate woman, very dark haired, sort of that northern-European-Jewish-gypsy-type. It was a very strong kind of role model for me.

I also remember reading a book about Rosa Bonheur when I was very young—about eight or nine—and I was just totally fascinated by that. I used to draw all of my pets and all of the animals and pretend I was Rosa

Bonheur. Also Käthe Kollwitz was a very, very big influence on me. I still have copies of her drawings which I made.

BS: You knew of her?

FW: Oh yes, yes. There was a book that someone had brought from Germany, and I used to copy her drawings. So those were my art influences, and this was my art training. When I went to college I was told by the commune to take English courses and to be a teacher. I was supposed to take education courses. None of that was lost, but on the side I took art history and stuff. I didn't actually take visual art courses, but after I left the commune and I married then I started just taking courses. I took courses in weaving, and ceramics, and figure drawing, and all those things, but I didn't connect to it somehow. It didn't seem to connect to my other interests. That was when I met Judy Chicago, and she was saying, Let's start this program. And I said, "Okay, I don't know anything about it; I'm not a trained artist or anything. But, sure, let's start this program." I had already started an experimental course at the university, called the Second Sex, where we were reading Simone de Beauvoir and all the feminist books we could get hold of. We had a consciousness-raising group, and through that first feminist studio workshop that Judy and I had started, that's really when my art came together with my interests, because that's what we were doing, you know, working very personally. That was the whole aim of it. That was the first time I actually explored my past in my art. The first piece I made in that situation was an installation, an environment, which wasn't so usual in those days.

BS: That seems quite early for that.

FW: Yes, it was kind of a new thing to do. There was an altar on one side of the room with a whole bunch of things on it — a crucified bird with lots of blood running down, lots of tampons all over with blood running — it was a very bloody, angry thing. Then there was kind of a platform in front of the altar and lying on it I made a life-size image of myself cast with my head screaming with my mouth wide open. I was dressed as a bride, and my stomach had been ripped open, and I filled it with real cow guts, real blood. Then there were candles all over, and flowers, and blood dripping from the walls. It took me something like four months to do this piece because it was so difficult for me. I had completely covered over my past. I wouldn't tell people where I came from. I wouldn't tell people what my background was because I couldn't deal with it. I tried to pretend I was just like everybody else, and when people said I had a weird accent I would say, Well, that's because I come from Connecticut, or something like that. I had not talked about my past much to anybody.

I wanted to be just a normal person; I wanted to be seen as just an ordinary everyday American, and I didn't want to get into any of this stuff. The first assignment in the feminist workshop was to do something autobiographical, and I started uncovering all these layers of experience from South America, and so this whole thing came out, and it was very crude—powerful, but so crude. It was like a catharsis for me, and it was the first time that in my adult conscious life as an artist—beginning to be an artist and thinking about art—that I brought together my own self, my own contacts, with feminism and the sort of intellectual things I was interested in making in art. That really was the whole focus of that workshop: to make art out of a content that was different than the usual sort of art school approach where you draw from a model and you make paintings and you copy things. It was a very revolutionary approach to art making at that time. And we started doing performance, and I also got into performance—writing, doing text for performance, and so on. And so, when I say I wasn't really trained as an artist, I mean that I haven't gone through traditional training. I then went to Cal Arts as a graduate student, but it wasn't a traditional artist's training that the kids I teach now go through. Actually, I would have died of boredom if it had been. I don't think I would have survived very well if I had to go through that experience doing regular drawing assignments. It was very strong and revolutionary for me to be plunged into this feminist environment where I was given permission to contact my past and to explore in so many different media. Another thing that's very hard for me is the way people in art school tend to get tracked—it's not so true anymore, thank God, but it's still difficult. People say if you really want an art career you should concentrate on one thing. You always have to classify yourself when you're applying for a grant or a job. They want to know, are you a painter or do you draw? Well, from my background I learned to make things in many different media. I love to make things. I've always worked with books, and sculptures, and prints, and drawings, and environments, and performances, and I work with sound a lot. I've done quite a bit of work in radio.

BS: Well, this seems to me like the hallmark of an artist—when we say to the artist, "classify yourself," what we are doing is putting the lid on.

FW: Yes, but I just applied for three or four major grants in the last two months, and in each one I had to classify myself—you know, they say, This is going to be judged by a panel of painters—well, hopefully they're not rigid people who will just—

BS: But that's the fault of the kind of peripheral art world where you have got to categorize things because you have x number of dollars and

you will give some to painting and some to sculpture. It's unfortunate, and yet we don't seem as a society to be able to surmount that in any way. Everything has a pigeonhole.

FW: Actually, many of the most interesting artists today tend to work in many different media, and installation is very much in—you know, there is the big show at the Modern that opened last week. That's what everybody is doing and what I have been doing all along. I've never just hung a painting or drawing show; I've always put it in context where I've written on walls, or I've drawn frames, or I'll have books on another side of the wall, or I'll have a collaborative piece that people have built with me on another. I've never just hung up a couple of paintings, except maybe at the Douglass Library.

BS: I wondered what you did there.

FW: Well, actually, I had a watercolor show. It was a suite of twenty-eight watercolors that I called "Imago Femina," built around themes of nature and shapes that I've used for a long time: pods, chrysalises, cocoons—all images taken from myth and archetypal images of growth and birth and decay, which is an underlying theme in all of my work. Then they invited me to also come and do a performance. So I came, and I did a performance with students at the Mason Gross School, and I had four or five women who represented the four elements, and we did this whole thing with sound, and it was a poetic thing that I had written and they performed. I always see that in tandem with my work, and that was very much, to me, part of the visual—to also have this whole audio thing and this whole performance going on.

My early work—after Cal Arts and after I went out on my own and started teaching and started showing—my work became very decorative and kind of beautiful with lots of color and lots of pattern and a lot of images from nature and myth and archetypes. It was somewhat in the vein of O'Keeffe. What I was doing, in a way, was going through my own training like kids do in art school. I realize this now. Kids in art school spend four or five years learning how to draw and paint—practicing. That's what I was doing in those years after I got my M.F.A. and left school. I was, for the first time, taking a lot of time and developing imagery and learning how to paint in various media. I taught myself to oil paint in the old manner with glazes, and tempera painting, and watercolor, and I actually taught myself this whole repertoire of very classical techniques. I had been drawing the same way. If you look at my drawings, I'm using tiny little strokes with cross-hatchings on very large surfaces, and I'm using various techniques with watercolor and inks, and I'm using the figure, but I never draw from models. I cannot draw from

live models. I draw completely from memory or from imagination. I mean, I see plenty of naked people in my art classes, and I go to the sauna and I study people's bodies. I love to look at bodies because this was so forbidden as a child. I never saw anybody's body.

BS: Not even your mother's?

FW: No. I got one glimpse of my mother's body shortly after she had given birth to my sister. But I never saw anyone's body except when we played doctor.

BS: But that must have been very distressing for you as you grew and your body changed.

FW: Yes, very. I wanted to know what they looked like—am I normal or am I abnormal. I remember one time two or three of my friends getting together comparing amounts of pubic hair. Of course this was something that I felt was an incredible sin, something that was on my conscience for years. But that was about it. I just never saw a body, so I became very obsessed with the body, and I still am very interested in the body. That's really become important; that's one of my main subjects— the body—which is of course very much what a lot of feminist artists and writers have become interested in. It's become, now, something that I feel very comfortable with. I'm healing and opening up all of those places where as a child I was repressed and wounded; and it's just providing endless subject matter for me. It's great. It's actually what artists—Do you know the book by Eleanor Munro, *Originals,* where she talks with about fifteen artists about childhood things—what they were doing, the first impressions that they had in childhood, and how it marks their art? You know, I think there's a lot of truth in that, where you delve for your subject matter.

BS: This was the time when women were really coming into their own. How did your husband accept this, because this must have been a very difficult thing for him?

FW: Oh, it was really difficult. We've been married now for twenty-four years. There are still some little pockets there we have to explore. The anger thing was really difficult, because women were really angry and often incredibly nasty to men and were very separatist. A lot of women became lesbians, at least for a while, completely turned off men. I knew a lot of young married women who came to the college with their husbands. It was the typical scene: the husbands were hired as professors at California State University, Fresno, which was where we were, where

my husband had been hired as a young professor. They came with their wives; they all tended to be young, very educated, overeducated women who had a lot of smarts and no careers, or they had some interest in careers, or they didn't know what they were going to do but they knew that they wanted to do something with their lives and they were stuck in this little town. We started fomenting a feminist revolution. That's what we were doing with our lives. And women would come to consciousness-raising groups—something like fifty or sixty people. It grew every week; it was outrageous. It's hard to recapture that atmosphere now; everybody's so jaded. But women would sit there and say, "You mean you can actually get an orgasm when he's inside you?" And they'd be actually screaming, "Really, you can do that?" And somebody else would say, "What's an orgasm? I never had one." People would try to describe—I wish I had tape from those meetings because it's so different now where everybody's very jaded about these subjects. They are still very painful subjects, but it's not the same kind of discovery. Marriages were coming apart. People were doing outrageous things, and we tried to organize the men into men's groups, which they really resisted and hated.

BS: I can see a real polarization there.

FW: They were trying to be very politically correct. After all, they were sixties men and they were part of the revolution, and yes, women had to be emancipated also. So they would do their best, and they would go to these men's groups. Now of course it's a big thing; men are discovering themselves and they're off in the woods, drumming. But then it was very difficult. There was a lot of rage. Because I was off all the time doing my own thing, it was very difficult for him. The minute he got to his job, he was fired for political reasons. Within two weeks of getting to California and starting to teach, he was notified that he was fired because it turns out the F.B.I. was following him for years. I mean, he was a campus radical. He hadn't done anything. He was a pacifist, and he never incited violence, but he was a leader, and he gave a lot of speeches, he wrote a lot of articles, he was an antidraft organizer—both of us were—and he was a conscientious objector. He fought that and got reinstated for the next year. The next year, within a month, he was accused of burning a piano, which of course he would never do. Somebody had a secret tape and accused him of doing something. We had to go all the way to the California Supreme Court, a five-year court case, to find out what really happened and get the secret tape. After a five-year court case, he got reinstated with some little back pay, but his academic career had been ruined. At the same time that I was discovering feminism and saying "Fuck housework," and "I'm not doing the dishes," and "I don't care if you're fighting your grievance and staying up all night to write your dis-

sertation, I'm still not going to do the housework." I'd come home every day from working in the feminist studio with Judy—usually Judy came with me—and he'd have cooked the dinner. Then he'd stay up all night typing his dissertation. So he has a lot of anger from those years, and we did a lot of pretty outrageous things, things which I apologize to him for. There was a lot of anger, there was a lot of friction for quite a few years. Of course, you know, men also behaved badly and treated us badly. These were all difficult things to work out within one's marriage, but somehow I guess we have worked a lot of it out because we're still married and we're still pretty good friends.

We never had children, which is interesting. It might be a fallout from all of that. I always wanted a child. I love children, and I never thought that I wouldn't have children. We never consciously said we are or we aren't. We always assumed we were going to have children, or at least a child. Then when it came down to it—there were a lot of problems because of his firing, and we had to move, he had to look for a job. So, there were a lot of years of real struggle when he was blackballed and nobody would hire him in California. He was supportive in many ways, and I give him a lot of credit because in quite a few of those years he was making the primary income, although I always worked and always have earned money, and often I have had full-time teaching jobs. I did have a full-time tenure-track job in California, and then the college in which I was teaching folded. After that it was sort of piecing together. Usually I had four or five part-time jobs, and I spent five times as much time teaching as he did and made about a quarter as much. He was always very supportive of my spending time and money on my work and has always encouraged me. He thinks it's great that I'm an artist and thinks I'm much too reticent about myself and my work and tries to push me—flog me into—

BS: That's good.

FW: Yeah, I need somebody like that. And he's a very aggressive, assertive person. It kind of helps me in that direction. I would say he's been a great supporter of mine, with all the battles we've had, and we still have plenty. In a way, he taught me how to fight. I mean, growing up on the commune, anger was totally taboo and fighting was taboo. Especially fighting a man, my God. I mean, I had been totally programmed for docility, but I was actually very rebellious inside.

BS: Well, certainly everything is very powerful even at this remove.

FW: Yeah, I have very powerful and raw feelings, and I've always done a lot of work about the body and sex; and he's been good about that too.

He grew up in a very puritanical family—New England—very straight little religious family who go "AOOOOOO" when he says "fuck" or when I say "fuck." It was very hard for him to see a lot of this content that I have been working with all these years and to see me do performances that are sort of very out front and very revealing. That's hard for him.

BS: You wrote an article not too long ago with Miriam Schapiro that classified the kinds of art in the women's movement.

FW: That was in the twelfth anniversary issue of *Heresies,* called "Cunts, Quilts and Consciousness." That was a naughty title.

BS: Well, I had trouble with the title because I have trouble, from my background, with saying that *C* word.

FW: We debated that for a long time, but since what we were trying to do was a historical issue of *Heresies,* we were trying to look over the whole history, and the cunt thing had been a whole "genre" in California art. So we felt we had to put that in because it was very revolutionary and very radical at the time and maybe not in very good taste. Certainly Congress wouldn't have thought so, but it was a very liberating thing for women, you know, as much as quilts, very much a part of the feminist art movement.

BS: How do you feel about the feminist art movement right at this point? Certainly there have been changes.

FW: You know, I don't even think of there being a feminist art movement anymore, because everything is very diffuse. I think of there being a lot of feminist artists, and I think of there being a lot of feminists who are artists, that would not necessarily identify themselves as feminist artists or say that their art directly deals with feminism. There are so many different categories now, and so many different categories of feminism. But as a visible, organized group, I don't think you can say that there is a feminist art movement anymore. There's the Women's Caucus for Art, which is a very organized, a very well-established caucus within the College Art Association. It is quite highly regarded and, in some ways, a very effective body of women; but they are mostly academic women fighting those battles. I certainly see myself as someone who is terribly interested in education, particularly education for women. I've been in other kinds of groups, mostly artists' groups, since I left California. I've always been part of some kind of group. Most recently I've been part of Heresies, but I'm not anymore. I stopped doing Heresies for various reasons, but actually it wasn't grabbing me anymore, it wasn't exciting me, it wasn't in-

teresting, and I'm trying to figure out what is interesting. I've also been part of two reading groups in the last two years—women's reading groups mostly composed of artists, reading and discussing various things. I'm about to become part of another artists' group,[2] and we don't know what we're going to do but we're going to meet for dinner once a month or something like that and see what happens. I just feel that we need each other still, women artists, and I feel that we don't have enough links to younger women artists; I don't, anyway. Some younger women artists are getting a lot of visibility in the art world, much more so than people of my generation, the middle-aged artists. I've been working for twenty-five years, very steadily, and I've had a lot of shows, and I've had various grants, but I have little visibility. Partly it is my own fault. One of the problems is moving to New York where it's very difficult. I had a lot of visibility in California, in Los Angeles. Another problem has to do with my subject matter and the way I work. Commercial galleries have found it very difficult to deal with my work. I've mostly shown in museums and university or college galleries, which I actually like to do because there's much more freedom there. I hate the commercial art scene, I think it's ghastly; and you know, I don't think they particularly like me either. But there's a lot of networks. I would say there's a very strong feminist net-work, and there are organized groups doing various things, like the Guer-rilla Girls. In some ways, the Guerrilla Girls have carried on a tradition, which we were certainly doing in California, of activism; they are the wheels of organized activism in the feminist art world, and I'm glad that they're doing that. I'd like to do something more, but I don't know what exactly. Actually, probably writing is the thing that I want to do because I feel that there's a lot of stuff that has slipped through the cracks. When I teach, my women students don't know anything about women artists. At Cooper Union we don't have a course about women artists. All three hun-dred students signed a petition to have one last year, and they still don't have one. It still is something that the students largely have to discover on their own. A lot of stuff isn't known or has been forgotten, and I'm very much concerned about that. I think it's only through writing our own his-tory (as Virginia Woolf says in *A Room of One's Own*) that we're going to preserve that history. I have four file drawers here of history—archives of the feminist art movement.

BS: Times have changed so greatly. Students in women's studies pro-grams today often have trouble understanding the early years of the movement.

[2]W.A.C. (Women's Action Coalitions) started in December 1991. There are now about 1,500 members, and they deal largely with issues around women and violence, gender politics, and choice.

FW: Well, there's this whole puritanical thing also which has happened in feminism—the whole aspect of pornography. I am totally opposed to pornography and I hate it, but I do not believe in any kind of censorship because I think it is just too dangerous. You start censoring pornography and that just opens the door to censoring anybody else. It's also from my background; I know from my background what censorship and repression can do. It just heightens all those things and makes them come out in other ways, often even more destructive. People cannot deal with their fears by legislating or forbidding them. You know, that is not the way to deal with those fears and anxieties, and I think that's been very strong in a whole branch of the feminist movement. I think a lot of academic feminists study the writings of Kristeva and Helen Cixous and other French feminists, and they give lengthy papers about it, but they know little of what many women artists are doing who are dealing with these subjects very graphically in their work. There seems to be a big gap. That's something that really bothers me too—that somehow it's all in the head, and people still can't deal with the body or the art. The work I'm doing now is complex. I have talked with a couple of people who have come to the studio and they said, "God, you know you're going to be accused of being antifeminist and showing the woman as victim, of showing women as only weak and victimized, and as a freak, or so on, and haven't we gone beyond that, and don't we need positive models?" Then I opened the newspaper today, and there's at least three stories about women and children being victimized—the child bride being sold, the baby being flung off the roof—I mean there is so much that is still there, and people don't know how to deal with these fears and these body things. Women's bodies are constantly on the line, and you can't have a party line about it. I have many different images. Some of the images show very rebellious adolescents and women really kicking back, and others show women as victims, and there's a whole spectrum. For me this is real; this is what is and the way I see it and the way I deal with it. And I don't think we are beyond it, and I don't know how to make it artificially positive. I think it's positive to bring these things out and to speak about them. It certainly strengthened me personally.

BS: Well, certainly you can't deal with anything until you see it, and artists are always on the forefront of bringing things out, it seems.

FW: There's a lot of taboo stuff about kids in my work, and that's what I'm also focusing on now: going back to my own background but, in a way, also because I see it so much in the culture—little girls and kids and how they're victimized and traumatized and how we completely throw away just millions of kids in this country and around the world. The whole issue of powerlessness is so strong when you deal with children,

and it's something that isn't dealt with a lot in art. I'm doing a lot of work with images of adolescent kids. It goes back to my adolescence when I was trying to feel my own power and made to feel completely powerless, completely swallowed and ground up. I'm doing this whole thing with these dresses and pants, where the child is sort of disappearing into the costume. I've got a bunch of other images where I'm dealing a lot with the child image and how the child is being engulfed or swallowed or is trying to separate from parental authority or this tremendous power image—the man and the woman. There is a kind of comparing the child with the animals, and this also comes out of some of the Holocaust readings and thinking about these issues of victimization that are difficult to think through. We had a lot of Jews in our commune and a lot of people who had been in camps. We had a lot of people who had been victims, so it was very alive to me as a child, and I was very curious about it then. We were never told about the Holocaust as children. It was just some very dark and horrible secret, and I've been very drawn to reading about it. I've done a lot of research because I guess I have a real kind of fascination about victims or about how people can be victims or how humiliated people can be and still live or still have some power. Some of these images come from that reading and from watching my brother with his five-year-old daughter. She's a little nudist; she's growing up completely opposite to how I grew up. When we take her into town we have to tell her that she has to put clothes on. She's got this lovely little sexual body and—

BS: Is this his response to how you grew up?

FW: Probably. We've discussed this several times, and he's said we were obsessed with sex and playing doctor and we never were allowed to see people's bodies. You know, his kids are somewhat curious about people's bodies, but it doesn't obsess them. They are completely free of that obsession, and when I watch that it pains me when I think about how I was repressed about perfectly natural things. But I think the images I painted also showed the seductiveness of the child—which is there, it's true. I mean, I feel the seductiveness and the sexuality and the beauty of that little body. They are very close together—sensuousness, and gentleness, and sexuality. I think people have such incredible fears about taboos and inhibitions that are all twisted up, and its much better to talk about it. When I think of the censored Mapplethorpe photos of children—I've seen those photos—it's ridiculous; it shows how sick people are about this whole thing of child sexuality and repression, because it really has to do with what they themselves were taught to repress as children. For me, it's a very strong subject that now seems to have taken over my work in many ways. My work's actually changed a lot in the last four

years, since I came to New York, because I have been delving into this very personal subject matter. But I don't want it to be just personal; I want it to be applicable to others.

BS: Let me ask you a little bit about the way you work, because I see you have sketches on the wall. Is that the way you work: draw small and translate?

FW: It hasn't been in the past. I worked very spontaneously in the past, but when I changed my work pretty drastically, in about 1988 or 1987, I started making a series called the "Daily Text," a series of very small drawings, little pages. Every day I generated little pages. I tried to work very much out of my subconscious, and I would just make blots and stains of watercolors and ink and do sort of unconscious drawings, trying to contact the subject matter that I was really getting close to and discovering. For about two years that was all I did. I have hundreds of pages, and I would love to have a show of all this work. I just have to find a place to do it. I'm going to install a whole wall of these pages, because to me they are kind of like little blueprints from my subconscious. Then, later, I started developing them much more, and then, even later, I got this feeling that I'd like to see some of these costumes life-sized. So I started just taking ones that I thought were particularly strong and blowing them up. That's what I'm doing right now. I've got about fifteen of these big drawings in various series, most of which I made this summer in my new, wonderful studio in Vermont, and the colors are very subtle. Some of the other ones I have are even more delicate than that: they're sort of like moth wings or rotting leaves or ashes, and when you have a real, proper light on them—daylight—they're so beautiful, there's a lot of beauty in the work. It's very raw and powerful, but it's also very delicate. I'm sort of playing with that edge of the rawness of the power and the delicacy, that sort of tenderness and delicacy. It's not about shocking people at all, this work; it's about trying to feel something, to feel very contradictory feelings. I'm trying, in a way, to work in a very contradictory way. I work with very traditional materials: watercolor and ink drawing. Some of these bodies have a flavor of the medieval about them, but I want that contradiction and I'm trying to get at a feeling, almost a skin sort of feeling, and a feeling of memory. I want people to go into places that are hidden in them, and the only way I can think of really doing that is by trying to make some kind of a sensuous quality, trying to make allusions with these kinds of mottled and spotted surfaces that remind you of layers of cocoons or webbing, or I-don't-know-what. There are a lot of memory feelings for me in the work. A lot of it has to do with qualities of the memory of the sort of mysterious things that you experience in childhood, that you don't understand at the time but that stay in

your mind as a sense memory. I have a sense memory of these heavy, dark, huge dresses that enveloped the women, and a tremendous curiosity that I had about what was under there. A lot of them were pregnant all the time, you know, and they'd have these huge pregnancies under these aprons, and I had a tremendous curiosity about what was under the men's clothing too. I was totally obsessed by their flies and the buttons on them. As a child, you have these experiences; it's an unexplained mystery that fixates you in a way. I'm trying to capture that, and focusing on the costume or the dress. I've got a lot of series of dresses here. So I'm working spontaneously, in some ways. Part of this is done very freely, it's very loose, very wet, extremely wet, laid down in a very uncontrolled method. Then on top of this it is very controlled—hours and hours of just making tiny, tiny little strokes with a tiny little crow quill pen. That's what I mean by contradictoriness. I know by now which inks will creep, or will make beautiful kinds of stains, which I love, but then these blue veins happened, and I didn't know it was going to happen, and I loved them. So in a way it's intuitive, in another way it's controlled— that quality of the unconscious and the conscious that art is made out of.

BS: Have you ever done any etching?

FW: I have. I got a grant from the New York State Council, and I did a suite of eight etchings—the first time I ever etched—and it's my medium. I loved it. I would like to do big figures; I want to try some things out. I would like to do some dresses and things with the dresses, because I think it would be really interesting. Maybe monoprints, because it's slow turning out some of these images, and they are very precious. They are very singular, and I would really like to make this work more available. I like too, just politically, that it's not just a few rich people who can have a precious object, but that you can make it more available to everybody, everybody who wants that. I don't know who'd want to hang something like this in their living room though.

BS: Well, actually that raises another issue which comes often with the art that we show at Douglass. It's almost a dichotomy. It's made often as a rebellion or a way of getting out whatever is down under, but it then becomes so powerful, or the subject matter is so difficult to most people, that they wouldn't buy it and put it on a wall, so then the art that is good, fine, strong art, if it isn't picked up by a museum, is lost. It's not available to anyone then.

FW: I know. I have that problem because of the nature of this work. I'm not sure I would hang some of these pieces in the living room. In a way it's museum art. It's certainly no different than people like David Salle

with his horrendous stuff. People seem to want to hang that stuff in their living room, but when women do it, it's not the same. Then you think of artists like Ida Applebroog, whose art is being collected now. Some of her stuff is hard to take, but it's strong art, and really discerning people are collecting it, not for its blue-chip value, and museums are collecting it. I think her small works are widely collected by all sorts of people. I would love to sell my small works for fifty dollars to anybody who'd like them, and to make the work available in that way. I hate that idea of rich collectors having all the stuff. Some of them are good people, of course, but a lot of them are not my audience, and that is really a big issue for me: Who is my audience? And how to make myself available to my audience. That's what I'm trying to wrestle with now, trying to find places to show, and showing my work to a lot of people.

BS: You're not affiliated with a gallery?

FW: No, and I never have been, no commercial gallery. I've been part of women's galleries in Los Angeles, the same as A.I.R. here, the co-op galleries—I've always been part of that. I have that option here too, but I've decided not to do that for various reasons; although times are changing again, and a lot of commercial galleries are folding, and maybe the whole alternative co-op gallery scene is going to sort of grow again. It can be a trap; it can be a way to hide and not deal with getting out in the so-called serious art world. Whether rightly or wrongly, I have set myself the challenge of trying to get out to the bigger world. I don't know how it's going to work, or even what my criterion for success is exactly. I know that I want to be part of the dialogue of my times. You can't do that if you are not showing at all or only showing in a small, sort of parochial, space where you essentially talk to a very limited audience. That's what I'm trying to deal with now—finding a bigger audience and not hiding in the alternative crack—and it's hard.

BS: When you get into the bigger world there are very few people willing to take chances.

FW: I do think my work has a lot of beauty to it and it has real value—the process and techniques and so on. It's not just sloppy and tossed up; and I've been working for a long time. I'm not a fly-by-night kid who next year will decide I'm going to be a fashion model or something like that. I've got a very strong idea. I think that what keeps me going is that my way of dealing with the world is through art, making my images. I've always made art, always had a studio, always continued to make art on as regular a basis as I possibly could. And so there seems to be a very, very strong compulsion in me to do that. I can't imagine what I would

do if I weren't an artist. How would I get up in the morning? Plenty of times I don't want to get up in the morning; I don't want to face dealing with it. But then, when I finally make myself come to the studio, and I've got my cappuccino, and I'm sitting here, I think, This is great; I'm in the right place. And I start doing my stuff and pretty soon five hours have passed and I haven't even noticed it. That's one of the reasons I keep going, because I seem to have this need to do that. I've gotten a lot of help and encouragment from my husband, who has also often made it financially possible. We've just sort of made that commitment. We've made that commitment to his work too, and that's how we spend our money. We don't acquire stuff, we don't have fabulous wardrobes or wonderful furniture or geegaws. We spend our money on time to do our work and on travel if we can. It's my way of knowing the world. It's the way I keep the mind open or the conversations open with the world. Käthe Kollwitz is a big role model of mine. I've read all of her diaries and seen much of her work in museums in Europe. She was a very socially committed person, and her thing was that she wanted to be a force in her time. It's sort of a pun; she wanted to be part of her time, and she wanted to influence her time. She wanted what she was doing to influence the conversation or discourse of her time, and I very much want that for myself, hopefully through the whole feminism thing, through teaching, lecturing, and doing workshops—that's my political work in a way too.

BS: The workshops you do—what kind?

FW: Well, I haven't done anything in the last few years, but I used to do a lot of different things with journals, autobiography, some of the techniques that we developed in the feminist studio workshops about working with one's own subject matter, using performance, or installation, or acting it out, or journalistic things, or everyone working on a subject and sharing it—the kind of techniques that get people to link up their art with their real burning concerns.

My family sometimes has trouble with this new art. They loved my old art when I was dealing with nature, and they have quite a few of my earlier pieces. We bought property together in Vermont. My brother built my parents a house about two hundred yards away from our house, so they're close. They live there year round. In the beginning of the summer I said, "I'm behind closed doors. You can't come down here unless you're invited." That was real hard for them because they sort of got used to popping in on us and chatting, and that was kind of nice. But, I completely kept my studio off bounds to them all summer long, and then at the end of summer I made a formal invitation. I invited them to dinner and said, Before dinner you can come down and I'll show you my work. I think they were a bit shocked, but they were also interested because

they shared my background. They immediately picked up on the costumes, and they were actually pretty open to it. I talked with them quite a while, and they were very impressed by the techniques and so on. My parents have been very supportive of my art all along, even when I've been involved in things that were difficult for them to understand. Working in Vermont brings up the question of audience. For a while I started feeling very paranoid. Here is this little town; everybody is very socially concerned; and I got this feeling that I don't want to show these people my work, I don't think this is my audience, but then thinking maybe I'm prejudging them. And then my brother said, "Oh, you should show this in Brattleboro; they'll love it." I didn't know quite what he meant by that. Then I realized it had to do with the fact that it was my family, and we had grown up in many ways in such a repressive situation, and while we now talk quite openly about that, and we talk about the damage we think it did us, and my parents have often asked us for forgiveness for bringing us up in such a situation, it's a family thing. It's hard for my parents to look at this and not read themselves into it, and without all of these sexual things in the family sort of falling into it.

BS: You put the largest taboo right on the wall.

FW: That's what I was feeling, and that's probably what they were feeling. The way I always talked to them about it was to try to depersonalize it somewhat. You know, its not just my personal history, that's not really the main thing so much as trying to take positions by using very intimate, strong images. I think they got it. They're intelligent people. They've watched me work all these years, and I've talked to them very openly about feminism and all these things that were going on. As they've gotten older they've gotten so much more open-minded, thank God.

BS: Probably as they got away from the commune, and they got away from that influence, but I think there's a certain education that comes with life too. I'm not sure if ten years ago I could have looked at the work without squirming a bit for my own Victorian reasons, but I think there's something that comes with looking and talking and opening the mind.

FW: At this point, statistically, women artists are not doing half as well as men. I think it's still very difficult. Maybe I'm wrong about this, but I think it's difficult for women like me. I know quite a few contemporaries of mine who are very strong artists; they've had long careers. We went to a school that is now getting very good publicity, Cal Arts—it's supposed to be a hot place to come from—and we're not doing well professionally. We're pretty invisible; we've had no luck in finding permanent teaching jobs. I've got so much teaching experience. I've been in such

good places, and I've got such good recommendations, and I cannot find a teaching job. By now I fall between the cracks because I'm not a young person just starting out so they can hire me at a very low level, and I'm not a famous person who can be hired as a star, and it's very hard. Now I'm forty-eight, and it's very hard for people like me to get jobs. I know quite a few women in my position, and we have seen the men who went to graduate school with us soar in much larger numbers. Most of the male artists who were at Cal Arts at the same time as I and my friends are doing much better than we are. Cal Arts has featured them in alumni shows, but Cal Arts has never shown any women from the Feminist Art Program in their alumni shows, and quite a few of them are very good artists who have been working all these years. I lectured at Cal Arts about ten years ago. Somebody asked me to come and talk about careers and future, what it's like to be out there for a while and what students should expect. I went and gave them a very, very, sorry story. The women were incredibly defensive during the whole class because I kept saying it's especially hard for women, and I read them a whole bunch of statistics. The women were incredibly resistant; they did not want to hear this, and they fought me all the way during the class. But after the class, after all the men had left, the women came up to me and said, "You are absolutely right. We believe every word you said, but we cannot ally ourselves with feminists in front of the guys, and we cannot in public acknowledge these things that you are saying because we have our careers to think of and we would just be killed." This was so hard to hear after knowing Cal Arts' history of feminism, which has just been completely erased, at least at the time I lectured there in the early eighties. Women's history just keeps being buried. We keep having to revive it, and that's why I think it's important to have an ongoing series like the Douglass College series. It at least keeps that history open. There are women artists, and women can come in and ask themselves why are they showing women artists, and then they can go to the library and they can read about the history and they can look it up. That's why I think it's good to have women's studies courses or women artists' history courses, because it keeps that question going, and every new generation doesn't have to rediscover it on their own. At Cooper, when I talk about it and give them a little reading list and show this existed, they get all enthused and immediately organize a consciousness-raising group, and it goes for a few months. And then it drops because there's no institutional support. That's why I think it's very important for institutions to have that kind of thing going on, because it keeps it visible, it keeps the questions on the table.

BS: Well, every time you start from scratch you start with a resistant group, too, who feel like they have accomplished something, and then when you put everything there they see what they haven't accomplished.

FW: A few years ago, anyway, the kids were often daughters of women who were very much touched by the feminist movement, the first generation who had been liberated in many ways. A lot of them had very negative feelings about feminists because they felt that their mothers had neglected them for their careers, which I'm sure happened, and they had very angry, very conflicted feelings about it. They are the kids who are now really interested in feminism because, as they go out into the world and see how difficult it is to do all those things and to pay proper attention to their children, they start empathizing with their mothers and they see what it is that their mothers had to deal with. Unfortunately, a lot of that happens after they leave school and go out into the world, and if they haven't had anything in school to help them deal with that, then they have to do it on their own and that's more difficult. They reinvent the wheel every time, and so it's difficult to make progress. I use all these arguments when I try to talk to the curriculum committee.

BS: If you had to pick a major accomplishment that you did in your life with your art—

FW: Oh, dear—You know, I've had some grants and I've had some shows, but the major accomplishment to me is that now I'm doing this work which is to me the best work I've ever done, the strongest, and I'm really into it with no encouragment from the outside world. I'm nearing age fifty and I'm really hitting a stride now in my work. But there is the taboo against older women. Now, of course, I'm getting to the age where I'm going to start dealing with that. I still look pretty young; I look a lot younger than I am.

BS: You do. You could walk in and lie about your age and be believed.

FW: That's what I am constantly being advised by other women to do. To never mention my age, to put on a sexy little black dress, but—

BS: It's kind of selling out on your principles.

FW: Kind of impossible for me to do in a way. Of course I don't have to go in there and say I'm forty-eight years old and I want a show, but I see the maturity now as such a valuable thing. It's so hard when I think of everything that I've been through and everything I've done. The way I've worked all these years is a feather in my cap. I think of all the things I've started to experience, the stereotyping of older women. Boy, I'm going to do work about that because it's cruel.

BS: That's so true. A man becomes distinguished, and a woman becomes old.

FW: I'm already feeling the loss of that youth, and the youthful looks, and what it seems to automatically give you—the doors it opens and the power, the completely false power, but the power it gives you. It's really something that nobody wants to deal with, it's so unsexy. It's a horrible taboo, but I feel that it's one of my big achievements that I've gotten to this place, and I'm very much alive. I'm growing, and I'm working like crazy, and my life is very rich, and I have all these wonderful older women friends.

BS: Early on you had relationships with Miriam Schapiro, Judy Chicago, and all of these people that were very, very important. Do you still see them? Well, you obviously do still see Miriam Schapiro.

FW: Yes, Mimi and I are still close, and I keep in touch with Judy. I know all these women—Betsy Hess, Joyce Kozloff, May Stevens, Lucy Lippard, Mira Schor—these are all my friends, my peers, my role models, and my sisters. I feel very lucky to know these incredible women. I know these women because of my involvement with the feminist art movement, and this is still sort of our network, our really close network. I can't tell you how wonderful it is and how lucky I feel to have this network, to know that I can call on them, and talk about our work and try to help each other out. This was one of the big goals of the feminist art movement: that women would begin to have some of the same networks and support structures as the men have had all these years. And some of us have really achieved it. I only wish that we could do more and that we could link more. This is a real goal for me: to link more to some of the younger women artists. I know their work, but I don't know them at all socially, and they seem to have completely different networks. I don't even know what they feel about feminism, although there's a lot of feminist issues in their work.

May Stevens teaches a course every year at the School for Visual Arts, "Women and Art," and for the last two years she's invited me to speak—in fact they came to my studio two weeks ago, fifteen of them. It was great. They were strong. We got into some really good issues. There were a couple of men in the class, and one of the men in the class was talking about erections and what it felt like, and he was responding to some of my little boy images that I have. There's a strong interest there, and I think it's partly because it's become academically very fashionable; multiculturalism, and racial issues, and gender issues, and sexual issues are *in,* and students always respond to that.

BS: Anything else you want to say for the record?

FW: No. So many people have asked me to write about my experiences. I've written little parts of it here and there, and I do think of myself as a writer also, and I really do want to write about it, and some day I will.

Plate 27. Jackie Winsor.

Jackie Winsor

Education

1967 M.F.A., Rutgers University, New Brunswick, New Jersey
1965 B.F.A., Massachusetts College of Art, Boston, Massachusetts
1964 Yale University Summer School of Art and Music, New Haven, Connecticut

Selected Solo Exhibitions

1989	Paula Cooper Gallery, New York, New York
1988	Centre d'Art du Domaine de Kerguehennec Bignan, Locmine, France (catalogue)
1987	Margo Leavin Gallery, Los Angeles, California (catalogue)
1979	Museum of Modern Art, New York, New York (traveling exhibit; catalogue)
1976	Contemporary Arts Center, Cincinnati, Ohio (traveling exhibit; catalogue)
1976	Paula Cooper Gallery, New York, New York
1972–73	Women Artists Series, Douglass College, New Brunswick, New Jersey

Selected Group Exhibitions

1990	"Sculpture," Daniel Weinberg Gallery, Santa Monica, California
1989	"Floor Works," Museum of Contemporary Art, Los Angeles, California
1989	"Making Their Mark," Cincinnati Art Museum, Cincinnati, Ohio (traveling exhibit; catalogue)
1973	"Biennial Exhibition of American Painting and Sculpture," Whitney Museum of American Art, New York, New York
	"Four Young Americans," Allen Memorial Art Museum, Oberlin, Ohio
	"Eighth Biennial of Paris," Musée d'Art Moderne, Paris, France
1971	"Twenty-six by Twenty-six," Vassar College Art Gallery, Poughkeepsie, New York

Selected Bibliography

Sobel, Dean. *Jackie Winsor*. Essays by Peter Schjeldahl and John Yau. Milwaukee, Wis.: Milwaukee Art Museum, 1991.

Jackie Winsor. Essays by Peter Schjeldahl and Jean-Pierre Criqui. Rennes, France: Centre d'Art Contemporain du Domaine de Kerguehennec, 1988.

Decter, Joshua. *Jackie Winsor*. Los Angeles: Margo Leavin Gallery, 1987.

Gholson, Craig. "Jackie Winsor." *Bomb* (Winter 1986): 32–36.

Munro, Eleanor. *Originals: American Women Artists*. New York: Simon and Schuster, 1979, 431–37.

Johnson, Ellen. "Jackie Winsor." *Parachute* (Winter 1979): 26–29.

Interview

Jackie Winsor was interviewed by Sally Swenson

SS: I think a good place to start would be to ask you a formal question. When did you realize that you wanted to be an artist?

JW: My family had been in Newfoundland for a couple of centuries. In my family you were a fisherman or in some trade. You were schooled in sailing a ship. For a woman it was taken for granted you would be a wife and mother, a homemaker. Art as an idea was late in coming, but not the doing of it. That goes back quite a ways; it manifested itself early enough on. I didn't have a formed idea about that relationship to myself of making art, but I seemed to have a whole variety of abilities. I see abilities as doing this and doing that, and I did all of them. I did them well. I was in college before I quite knew what I was going to do.

SS: What did your parents think about you studying art? Were they supportive?

JW: Although I did very well in high school—I was in the Honor Society—I had had a difficult time in the lower grades because I am dyslexic. They didn't understand why I had trouble in school, and they just didn't want me to feel badly about it, so they tried not to put too much pressure on me. My older sister was very smart, and they had more ambitions for her. They were just happy that I could figure out to do anything, and if I could do this thing, well great, whatever that was. It appeared as though I was going to school to become a teacher.

SS: You could actually make a living at that.

JW: That was how it was packaged. I was going to art school at Massachusetts College of Art, and among the things you could major in was design. I had no idea what that was. You could major in industrial design, fashion design, ceramics, painting, but you could also be a teacher. Basically, it was like door after door opening, going there. I remember when I went up to Yale summer school after my junior year, the thing I was most taken with was that professional artists came up from New York. They didn't appear to be overly articulate, but they came in and it was really my first exposure to the idea that they were just artists. They didn't have something else that mediated their work. I was intrigued by that. When I was in graduate school at Rutgers University, people then seemed to have slightly awed versions of what their lives were about,

which had no relationship to me. One of the advantages that I had was that there was so little considered for women to do in my family. You were a mother and that was a beginning and end. It's interesting that I didn't do that at all, and I didn't know what else to do. It made me more willing to gamble and all of it. I didn't have any preconceived idea. As an undergraduate at Massachusetts College of Art, the mode of the school at that time was that painting majors would hire models, and we painted models, and that's what I did, and I did that well. At the end of my junior year I went off to summer school at Yale, and there was nothing saying what you should paint, so it was a crisis of what to paint — content or composing or having a point of view. There were a lot of trees around, but they didn't have that central focus of the human figure. It took most of my time there to figure out what in the world to paint. When I went back to college I went right back to the model in the middle of the room. It never worked again; it failed me. As a matter of fact, I spent my senior year in college trying to figure out how this way of working could fail you. It was quite perplexing to me; it was very depressing, I'll tell you. I went on to graduate school at Rutgers. I seemed to be floundering. I think mostly out of my lack of success I was compelled to try to figure out what was going on. In my first year, I started eliminating the things in painting that I loved but that didn't support the interest. Strokes got eliminated, then color got eliminated, texture of any sort got eliminated. Finally, I had a stretched, gessoed canvas sitting around with this big box of paints underneath it, and I never did a painting. Then I started drawing; I cut canvas. I did drawing all the way through graduate school. It was a very particular kind of drawing that I did. By the time I was about halfway into that first year, somewhere in that second semester, it occurred to me that where I was with the work was exactly where I was at summer school, where the focus was form and not color and surface. It was at that point that things started working; it was at that point where sculpture started emerging — just the beginning formation of it. It was still drawing, but the form began to take precedence. That was right where I was at summer school. I learned that you are meant to follow the work. Where you go off is when you manipulate it and think you can pull it together. When you are sensitive to it, you have to use your mental facilities to facilitate that. What you're doing is following an intuitive path that some other part of yourself is leading you towards.

SS: Your work has a very strong focus. Once you became a sculptor, do you think that focus had to do with containment? Would you talk about the idea of inside/outside?

JW: I think that you work out of an unarticulated area of yourself. It is articulated through movement; it is articulated through a kind of attitude

Plate 28. *Exploded Piece,* 1980–1982. Cement, plaster, wood, gold leaf, explosives residue, 34 1/2″ × 34 1/2″ × 34 1/4″. Courtesy of Paula Cooper Gallery.

towards materials. It takes living life and experiencing life and reflecting on life for a period of time for you to even get some knowledge of who you are.

SS: What you make art about, what your art expresses . . .

JW: When I first moved to New York, in the late sixties, I became interested in the physical nature of people, the part that was hidden, the part that wasn't thoroughly revealed. This is what I wanted to express in my work.

SS: You wanted that sense of mystery.

JW: There's a sense that it's there—this inner space—and you know it is there, but you don't get to see it, and it is not really important that you don't get to see it.

SS: Do you think that a lot of your work draws the individual viewer into the object?

JW: Yes. I didn't really have a clue about what it was except it was a concern of mine, and I knew that it was a concern. It wasn't about the veneer or outside of something; it was integral to what was taking place in the piece.

SS: This was always about the same message in a sense?

JW: Well, that is part of it. I think I have expanded on that and simply gotten bigger. The early, first cube piece was Sheetrock. It had walls of twelve, fifteen, seventeen or so inches. One layer was laminated on another, and there were windows on each flat surface; so there were six of them and two in the interior of a tiny, twelve-inch room. In the middle was a little space with a little bit of light so you didn't see anything much; you don't see anything from the outside. However, it was contained. This is what I liked about it. I liked it for various reasons, but one thing I liked about it was that this mass of Sheetrock weighed about a thousand pounds; it was very resistant, it held its ground. It was very delicately drawn on the outside. The drawing on it was on a delicate, papered surface, with little staples all over it, which I used to hold one sheet of Sheetrock against the inner one while the glue was drying, because it took these large staples to hold it in place until it dried. Then the staples didn't function anymore, but I left them there. I left all that. You have this massive volume that has its own delicacy but really doesn't hold its place. Then you peek into the window. As you peek into the window, the

mass disappears. All you have is this little negative, delicate little bit of space inside. All those layers with this huge thick wall silenced that space, it protected it and it silenced it. It most reminded me of when you peeked in, the physical exterior disappeared and the focus was then this empty, illusive little space.

SS: Was it a protective shell of itself then?

JW: The interest is that it was much like when you close your eyes. When you close your eyes you lose your whole body. It disappears and you are floating in space. The thoughts you have may be related to physical things out there, but all that physical nature of things around you and even the physical nature of your body is gone. It doesn't do it with trumpets, but it does do it. It gives you a slight indication of that experience. That was really my interest.

SS: You couldn't have the inner space without your body.

JW: Right. Otherwise it would just be empty space. You wouldn't be anything either if you didn't have a body. Your body is the vehicle for your consciousness.

SS: Your work is extremely well made, and crafted, and singular. Do you work on one piece at a time or do you work on a whole series?

JW: I don't have a strong point of view about that except that certain practical matters seem to come into the process. When I was first making pieces I often worked on more than one because I would get a certain part of my body tired doing one thing, and it would be more relaxing to do this other particular one.

SS: It was the practical realities of it.

JW: Yes. Then I had a few assistants, which I thought was a good idea; I thought they could work on one and I could work on the other. But I found that they couldn't do this. So I would work with them on one, and it was less confusing for them. That went on for a fair amount of time. More recently, making these small pieces that are over now at the Paula Cooper Gallery, I work on more than one at a time.

SS: That is a tight series. Each piece is closely related to the others.

JW: I have not worked with anybody doing those. I worked only by myself, so the requirements of working with somebody else and having

them be clear with what you are doing and understanding—that's not there anymore. Also the requirements of each piece differ. So I would cast a piece and then let it sit and cure a bit before I could work it some more.

SS: This series was made of concrete. Do you want to discuss the process? Was the concrete altered in some way?

JW: Way back, while I was a painter, color interested me. I don't think interests ever leave you. It is just that they may take on a more subtle form. I have always been interested in texture or surface of the material I chose and the scale of those things in relationship to the overall size of the piece. This has always been there. Somewhere around 1977, I had an interest in that inner fleeting-through-space idea. I was interested in the solidness of the cube, combining the really known and solid with the unknown and less predictable. To bring them together absolutely equally and absolutely seamlessly was the focus. I made a cube. It was made out of concrete and its partnership was with fire. I burned out the inside of the cube and there was left charring and scorching on the outside too. Fire was the unknown. I was interested in form and force and known and the unknown.

SS: I have seen that work. It is very powerful and dramatic.

JW: I did a number of pieces. I did one piece where I used explosives in a similar way. The scale of it in terms of power was much larger. I wanted to reduce the drama of it and just have the quiet part that stays after that. After I did that, I had a growing interest in putting color in the pieces, and that took various forms.

SS: These latest open pyramid works have vivid deep pink color impregnated into the sculptures.

JW: Yes, the color is integrated. It is not on top of it. The color is part of the concrete. Colors have their own qualities. Some colors want to go away from you and some want to come to you, and some colors want to hold their place and some want to surrender. You sink into that sumptuous, vibrant pink, away from the round-sided, cooler gray concrete. I think they are very sensuous and sumptuous.

SS: Yes, the material looks soft but is hard.

JW: That's true. However, it has a well container in the midst so there is a contradiction of form. It is still a geometric form. That color is very

inviting, that part of the form is inviting. In the work for my most recent show it didn't seem necessary then to have that space inside. It was all right to have it opened up because the space *around* it was the piece. You were, in a way, in the interior even though you were also outside. They have an inviting quality. The major effect was that somehow I no longer had to put the top on the piece.

SS: They're opened up, but they're still mysterious.

JW: That same interest seems to be one that affected me about simply wanting to work on my pieces myself without assistants. It is much more difficult to manage other people's states of mind, and I seemed to be spending all my time managing their states so I could get them physically to help me. I decided to work smaller, to make pieces that are physically more manageable to work on.

SS: Smaller scale-wise.

JW: Yes, scale-wise.

SS: Do you think of them as iconic, the same image over and over again, labored in a different way?

JW: Well, you can almost look at an artist's paintings and they don't really vary a lot. In a sense it is a variation on one idea.

SS: Less is more?

JW: I wouldn't necessarily say that.

SS: I was thinking imagistically.

JW: It is true, it is very simple geometry. When you pare down all the surface you get form. When you simplify the form you go within the refinement of the surface—what is happening there, what is happening in those relationships within it. So, we get back to what my interest in those things is. I think that is the basic difference. A lot of Western work, particularly American, is really interested in activity and change, and in some way the more things change the more they remain the same. It is as though there is a huge belief in new-is-better, that new really is a reality, that a certain kind of variation, a kind of range of possibilities within human consciousness is different. I am not as much of an advocate of new-is-better. My interest is that the quality of the pieces is very quiet. The Western idea is that things are very active; things are interesting or they're exciting—spectacular. My interest is in silence.

SS: Your pieces have the great silent quality of the eternal.

JW: Silence and silence; I don't want all of that activity. I like to have just enough variety to hold interest.

SS: Why do you live here in New York City if you like silence?

JW: I spent some time in the country, but I need a community of people making art. The community is a base, other people doing the same thing. The attraction of New York is that in the art community, regardless of what goes on in this community, the common foundation in making art is a regular activity.

SS: When you see someone on the street, they ask, "How's the work going?" What advice would you give to young artists coming out of school now? Everybody's majoring in business, but for the five that are majoring in painting and sculpture, what advice would you give them?

JW: Well, one of the ideas I've developed over a period of time about myself is that there is something about art making that has no choice in it. You have to do it because you have no choice. That lack of choice has to be there. You simply have to make art regardless of the outcome. It's a commitment. You step off the cliff and you're in the abyss. Unless that's there, you'll just really never make it. It seems to me, if you surrender yourself to the whole overall pattern, life comes and supports you in it.

SS: That's interesting.

JW: You have to be at the junction of no other choices. If you're going to be happy doing something else, do it.

SS: How important do you think it is for a young artist to come and live in New York? To come and be in connection with the art world?

JW: It's basically that same thing I said to you. It's not hard at all if you're willing to experience complete poverty, humiliation.

SS: A lot of the artists can't afford to live in New York; they could live in Brooklyn or somewhere else close by.

JW: Life always has certain compromises in it, and I think a lot of kids have fairly middle-class values and they're comparing it to the values that they've come out of. I was reared with no plumbing and way out in

the country. We had coal heat and no hot water. This just seemed like normal life to me when I got here.

SS: If they come from privilege then it would be harder for them in a way.

JW: Unless the privilege keeps supporting them. But the privilege takes away that "no other choice." It's interesting: there are a few people around who come from extreme privilege and are very motivated. I think that they simply must realize that money doesn't do it for them.

SS: For others who don't have money, how would you suggest they make a living? Should they try to teach or do something unrelated— drive a cab, work as a waitress, a waiter?

JW: That seems to have to do temperamentally with the person. People are somehow willing to do certain things in order to make art.

SS: Another problem is that it's just about impossible for them to get galleries interested in their work.

JW: That is such a contemporary phenomenon. It's as though everybody needs their A-plus and a pat on the back to make art. You're dealing with this activity that's private, in the protections of your home, and then the very first thing that seems important is showing your work.

SS: Would you suggest that they wait and develp their craft?

JW: It's an odd relationship—like when worlds collide. You have to deal with it; if you deal with it too well you may undermine something else. There's a balance there that somehow has to be met. It's not easy, because the trouble is that you become the subsidizer. You know our culture doesn't really support art, and yet a lot of money exchanging is going on at the moment related to art. That money exchanging gets to be between moneylenders. There are people who collect and sell and speculate all the time. Well, they're not first sales generally. Now there are some first sales—some artists who make lots of money but somehow have mainstreamed into that bracket. Most haven't. It has as much to do with the world as it has anything to do with the work.

SS: That's a whole set of other problems in a sense.

JW: There's just no right and wrong; it ends up being what works is right and what doesn't work is wrong.

SS: You had a pretty supercharged class at Rutgers, but if you went back to the alumni of your class, there would only be a few that still make art.

JW: Yes, one percent. You had to take that step off into the abyss, it seems to me, and people who have done that, the community supports them. But, I'll tell you, you can make images, put paint on a canvas with gusto, but there is a hell of a lot of difference between that and art making. Somehow, it's a life commitment of self-inquiry and self-discovery and that kind of illumination in some way being present in the work. It doesn't necessarily affect your imagery—it could but needn't be—but it's that "juice" that's needed to enliven the material. That juice seems to come from something that is inherent in the nature of the person. It's not a gift, it is its own hardship. It seems, in the end, it is not so much different than a foot off the cliff into the abyss. When that is there—that quality is there—you're making it.

SS: It's magic.

JW: Yes, and there's no telling anybody it. When I wanted to use the unknown in my work, the first thing I ran out and did was try and learn everything about everything I was using. I made a large cube sculpture that was very well made. I hired an explosives expert, and he brought in the police department bomb squad. I wanted to explode just the inside of the piece as I had done earlier with the sculpture I burned on the inside. But because of some miscommunication, the police squad used the wrong kind of explosives. They exploded it four times; on the fifth try they blew up the whole sculpture. Although I was very angry, in a way I got what I wanted—the unknown.

SS: Everything about the materials.

JW: Yes, I learned about explosives, and I learned about concrete, and I learned stress, and I learned this and I went off to do this exploding piece; and what I wanted—and I was simply asking for it—was the unknown.

SS: You use some of the same materials that craft artists have used. What is the difference between craft and fine art?

JW: The purpose of craft is to enhance the living of life, and the purpose of art is to prepare one's way for the leaving of life. I think that the leaving of life is taking that step into the unknown, the abyss.

SS: That's why it's so frightening.

JW: And there's no way to make it easy. Whatever it is, the commercial end of it is that crawling back on the ledge again.

SS: Between the first book, the first part of *Lives and Works,* that I did about ten years ago, and now, working on the second volume, it's interesting to note what the different artists are saying about the women's movement. Would you talk about that a little bit?

JW: As far as art making is concerned, I think art making is a fairly androgynous activity. It addresses a bigger issue than our genital identification. I think it addresses our humanity and the experiences we have. The women's movement was certainly a godsend to me. The first time I showed something publicly in a substantial way was at the Whitney Museum. They were looking for women artists because they were being picketed by women artists. I happened to be there at the right time, with a studio full of work, and was included. It was as simple as that. It was really a godsend, and you know, it was a kind of marriage of a perfect moment. Everybody's life is a marriage of specific moments when things come together. To me, we run the gamut of patriarchal domination on some level. To me, the feminine sensibility is peacetime and the male patriarchal references are to wartime, for protecting. The difficulty that has arisen is that we've gotten a lot of machinery to empower our warring ability, and we don't have a balance of insight to take care of peacetime. So we simply can never have peacetime. We have taken the role of patriarchal protector and moved it into our peacetime daily activity as competition, and basically we've warred on these principalities of life. We just war all the time; we don't know how to have peace. We just don't have a clue as to how to have peace. I think the women's movement has been hugely successful. Certain issues have come to light—abuse of women, abuse of children. Historically women and nature have all been synonymous. The way we have destroyed nature is a large-scale version of what we have done to women, particularly to the principle of nurturing. We're busy having war games during peace—one nation competing with the other, getting the best this, buying more, insulating ourselves from everybody. We insulate ourselves from each other. We can't even have dear relationships, we can't have marriage anymore because we are all functioning on a patriarchal, warring sensibility, and really we don't know how to live together. Yet, I can't imagine a better time to have lived, given the fact we were born in Western culture.

SS: As a woman?

JW: Yes. On the other hand, it is riddled with limitations.

SS: Still? I would like to ask what you think of museums such as the new Women's Art Museum in Washington, D.C., which shows just women artists?

JW: You have to exist in the world. You essentially have to mainstream or you end up isolating yourself in a ghetto-fashion otherwise.

SS: Certainly the art world mirrors that behavior.

JW: The art making in the studio, hopefully, isn't engaged in that selling, showing, promotion activity—the competition. The competition is just outrageous. Business is based on that, and business and money are our new set of gods. They don't do much for the abyss; they do a fair amount for the cliff. Horrible. What about the community? Nobody gets rich unless it's at somebody else's expense. In the darkness of night, the rays of the new day are being born. So the coldest time during the day is just before dawn. My search as an artist is for that unknown.

Index

About the Authors

Beryl K. Smith is a graduate of Douglass College. She earned an M.L.S. and an M.A. in art history from Rutgers University. Ms. Smith is an art librarian at Rutgers University and was curator of the Mary H. Dana Women Artists Series at Douglass College from 1983 to 1991. She serves as the editor of *Art Documentation* and has published articles about women artists and the Women Artists Series as well as about library topics.

Joan Arbeiter earned a B.A. from Brooklyn College and an M.F.A. in painting and drawing from Pratt Institute. Her work has been shown widely and reproduced in *The Language of Visual Arts* as well as in several periodicals. She is an exhibiting member of CERES Gallery in New York City. Ms. Arbeiter teaches at the DuCret School of Art in Plainfield, New Jersey, and she has also conducted her own studio school. She has served as master teacher, art education consultant, curator, juror, lecturer, and demonstrator for art groups throughout New Jersey. She is the author of several catalogue essays as well as an article about Sari Dienes in *Women's Art Journal.*

Sally Shearer Swenson received a B.A. in Fine Arts from Elmira College, studied painting at Boston University, and earned an M.A. in education from Salem State College. She has been a practicing artist for twenty-five years, has exhibited nationally in museums and galleries, and her work is in numerous private and public collections. She was a member of the fine arts faculty at Trenton State College from 1980 through 1993. Ms. Swenson has co-authored two books: *Questions and Answers about Learning Disabilities* (1988) and *Lives and Works: Talks with Women Artists* (1981). The present volume is meant to be used with the latter work.